HAWAIIAN
SCULPTURE

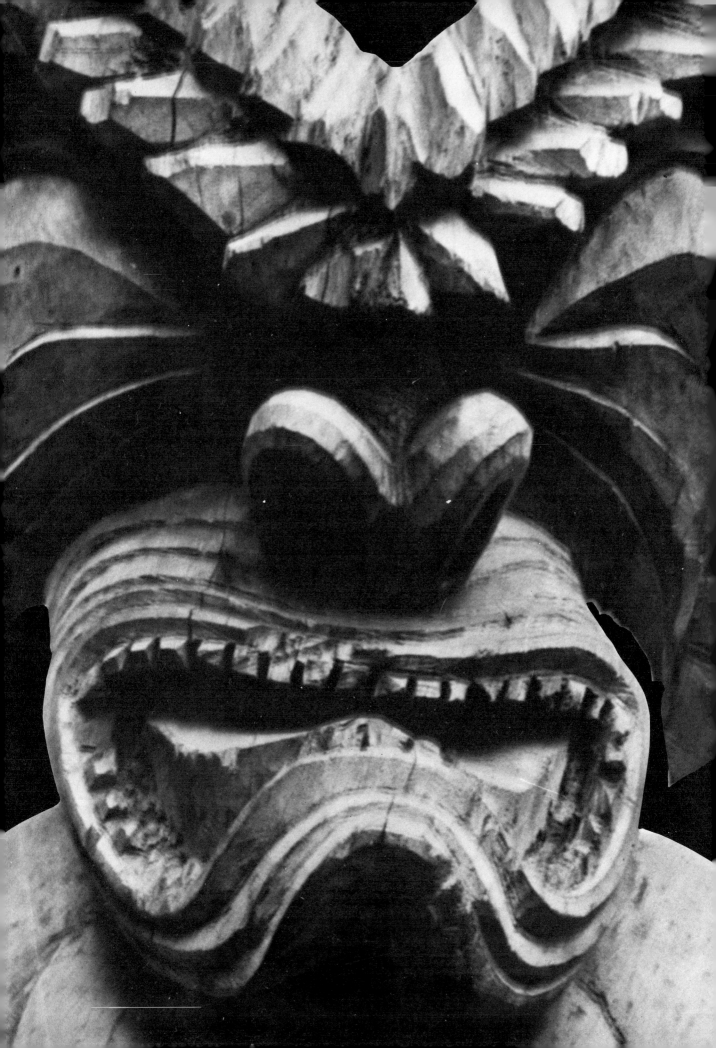

HAWAIIAN SCULPTURE

J. Halley Cox
with
William H. Davenport

The
University
Press
of Hawaii

Honolulu

Copyright © 1974 by The University Press of Hawaii
All rights reserved
Library of Congress Catalog Card Number 73-151453
ISBN 0-8248-0281-0
Manufactured in the United States of America
Designed by James C. Wageman

Contents

FOREWORD VII

ACKNOWLEDGMENTS IX

HAWAIIAN SCULPTURE 1
 Introduction 3
 History and Culture 7
 Hawaiian Sculptural Tradition 23
 Style 104

CATALOG OF EXTANT PIECES 115

BIBLIOGRAPHY 195

PHOTO CREDITS 198

Foreword

Within the broad context of Oceanic art with its fascinating array of forms and traditions, the art of ancient Hawaii has long been recognized for its distinctive quality. The Hawaiians who produced this art are unknown as individuals and their personal identities are completely obscured by the past. Yet outstanding examples of their work are included in all comprehensive books on Polynesian and Oceanic art. There are today a growing number of such scholarly studies.

What has heretofore been lacking is the intensive treatment of the most important manifestation of Hawaiian art—the sculptural tradition. This is said not to deprecate the usefulness of Brigham's early report on Hawaiian carving, Luquiens' modest but pioneering study of Hawaiian art, or Buck's masterful compendium on Hawaiian arts and crafts. However, none of these writers set as their task the analysis of Hawaiian sculpture in all its technical and stylistic complexity and in its social and cultural relationship. This volume fills this need and will be indispensable to students and laymen alike.

The Hawaiian sculptural tradition was so closely linked to the ancient religion of Hawaii that it came to an end with the overthrow of the old gods in 1819. Many images were destroyed by the Hawaiians; many others were abandoned to rot and decay, as wood was the primary medium. Surviving in museums and private collections in various parts of the world are some one hundred fifty examples of sculpture of the human figure. The corpus of material is consequently limited, but as the authors demonstrate, this corpus is large enough to include a wide variety of forms. Furthermore, this book is based not on a selected sample of either outstanding or typical pieces, but rather on the entire range of known Hawaiian sculpture embodying the human figure.

Twenty years ago it was impossible for the student of Oceanic art to place this material in a historical continuum of any actual time depth. The remarkable progress of archaeological research in Oceania has enabled the authors to present Hawaiian sculpture as the culmination of historical processes involving the establishment of the Hawaiians in their island home, contact between the Marquesas, Tahiti, and Hawaii, and the development of Hawaiian culture as a separate entity in the Polynesian realm.

As in the case of many societies of the past, religion provided most of the basic rationale for the Hawaiian sculptor's work. Just as important was the place of the artist in Hawaiian society. This society was preliterate and technically much less specialized than those of the contemporary world, but its organization was not a simple one. Hawaiian social structure included a differentiation of the people into classes, an involved religious organization, and, with the assumption of Kamehameha I to full political power, the formation

of a classic example of the conquest state. Within this society there also developed socially recognized groups of specialists responsible for the transmission of knowledge, both sacred and secular. Just how these specialists were recruited and most of the details surrounding the transmission of their knowledge are imperfectly known, but it was to this group that the Hawaiian sculptor belonged. One of the valuable aspects of the present book is the utilization of ethno-historical sources in describing, to the extent that it is possible to do so, the place of the sculptor in Hawaiian society and the role of his art in Hawaiian culture.

One could dwell at length on the authors' treatment of techniques, form, style, sculptural traits unique to Hawaii and those common to Hawaii and other parts of Polynesia, but in such matters they speak fully, and comment is redundant. It is a pleasure to point out that the book is the product of fruitful collaboration between a professional artist and a practicing field anthropologist, each with many years of personal experience in Oceania and sharing a profound knowledge of Hawaiian art.

ALEXANDER SPOEHR
Professor, Department of Anthropology
University of Pittsburgh

Acknowledgments

This book developed out of a project, the aim of which was an effective visual presentation through photography of the Hawaiian sculpture in the Bernice P. Bishop Museum. Credit must go to my co-worker William H. Davenport, who is almost entirely responsible for this phase of the work. I am most grateful to him for the fine photographs and for his sensitiveness and insight in matters of sculptural qualities and meanings and especially for supplying the body of the material on Hawaiian history and culture. The University of Hawaii Research Committee supplied a small grant for materials for the original photographic project and another for the preparation of the manuscript. The authors are most appreciative for the cooperation of the staff at the Bishop Museum, particularly the directors—the late Peter H. Buck (Te Rangi Hiroa), past director; Dr. Alexander Spoehr, past director; and the present director, Dr. Roland Force—and also to Dr. Kenneth P. Emory, whose infinite enthusiasm and knowledge of Hawaiian and Polynesian ethnology were so graciously shared. We are also indebted to Margaret Titcomb, librarian, and to the Department of Anthropology of the Bishop Museum for their assistance with research. Acknowledgment and thanks are due Dr. Samuel Elbert, University of Hawaii, and Carol R. Cox for their advice in the translations of the Hawaiian chants, and also to a number of my students at the university who have assisted in the formulation of concepts relating to Hawaiian sculptural forms.

I am also most grateful for the gracious welcome from the directors, curators, and staff members of the several museums in Europe, the United States, and New Zealand and for their kind assistance with the photographing of the Hawaiian material and for making their museum records available. In this regard, thanks are particularly extended to B. A. L. Cranstone, assistant keeper, Department of Ethnography, British Museum; Sir Roger Duff, director, Canterbury Museum, Christchurch, New Zealand; Robert P. Griffing, past director, Honolulu Academy of Arts; and Mrs. Harry Edmundson for permission to photograph the images from the Forbes Collection.

If it were not for the sustained enthusiasm and encouragement of my wife, Carol, and her unfailing assistance in museum research, aid in the translations and use of the Hawaiian language, typing and editing, this work could not have been completed. It is to her that this book is dedicated.

J. HALLEY COX

HAWAIIAN
SCULPTURE

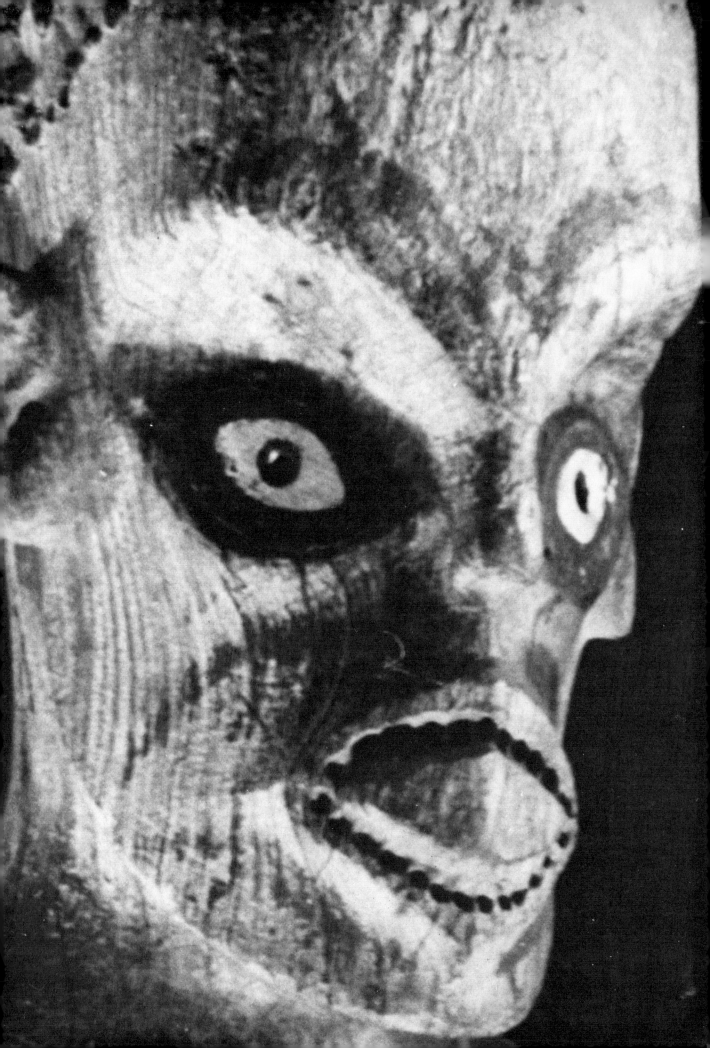

Introduction

Of the wood sculpture that comes from the rich and vital ancient Hawaiian culture, approximately one hundred fifty examples remain. These are now found in museums throughout the world, and some pieces are now as remote from the islands of their origin as New York and Munich. This study has been limited to the Hawaiian sculpture of the human figure in wood. Within the sculptural tradition there was very little else. There are no known examples of figurative subjects other than the human form. Sculpture in materials other than wood was sparse. For a complete view of the sculpture in wood a catalog with a photograph of each of the presently known pieces is included here.

Examples of Hawaiian sculpture have been presented in several books on primitive and Pacific art. These have always been the more spectacular examples—those that have been judged, almost universally by the authors, as outstanding examples of primitive sculpture. This they certainly are, but a broader view of the tradition is needed to fully understand and appreciate the variety and richness of its sculptural quality. Our aim is to present as total a view of this tradition as is now possible.

How representative the existing pieces may be is possibly questionable, but from all available evidence they represent a fair sampling of the thousands of pieces that existed prior to 1820. The wide range of types, styles, sizes, forms, and apparent functions is immediately noticeable. An examination of the relationships within this variety of sculptural treatments exposes an underlying continuity of style, indicates the boundaries of the tradition, and possibly accounts for some of the diversity of forms.

A further aim of this book is to explore the various functions and purposes of the sculpture within the culture, and to relate these to the specialized meanings and symbolisms that are associated with the individual sculptural forms. There is very little documented material of this nature in the literature that is directly related to the sculpture or the other arts. Most of the references to meaning and symbolism must be reconstructed from what has been recorded of the general cultural history of the Hawaiian people, or discussed as assumptions based on what seem to be similar or related forms from other traditions. Some evidence of symbolism may be assumed simply from the morphology of the remaining images, and, when this evidence does not conflict with what is known of the culture, it adds to the total picture of the sculptural tradition.

Of this tradition much still remains obscure. We remain ignorant of the nature of the basic judgments made by the sculptor at various stages of his production, and, consequently, of the significance of many of the details of the forms. There is little on which to formulate a theory of "Hawaiian aesthe-

tics," although some very broad generalizations may be broached. Our own aesthetic judgments about the sculpture may tend to prejudice our insight in this matter, and, since such a judgment would be valid only to the extent that there is a "universal aesthetic," it may be safer to disregard it. The areas of aesthetic agreement between two divergent cultures simply cannot be known. An example of this disparity is that the idea of fear as the motivating force producing the so-called grotesque features of the Hawaiian images has been overemphasized in the writings about Hawaiian sculpture. This misconception, or at least oversimplification, is due partly to the limited view of the sculptural tradition afforded by those few examples that have been most often published. However, such concepts also result from our limited knowledge of the creative and aesthetic processes, not just in exotic societies, but even in our own. The emotional associations accompanying the viewing of an object and the value judgments evoked by it, when it is completely removed from its original cultural context, will be significantly different from those of the artist who made it, or of the immediate audience for whom it was made.

The common denominator of knowledge and experience that enables the artist to create meaningful entities for his appreciators is the culture that they as members of a society share. The artist, motivated by subliminal impulses, draws upon the resources of his mind to make a new synthesis of forms, which, by means of skillful craftsmanship, he transmutes into a tangible concreteness that others can perceive. However, the artist does not work in a completely egocentric universe. True, his individual genetic heritage may account for the potentials of talent that underlie his abilities, but he has been conditioned by his culture and works in an already established art tradition. From this tradition he has learned forms, techniques, and values, all with meanings and connotations that are part of the culture matrix. Even the degree to which he as an individual may resynthesize and create innovations within the established forms is in part determined by the tradition in which he works. Also, he is dependent upon the physical environment for his materials. Thus a piece of sculpture is the end product of interaction among the culture, the biopsychological nature of the artist, and the physical environment. It is always a compromise, or a highly inconstant state of equilibrium that is achieved, never twice the same. It is undoubtedly because of this instability that sculptural styles vary so greatly from society to society and from artist to artist within the same society.

The specfic difference between the artist and the nonartist seems to be one of degree. This is more obvious in a nonliterate, or so-called primitive society, than in our own. In pre-European Hawaii, for example, nearly all women made bark cloth called *kapa* (tapa), decorating it with highly creative designs. In a

broad sense most of these women were artists, some better than others, for some examples of tapa display more intuitive inventiveness and mastery of technique than others. So it seems that, given the proper cultural incentives and opportunities, most people can become more than just passive receptors of aesthetic creation and can participate in the production of aesthetic objects. The exceptionally gifted artist is endowed with greater neuromuscular ability and greater talent for innovation and for conceptualizing and executing objects in his specific medium, than is a mere craftsman or a nonartist.

In a technologically sophisticated society, the average person is likely to know very little about the fine artist's tools, techniques, and materials, or about the artist's intentions and goals. This ignorance is a by-product of the extreme specialization in a complex civilization. In Hawaii, the professional sculptors of the great temple images were confined to men from a special professional group within the nobility, but their tools, materials, and basic techniques were in no way different from those used by the commoners, farmers, and fishermen who made things for their own personal use. With this common understanding the nonspecialist could not but be aware of the professional sculptor's technical problems and the degree to which he was successful in solving them in a particular instance. It must be remembered that a Hawaiian sculptor always carved his image to function in a magico-religious ritual. Its ultimate value was probably measured in terms of the efficacy of the rites. If an image's aesthetic qualities in any way affected its value, it is not now possible to know.

In Hawaii, as in the rest of the primitive world, sculpture was constructed for important magical, religious, and social uses. It was a representational form of art, undertaken for the express purpose of rendering abstract concepts into concrete form. In effect, sculpture was theatrical property for ritual drama. Its most immediate meaning is to be found in its relationship to the ritual context. Not only was the sculpture in most instances intended to be used as ritual objects, but the acts of carving were rituals in themselves to be performed only by a religious specialist and to be accompanied by the most rigorous observances. To understand the meanings, usages, and observances that provided the impetus for the production of the sculpture, it should be seen against a background of the culture that produced it.

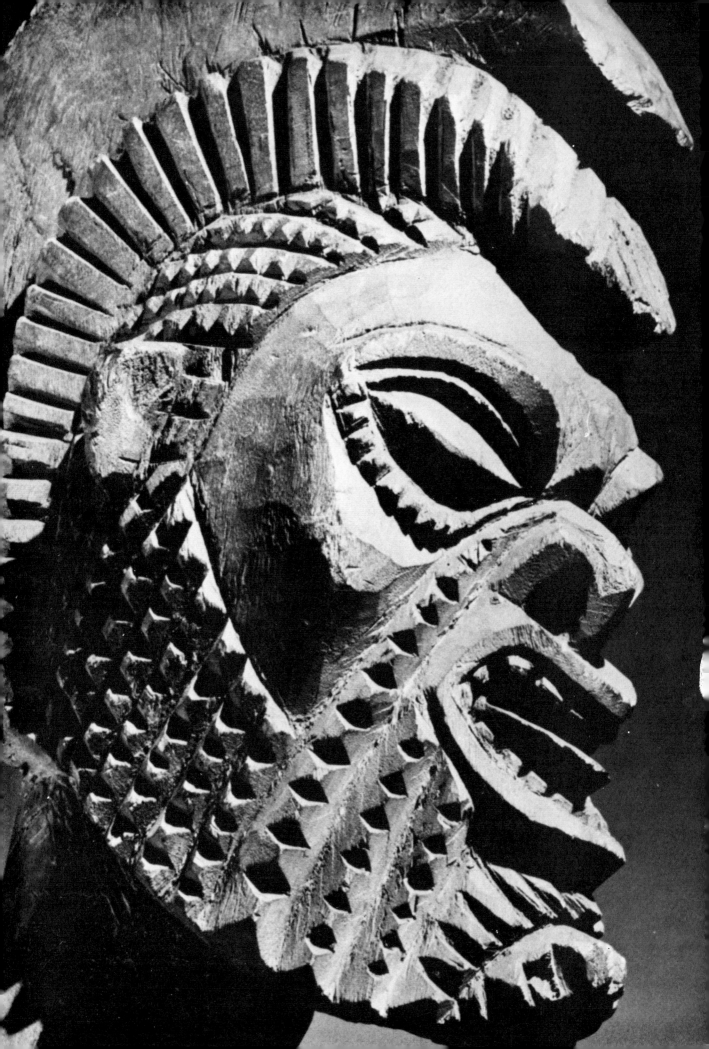

History and Culture

POLYNESIAN ORIGINS

During the millennia in which man spread out from the Asian mainland to occupy the islands of the Pacific and Indian oceans, the Hawaiian Islands lay isolated in their remote part of the ocean. Not until about two thousand years ago, long after nearly all the other habitable regions of the world had been well populated, did man first set eyes on the lofty volcanoes, luxurious rain forests, and sloping plains of the Hawaiian chain.

The Hawaiians are a branch of the widely spread Polynesian race, which had, through a sequence of discovery, migration, and isolation, settled a vast area of the Pacific. By the time the Europeans arrived in the Pacific, the Polynesians had reached north to Hawaii, southeast to Easter Island, southwest to New Zealand, and had occupied all the inhabitable islands within this triangle. They had also established themselves on many islands of Micronesia and Melanesia.

Archaeological evidence indicates that the Hawaiian Islands were well populated by A.D. 500 and that the first settlers may have arrived several centuries earlier. Two areas of origin are probable: the Marquesas and the Society islands. Recent archaeological studies in the Marquesas suggest that during the first to fifth centuries A.D. the Marquesans were exploring and settling the Tuamotus, the Society Islands, Easter Island, and Hawaii. After this initial discovery and settlement of the Hawaiian group, there was probably a period of several centuries of comparative isolation. Then followed migrations to and settlement of Hawaii by the Society Islanders, who had already spread throughout the south central Pacific to colonize the Cook Islands, Austral Islands, and New Zealand. Contact between Tahiti and Hawaii continued for some time but had ceased before Hawaii became known to Europeans in the late eighteenth century. The cultural influences from the Tahitian contacts came to dominate the previous Hawaiian patterns, particularly in language; religious practices, such as the temple ceremonies and the *kahuna* (priest) system; and the establishment of political and economic control by sanctified chiefs. However, the final period of three or four hundred years of isolation allowed time for the evolution, change, and innovation that produced the distinct character of the Hawaiian culture.

The differences among Hawaiian and other Polynesian cultures are particularly noticeable in the arts, such as in styles of sculptural treatment, decoration of tapa, and specialization in featherwork. These differences may be due partly to the temporary nature of the materials used for these objects, of which only the more recent examples have survived. It is apparent that in Hawaii, as well as in other Polynesian areas, most of the art objects that were in existence when these cultures became known to Europeans were the end products of a series of changes in isolation. The forms and styles did not run

parallel courses in each Polynesian area. Although originally many of the sources were the same, we cannot now know what those original forms and styles were like.

Hawaii shared with the other Polynesian cultures the skills of intensive cultivation of a rich assortment of root and tree crops. Some of these were grown under extensive irrigation. Most of these plants, as well as dozens of species cultivated for their fibers, medicinal properties, magical potency, and beauty had been transported from the homelands during the period of migration. Also brought to Hawaii were chickens, pigs, and dogs, all of which were bred either for consumption or for religious sacrifice. The great similarity among the physical environments of most of the Polynesian islands enabled the immigrants to Hawaii to re-establish their accustomed way of life without altering it greatly to fit new conditions.

Polynesians were gifted craftsmen in wood, bone, shell, stone, and fibers— the materials from which they made their tools and most other objects. Metalworking was unknown and loom weaving was limited to some of the Polynesian outliers in the western Pacific. Ceramic techniques had been introduced through western Polynesia to the Marquesas, but apparently spread no farther. The absence of these crafts, which are often used as a measure of technological and cultural advancement, indicates neither a lack of technical mastery of other skills nor an absence of creative motivations and abilities in a variety of media. As their artifacts testify, Polynesian craftsmen were rarely satisfied with the fabrication of objects of mere utility. Rather, nearly every object was fashioned with great care and in accordance with strict standards of excellence that far surpassed the minimal requirements of usefulness alone. In many Polynesian societies the standards of excellence were so demanding that only highly skilled specialists could participate in certain activities. One of these was sculpture, and it was in this medium that the skilled artisans of the Society, Cook, Marquesas, Easter, and Hawaiian islands produced some of their most distinguished creative works. Elaborating on the common cultural tradition, the artisans of each of these societies developed their own characteristic styles and aesthetic values. Hawaii seems to have produced sculpture that was the least stereotyped in design and execution, and for this reason it appears to be the boldest and most vigorous of the independent but historically related sculptural traditions in Polynesia.

HAWAII

Originally, the Hawaiians had no single name for the entire group of islands. Today the separate island names are still used, but that of the largest and most southerly, Hawaii, has come to stand for the whole group. The eight main

islands were divided into a number of feudal domains, each ruled by a supreme and absolute chief. The limits of each domain were not permanently fixed, but fluctuated as the war successes of the contending rulers waxed and waned. When Capt. James Cook first arrived in 1778, the chief Kalani'opu'u was ruler of all the domains of the island of Hawaii, while on the remaining islands other paramount chiefs controlled various domains or combinations of them. Despite this political segmentation, the culture was relatively uniform throughout the group.

The people were divided into three hereditary classes: nobility (ali'i), commoners (maka'āinana), and a small despised group of pariahs or outcasts (kauwā). The nobility was a sacred class that traced its descent directly from the highest deities. Rank within the class was based upon primogeniture, either through the males or the females, whichever was the most advantageous. The most sacred of the ali'i traced their descent only through eldest children to the gods, and their long genealogies were preserved orally by means of special "name chants" composed in their honor.

A corollary to the belief in divine descent of the nobility was the concept of a mystical property called mana. The exact source of mana is not clear, and perhaps Hawaiians did not speculate greatly about it, but its manifestation was the ability of a person or thing to achieve results of distinction. Therefore, mana can be roughly translated as mystical power. A gifted person had mana, and an object such as an adz or a charm that worked well also possessed mana. Mana was embodied in persons in rough proportion to their rank; therefore the nobility had mana and commoners did not. Furthermore, the ability to possess mana without suffering harmful effects depended upon rank. An individual of high rank could have considerable mana, but it was extremely dangerous to a commoner or an outcast when, by contagion, he contracted a supercharged amount of mana from an exceptionally high ali'i. For this reason those chiefs who were the direct descendants of the great deities and who were thought to be in some ways the incarnation of these gods, were so charged with mana that in some situations they could not even walk about the land without rendering all they touched, or upon which their shadows fell, prohibited to commoners.

The concepts of rank and mana reinforced the class divisions by creating a kind of avoidance between persons of extreme rank difference. This sanctioned avoidance, called kapu (taboo), was a system of religious law. Any prerogative of an ali'i was automatically kapu, or sacred, and thereby prohibited to commoners and outcasts. In addition, a ruling ali'i could proclaim a kapu on or over anything whenever he felt it necessary. In effect, the kapu was an

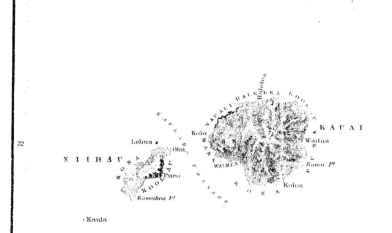

22

N I I H A U

Lehua
Oku.
Pueo
Kawaihoa Pt

Kolo

KAUAI

Wailua

WAIMEA
Koloa
Kawa Pt

· Kaula

Kahuku Pt
Waimea
Kaena Pt

Waianai
Laeloa
EWA
HONOLULU Leahi
Diamon

21

MAP

OF THE

HAWAIIAN GROUP

OR

SANDWICH ISLANDS

BY THE

U.S.Ex.Ex.

1841.

20

19

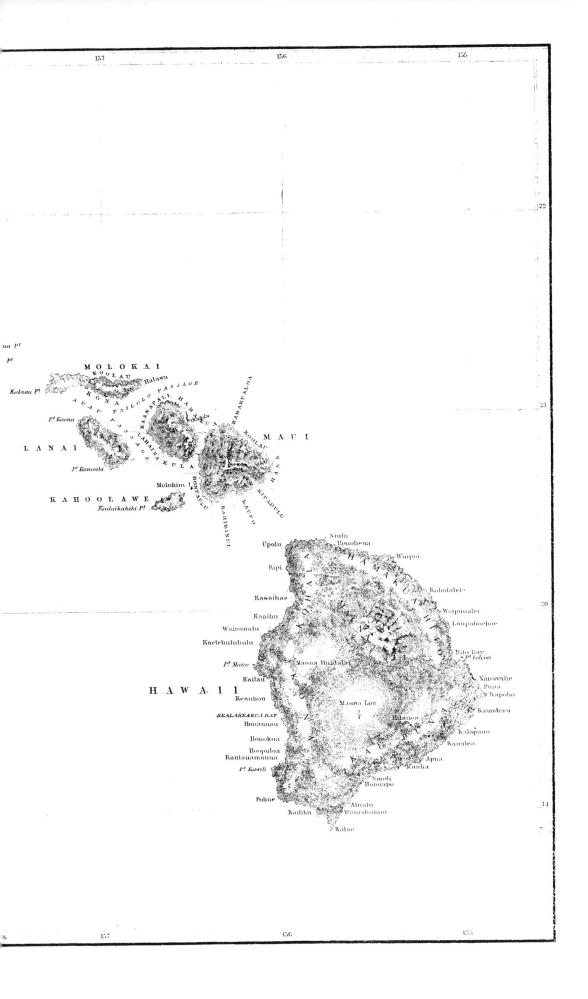

22

21

20

19

ua Pt

Pt

MOLOKAI

KOOLAU

Halawa

Kalaau Pt

KONA

PAILOLO PASSAGE

AUAU PASSAGE

Pt Kaena

KAANAPALI

LAHAINA

KAMAKALOA

KAHAKULOA

HAMAKUA

KULA

Paliuli

KOOLAU

MAUI

LANAI

Pt Kamaiki

HONUAULU

Molokini I.

HANA

KAHOOLAWE

Kealaikahiki Pt

KAMAOLU

KIPAHULU

KAHIKINUI

LAEPO

Upolu

Niulu

Honohena

Kipi

Waipio

Kawaihae

Kaholalele

Kapihi

Waipunalei

Wainanalu

Laupahoehoe

Kaelehuluhulu

HAMAKUA

HILO

Hilo Bay

Pt Mano

Mauna Huahalai

Pt Leleiwi

Kailau

Nanawalie

HAWAII

Puna

Keauhou

Kapoho

Mauna Loa

Kilauea

Kaunieu

KEALAKEAKUA BAY

Kalapana

Honaunau

Kauulea

Honokua

KAU

PUNA

Hoopuloa

Kaulanamauua

Apua

Pt Kawli

Kaaha

Ninoli

Honuapo

Pohue

Alualu

Waioahuhuui

Kailiku

Kalae

extension of the personal rank-mana potential of a paramount chief. The *kapu*, in addition to separating the nobility from the lower classes, provided protection from contact with such things as corpses and evil spirits, which were thought to be defiling. Women were considered in some aspects unclean, hence men and women prepared and ate their food separately. Probably the fear of defilement was somehow related to the fear of losing mana to an inferior. The *kapu* was also a reinforcement of political power, the method of conservation of natural resources, and a means of social control. In fact, serious crimes were always violations of the supernaturally sanctioned *kapu* system. Whether or not these two sets of beliefs, mana and *kapu*, were woven into a single, coherent theological system is not known, but together they provided the supernatural background for a rigid system of social control that permeated many phases of Hawaiian life.

There was a group of highly trained male artisan-priests called *kāhuna*. The name *kahuna* specifies someone who possessed special ritual by means of which supernatural powers were generated and manipulated. Since all gifted artisans probably possessed ritual used to assist them in their crafts, they too were classed as *kāhuna*. Every important skill was under the direction of *kāhuna*, who had been rigorously trained in the religious and manual aspects of their profession. For each major god there was a special group of *kāhuna* to perform services in its name. There were special *kāhuna* for planning the terraced religious temples; for navigation, meteorology, and healing; and also for sorcery. Any undertaking that required much skill and mana for its successful completion had an appropriate *kahuna*. The creative arts of dancing and sculpture were under the control of these priestly artisans. It is not clear exactly how *kāhuna* were distributed among the noble and commoner social classes.

An important prerogative and symbol of the *ali'i* was their special clothing. On ceremonial occasions, men wore magnificent capes or cloaks (*'ahu'ula*) made of fine netting completely covered with small, downy feathers. They were usually a bright yellow, with large geometric designs in red and black. These designs, which are reflected in the sculpture, were possibly symbols for mana. The higher the rank of the *ali'i*, the longer and more luxurious his cloak. The great Kamehameha I had a cloak that hung to the ground and was entirely covered with the rare yellow feathers of the now extinct *mamo* (Hawaiian honeycreeper). In addition to the cloaks, men also wore tight-fitting crested helmets of wickerwork (*mahiole*), which were covered with feathers to match the cloak. These headgear, though really symbols of rank and class, were also worn into battle, where they afforded some degree of protection and probably functioned to point out the *ali'i* to their supporters. Another symbol worn by

both men and women of the noble class was a very thick necklace made of many small strands of braided human hair from which a large whaletooth pendant (*lei niho palaoa*) hung. The tooth was carved into the shape of a blunt, flattened, tonguelike hook (figure 12).

Beneath the nobility, and separated from them by what seems to have been a sharp social break, were the commoners who constituted the mass of the Hawaiian population. They lived in large family groups that were widely scattered throughout the districts. Each family group seems to have had a senior person to whom was allotted a tract of land on which the family lived and worked. Adjoining tracts were occupied by related families. Because the families traded among themselves, produce and products of the inland sections found their way to the sea, and vice versa. A number of these adjacent tracts constituted a district, which ran from the mountains to the sea and was under the stewardship of a district chief. Several districts made up the political territory of a ruling chief. The ultimate control of all land always remained in the hands of the ruling chief. Secondary rights were given over to the district chiefs in return for valuable services they had rendered to the ruling chief, and rights of use only were held by the commoners who actually worked the land. These commoner family groups were obliged to give substantial quantities of their produce and to supply labor to their chiefs as tribute. These were used to support the nobles and priests and their respective undertakings in war and religion.

Commoner men and lesser nobles were expected to give military service when it was required by the ruling chief and also to provide him with labor and skills for the construction and maintenance of roads, temples, irrigation systems, and fortifications. A few commoners also seem to have been in the direct employ of nobles as personal attendants, servants, gardeners, fishermen, keepers of fish ponds, and entertainers. Since neither the lesser nobles nor the commoners possessed inalienable rights to land and were not unalterably bound to their land or to their chiefs, maintaining political stability was not automatic. If the demands of a ruling chief became oppressive, his subjects could desert him for another chief who would welcome the additional productive and military strength they offered. A coalition of commoners, lesser chiefs, and possibly even influential priests might overthrow and replace their ruler.

Below the commoners were the *kauwā*, a small hereditary group who were forbidden to marry out of their caste. They were supposed to have been physically different, to have had characteristic manners and habits of speech, and they wore special facial tattoos. Just what the precise economic and social roles these pariahs played in the society is not known. It seems quite probable

'Aumakua image. The similarity in style indicates that this image may have been carved by the same sculptor as that of figures 54 and 55. The teeth, shell eye-plates, and hair have been lost. Height: 17½ in. Bernice P. Bishop Museum. Cat. no. A5.

that they were not allowed to occupy productive lands and that they found their livelihoods by attaching themselves to commoner households as domestic servants or slaves. They were often chosen as the victims of human sacrifice at certain temples called *luakini*. It has been suggested that these pariahs were the survivors of early immigrants to the islands, who were later subjugated by a migration of persons with a superior culture. The evidence for this historical interpretation is so slight that it warrants very little consideration, but it is significant to note that much of Hawaiian cultural evolution was in the direction of more and more internal stratification.

The religion of Hawaii was composed of several ritually distinct cults. One of these was the worship of protective spirits, *'aumākua*, and another was the worship of specialized cosmic deities, *akua*. In a functional sense, this is one determinant of two of the types of figure sculpture, although it is not always possible to determine from the morphology of the images which are *akua* and which are *'aumākua*. To obtain an *'aumakua*, the soul of an illustrious and particularly successful deceased relative, or sometimes that of a young child, would, with proper ritual, be induced to enter some kind of fetish. The fetish could be either an animal or an inanimate object, such as a bone of the deceased or a carved image. Should an animal be selected as the receptacle of the spirit, the particular recipient of the departed soul would be treated as a pet, and a familiar relationship between its species and the venerator would be established. Although this resembles totemism, there was no idea of descent from the animal; furthermore, if such an *'aumākua* relationship did not prove successful, it could be discarded and another established.

In addition to *'aumākua* and *akua* there were many other supernatural beings, most of which were evil spirits. These malevolent spirits or ghosts were souls that for one reason or another had failed to reach the land of the dead or had been neglected by their descendants. A sorcerer could coerce one or several of these wandering spirits into a carving, a bone, or some inanimate object in much the same way as the *'aumākua* were ensnared. Thus controlled, they could be sent forth by proper ritual to perform the evil intent of the sorcerer or his client. Sorcery is another religious cult that defines the use and ritual context of the human figure images. But as with the other types, it is not now always possible to determine which images were used for sorcery. The best way to effect sorcery against an individual was to obtain some of his excreta, fingernail or hair cuttings, or a personal object belonging to him and to recite incantations over them. The best protection from these evil practices was a good *'aumakua*. The high chiefs feared sorcery so much that they maintained especially trusted personal servants whose only duty was to

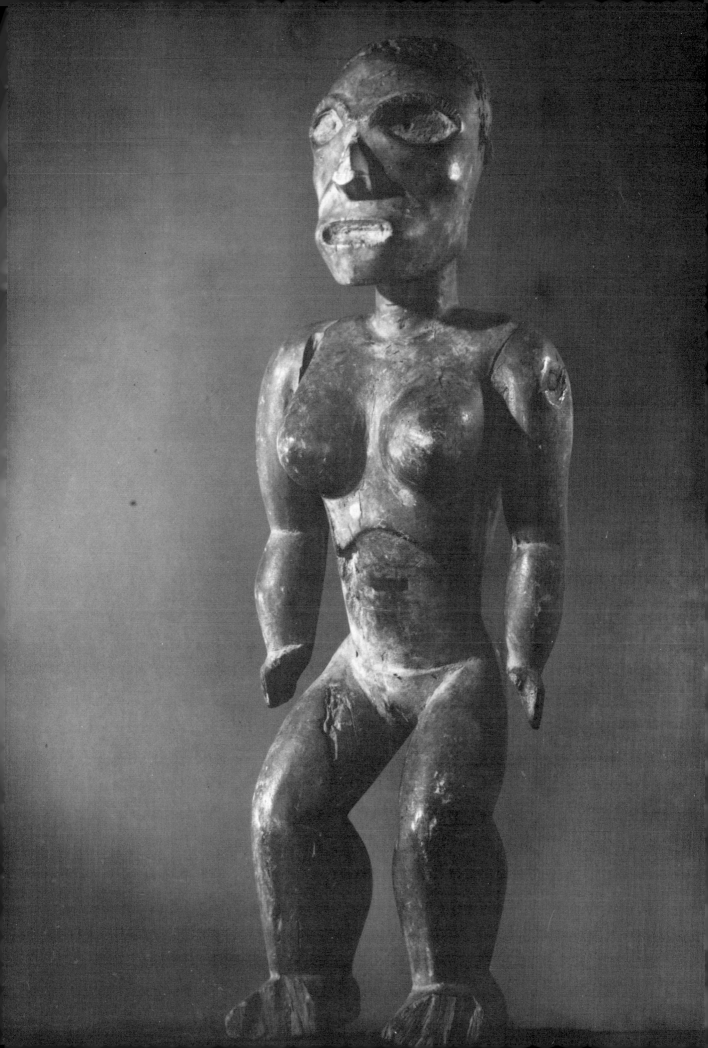

look after their clothes and the special containers in which their excreta and such things were kept prior to disposal. Probably the fear of losing mana also accounted for some of these extreme antisorcery precautions.

The principal *akua* were four great gods: Ku, Kane, Lono, and Kanaloa. These same four deities appeared throughout Polynesia, figuring variously in the different cosmogonic myths. In Hawaii, emphasis was placed on Ku, Kane, and Lono, Kanaloa being only secondarily associated with Kane. These *akua* were anthropomorphized to the extent of having male personalities but were not thought of as merely being humans possessing superhuman power. The images associated with the *heiau* (temples), especially those in the central area of the *heiau*, were representations of these major deities. An individual image, however, would not necessarily maintain a specific identity to any of the three.

All parts of nature were considered manifestations or aspects of one of these three gods. Seldom was any one of the gods addressed without several epithets attached to his name to designate what aspects of him were being addressed. A single prayer, however, might include two, three, or all the gods. Although there was some overlapping among the natural manifestations of the gods, there was a distinct difference in their "personalities" as reflected in the kind of phenomena and natural processes with which they were associated. Ku, for instance, was the most aggressive and active of the three. Common epithets used with his name were Ku-adzing-out-the-canoe, Ku-of-fishing, Ku-of-war, Ku-the-supreme-one, Ku-the-maggot-mouth, Ku-the-snatcher-of-islands. Kane was similar to Ku, but more closely aligned with life, procreation, the male principle, and similar life-giving and forming phenomena. Kane was frequently addressed by such names as Kane-life-giving-one, Kane-the-god-of-life, Kane-the-god-of-the-shooting-herb, Kane-the-water-of-eternal-life. Lono, sometimes familiarly called Lono-makua (Father Lono), was the most humane of the three *akua*. He specifically cared for crops, maturation, forgiveness, healing, and other life-sustaining aspects. Lono would be typically addressed, "O Lono, of the blue heavens, let the crops flourish in this land," or, "This is a petition to you for pardon, O Lono. Send gracious showers of rain, O Lono, life-giving rain, a grateful gift." During the rainy winter months (*makahiki*), Lono became the dominant god. Warfare was *kapu* during this time of year, and the rigorous observances of Ku and Kane were suspended. This aspect of Lono was represented by a specific type of image, and it is about the only one of the existing image forms that can be specifically identified (see p. 91).

The gradation of power and sacredness, from the godlike supreme chief to the lesser *ali'i* to the head of a family, was paralleled by a similar gradation in the major *akua*. Taken together, Ku and Kane represented the impersonal,

omnipotent forces of nature and were never approached on a familiar basis. Lono was powerful, too, but also fallibly human. He could be approached familiarly, as a parent.

In addition to these supreme deities, there were many demigods whose exploits are recounted in the exceedingly rich folklore. Most important of these were Maui, the trickster and culture hero, who fished the islands out of the sea and for whom the island of Maui is named; Pele, the treacherous, vindictive female, whose home is the active volcano of Kilauea; Kama-pua'a, the lecherous half-pig, half-man, the turncoat; and Laka, patron of the dance. To some of these gods, prayers and rituals were offered, but most were only mythological figures whose powers were not important in everyday life. Pele formed a distinctive regional cult, with special *kāhuna* and places of worship. There are a number of images (some of which are mistakenly taken to be female) that are called Pele, but historical evidence for such designations does not exist. The origin and rise of this cult is obscure. Pele was closely associated with volcanic activity, hence she had relations with all the islands. However, the cult of Pele was mainly localized on the island of Hawaii, where her home, the active volcano Kilauea, is located.

Temples (*heiau*), where special *kāhuna* performed the calendric rituals, were erected to each of the three major deities. Erecting temples was the prerogative and responsibility of the *ali'i*, for only they could command the necessary resources to build them, to maintain the priests, and to secure the sacrifices that were required for the rituals. Though temple worship was primarily an affair of the nobility, the whole land depended upon the effectiveness of these rituals. To ensure success, the performance was entrusted to special groups of professionals, the *kāhuna*. Actually, the temple worship was a form of ancestor worship, since the gods were looked upon as also being direct ancestors of the *ali'i* and progenitors of all Hawaiians.

Because a high chief was considered to be the incarnation of an *akua*, at his death his bones were deified and usually carefully concealed in remote burial caves. The bones of some deified chiefs were encased in a basketlike image made of tightly knotted cord. This image was named in honor of the god-chief and set in a sacred house on the *heiau*. This practice constantly reinforced the emotional beliefs in a genetic relationship between the gods and the rulers. In effect, the special ancestor and protector god of the ruling chief became in some respects a living symbol of the divine. The position of the paramount chief in this system was so vital that all aspects of the society were adjusted in order to maintain the supremacy of the *ali'i* and to reinforce the sacredness of the chief's lineage. Such was the case when Kamehameha I finally brought all the islands under his political control in 1810. Ku-ka'ili-moku (Ku-the-snatcher-

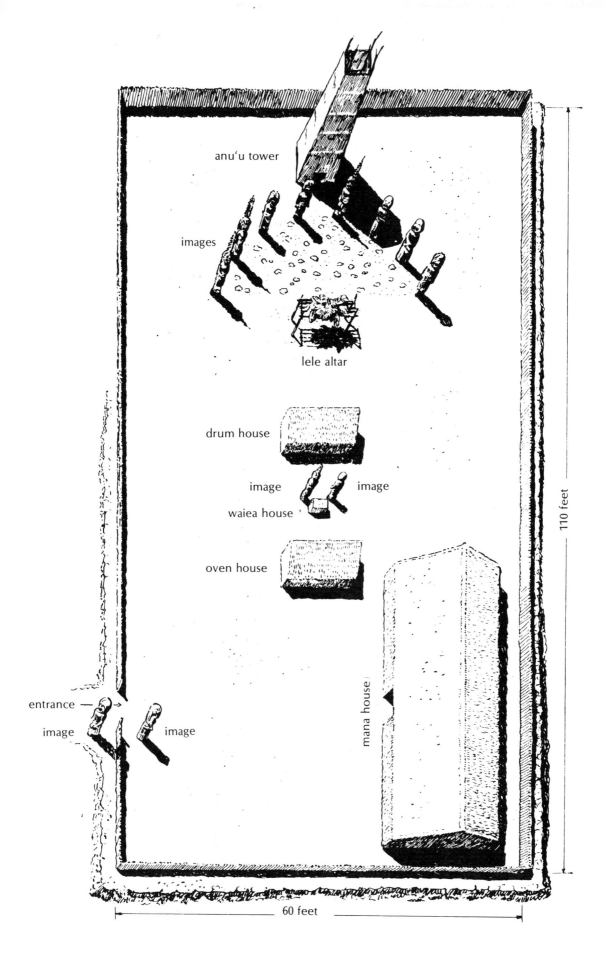

anu'u tower

images

lele altar

drum house

image image

waiea house

oven house

mana house

entrance →

image image

110 feet

60 feet

1 A *luakini heiau*. Drawing by Paul Rockwood. This reconstruction
of Waha'ula *heiau*, at Puna, Hawaii, was drawn by Paul Rockwood
from descriptions given by John Papa Ii (1959:34). It shows the major
features of the *luakini*, built only by the highest chiefs, at which
human sacrifice was performed. The structure and arrangement of the
features of these temples varied considerably throughout the islands.
Whereabouts of drawing unknown.

19

of-islands), Kamehameha's personal god (often represented by the portable
feather image), was established as the principal deity of the new chief's realm,
a kind of state god.

The building of a new temple, the carving of new images to place on it, or
the refurbishing of an old temple were just as much a part of the propitiatory
ceremonies to a god as were the spectacular ceremonies subsequently per-
formed on the temple terraces. These temples were walled enclosures, usually
with several terraces, compartments, and houses, each of which was the place
for a particular ritual. At one end of the *heiau* enclosure was a frame tower,
covered with bleached tapa, into which the seers entered to receive oracles.
In front of the oracle tower was an altar, set before a semicircle of carved
images, upon which sacrificial animals and fruit were laid (figure 1). During
most of the year the *kāhuna*, with the assistance of the chiefs and nobles, con-
ducted a regular calendar of ritual offerings. The ceremonies were accom-
plished with theatrical precision, for perfect execution of the sacred chants
and dances was as necessary as were the rites themselves. During the most
crucial phases of the ritual, the whole countryside might be placed under a
silence *kapu*. If anything interrupted the ceremony, a mistake was made or a
kapu broken, it was considered an ill omen and the rapport with the gods was
destroyed. On the temples to Ku where human sacrifices were offered (*luakini*),
victims were the *kapu* violators, the *kauwā*, and those who had failed to exer-
cise their ceremonial roles with the requisite precision.

Temple ritual seems to have been as much an attempt to establish a dia-
logue between the priests and the deities as it was to make propitiatory offer-
ings to please the gods. The priests invoked the gods with chants, prayers, or
offerings and waited for a reply in the form of omens, favorable and unfavor-
able. If the expected favorable omen was observed, the next part of the ritual
sequence was performed, and so on. If favorable omens were not observed or
if unfavorable signs were observed, the ritual episode was repeated or correc-
tive rituals were inserted in the sequence in order to persuade the deities to
manifest their acceptance of the votive acts by causing favorable signs. Thus,
the manifestations of a deity were not only the natural forces of the universe
that each controlled, but also specific signs or communications they used in
the ritual dialogue.

For the most part the images seemed to be ritual focuses through which
priests established direct communication with designated supernaturals. How-
ever, images were not the only medium through which ritual communication
was established. For some rituals priests entered an oracle tower to receive
messages, in other rituals priests went into a trance in order to obtain direct
contact with their gods, and in some instances it seems that a human, espe-
cially the paramount chief, replaced the image as the medium between gods
and men.

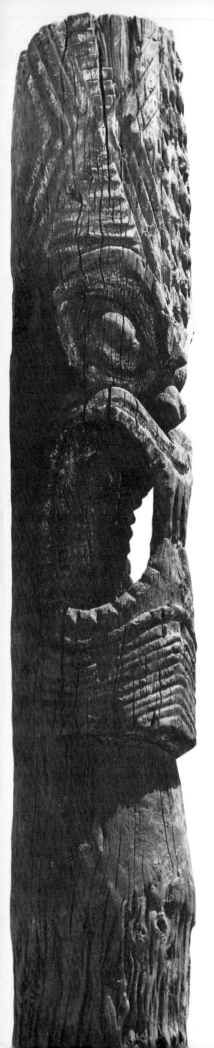

Post-type temple image. In size and style this image is similar to those that stood a the outer edges of the compound at Hale-o-Keawe, Honaunau, Hawaii, as shown in the drawing by Ellis made in 1823 (see figure 43). This image, however, was found on Kauai. It is the largest of all the Hawaiian carvings. Height: 9 ft 9 in. Bernice P. Bishop Museum. Cat. no. T11.

Another way of interpreting the relationship of the central temple image (mō'ī) to the deities and paramount chief is that the mō'ī symbolized the chief who was the god's human incarnation and the luakini temple symbolized the paramount chief's political domain on earth. The chief ruled only by a mandate from the state deity, who in latter days was some aspect of Ku. In the political sense, ritual at the luakini was the means by which the "advice and consent" to rule was maintained.

Although the temple worship of Ku, Kane, and Lono was restricted to the ali'i, the commoners could call upon an appropriate aspect of any of the gods according to their wishes or activities at the moment. Each household had a shrine in a men's house, which was kapu to women. These shrines were usually dedicated to Lono. Here the head of the family offered daily prayers and small sacrifices. Some of the smaller sculptured figures of the 'aumakua or the akua kā'ai type may have been used in these domestic rituals to Lono and the family tutelary. The women had their own gods. Hina, a female deity who was associated with the moon, was an important one. With such a variety of gods and protective spirits, the Hawaiian's universe was pervaded with supernatural beings. No matter what his occupation or situation, there was some entity to call upon for aid and protection. This highly animate view of the world is well illustrated by a common invocation to the supernatural: "Invoke we now the 40,000 gods, the 400,000 gods, the 4,000 gods."

The cultural shock caused by Captain Cook's visit in 1778 was quickly followed by ever-increasing contact with Western civilization. However, for about two generations the religious system, heiau ritual, and other patterns of religious activity changed considerably less than did other aspects of the culture, and consequently the arts related to religion survived. Political structure became centralized, with a unified kingdom based still on the divinity of the royalty, but reflecting an increasing emphasis on secular control to accommodate to the changes brought about by foreign contact. The economy shifted to import-export conditions never before known. Supplying foreign ships with food, water, and repair materials, and exporting sandalwood brought income for the royalty. The technological changes were rapid, especially in activities related to shipping and warfare. The chiefs were quick to see the value of meeting foreign demands, and their new wealth was spent on guns and ships, thus expanding their political control. Iron replaced stone for tools. Surprisingly, these changes had little discernible effect on the production of most of the arts. Religious images were still produced; tapa, featherwork, and petroglyphs continued to be made, although each of these arts reflected in some way the new techniques and foreign influences. It is probable that a consider-

able amount of the sculpture existing today was produced during this significant period of Hawaiian history.

Kamehameha's spectacular consolidation of power into a single, islandswide government was made possible only through the support given him by the foreigners. Up until his death in 1819, Kamehameha remained a staunch pagan and enforced a modified *kapu* system as the law of the land, but many Hawaiians had clearly noticed that the great mana displayed by the foreigners was not accompanied by an oppressive *kapu*. Kamehameha was succeeded by his young son, Liholiho. The old warrior's ranking widow, Ka'ahumanu, was the son's regent. This powerful chiefess had long been an advocate of religious tolerance and equal rights for women. She persuaded Liholiho to defy the eating *kapu* between men and women at a large public feast. When the people saw that their gods failed to punish this gross violation of a fundamental *kapu*, the religious sanctions of the whole social system collapsed. A cultural revolution was underway. Temple *kapu* were violated and images were burned. The resistance to change by some of the more conservative elements of society was ineffectual, since it had been the ruling monarchs themselves and many high-ranking priests who had defied the *kapu* and were leading the destruction of the temple religion and the overthrow of the cult of cosmic deities. A few months later, in 1820, when the first American missionaries arrived at the islands, they received a friendly welcome and found that the Hawaiians were primed for the new religion. The resulting accelerated changes in the social structure brought to an immediate end the arts related to the old religion, such as the carving of the images, and an eventual though somewhat slower end to the other arts. The making of beautifully decorated tapa declined rapidly with the adoption of European cloth. Although the feather capes and cloaks were still highly prized, the demand for them was gone and the exacting craft died out with the passing of the experts. Petroglyphs were still made until about 1870, but once their magic functions were no longer vital, the last of the old Hawaiian arts passed into oblivion.

In the old social and religious order, the power and influence of the priests had been surpassed only by that of the ruling chiefs whom they served. If legendary accounts can be believed, in some districts the priests had even succeeded in becoming the real power behind the rulers. In doing away with the organized religion, the importance and value of the priesthood was reduced to nothing, and the last remaining threat to the power of the Kamehameha dynasty was removed. The priests were the possessors of the greatest skills and the highest intellectual attainments of Hawaii, and as their importance waned, the special knowledge and abilities that they held passed into obscurity. No greater evidence of their particular genius exists than their sculpture, which has survived them.

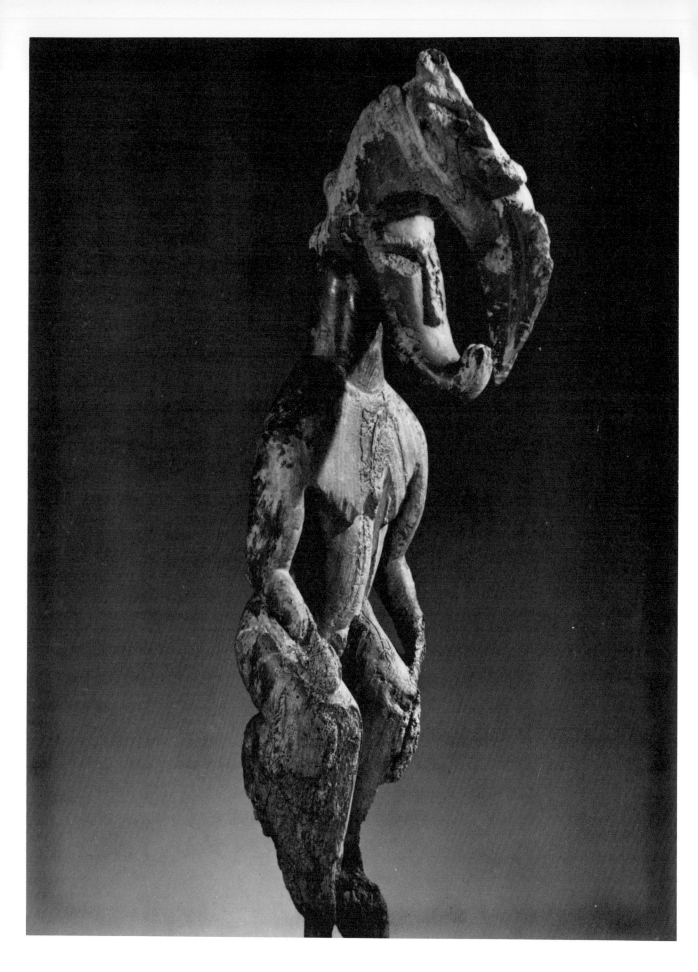

Hawaiian Sculptural Tradition

The term sculptural tradition refers to those aspects of the culture and the possibly noncultural aesthetic decisions that influence or determine the conformities of the sculpture itself. Since the total sculptural tradition is a seriation of objects, it has a historical depth. However, the data on Hawaiian sculpture are limited to the short period of about fifty years after the discovery of Hawaii by the Europeans, and it is not possible to show the changes that occurred through significant spans of time. The primal origins of Hawaiian sculpture were in a religion of ancestral deities and cosmic spirits that came into Polynesia with the first migrations. In view of the antiquity of this anthropomorphic concept of the universe, there is little doubt that some use of the human figure as a religious symbol existed in the very early history of the Polynesian people. There are no known examples existing of those very early symbols. Whatever they were like, they were the prototypes of the elaborate and varied forms of Polynesian sculpture known today. The evolution and continuity of the sculpture during the various migration periods are no longer evident. Only the more recent end products of the tradition remain.

For reconstruction and analysis of the tradition, it can be assumed that the pieces of Hawaiian sculpture known to exist throughout the world are a reasonably typical sampling of those that existed just prior to the overthrow of the old religion. At the time of the destruction of the images, the larger temple images were probably more vulnerable than the other types since they could not be easily removed and hidden. There are about thirty-five of these remaining, as compared to about sixty-five of the smaller portable religious images, and about forty of the support figures or secular objects with figure carving. It is also reasonably certain that the variation in style among all of the types, except for a few that exhibit European influences, is not due to historical change but represents the variation within the tradition at the period just prior to the overthrow of the old religion. These assumptions are reinforced by all of the reports by the first European visitors to the islands during the years 1778 to 1825. Of special value in these reports are the drawings. At least one hundred ten images were recorded by six artists: John Webber (1778–1779), surgeon William Ellis (1787–1789), Louis Choris (1816), Jacques Arago (1819), the Reverend William Ellis (1824), and Robert Dampier (1825). The images that are represented in these drawings are stylistically comparable to those now in existence, and even though many of the drawings are rudimentary and some possibly not wholly reliable (the two Ellises were amateur artists), they do add to the total oeuvre and are the only visual record of the images at the time when they were functioning in the society (figures 4, 26, 31, 35, 36, 43, 45).

The age of any of the existing examples of sculpture is almost impossible to determine. Those that can be designated as archaeological finds appear to be

Facing page: 'Aumakua image(?). Although badly eroded, this image still shows evidence of an unusual feature, the occurrence of a second face on the upper curve of the brow crest. The open mouth and tongue are at the upturned end of the curving jaw. Height: 19 in. Bernice P. Bishop Museum. Cat. no. A23.

Carrying pole (left and right). This pole is about 6 ft long. The heads on each end form the notches that held cords supporting the burden. Carrying poles such as this belonged only to the households of chiefs. Length of heads: approx. 2½ in. Bernice P. Bishop Museum. Cat. no. S17.

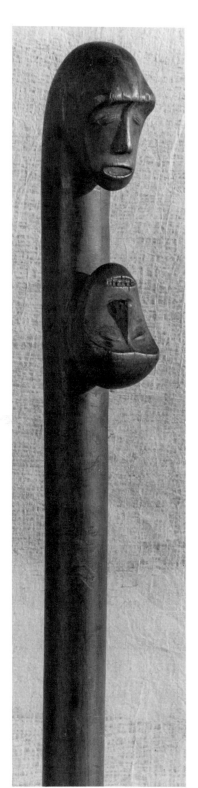

no different in style nor older than those collected by other means. None have been excavated from a stratified archaeological site because wooden objects deteriorate too rapidly in the soil and also because the chances of an image being lost or discarded were extremely slight. Some of the finest archaeological specimens have been found with burials and hidden caches in caves or within stone structures. Many of these have been found with European or other foreign objects, indicating that they were buried or hidden during the time of European contact rather than before it. This, of course, does not preclude the possibility that the images could have been made in precontact times, but the styles differ in no essential way from those collected and recorded during the early contact period. It is unlikely that any of the Hawaiian sculpture existing today was produced before A.D. 1750.

There is no possibility of reconstructing a detailed story of all the aspects of Hawaiian history and culture that had a determining effect on the sculptural style. The elements of influence are either too numerous and involved to submit to analysis or are simply unknown. It proves difficult enough for experts in ethnoaesthetics working within a living culture to relate all factors involved in an artistic tradition. The Hawaiian sculptural tradition terminated in 1819. To form a picture of this tradition, we have only the specimens themselves and a fairly well recorded cultural history.

By examining three broad categories—technology, specialized sculptural forms, and functional types—some of the direct influences of the tradition may be determined and the more obscure ones suggested. Of the technology little is directly known, but some may be inferred from the sculptured forms and some from historical and ethnological material. The sculptural forms and form relationships are observable as physical entities, making it theoretically possible to describe them in detail and arrive at empirical judgments concerning them. However, meaningful interpretations of the forms and especially of their interrelationships call also for subjective evaluations and intuitive judgments. The functions of the sculptured images can be known only from what has been recorded of them in Hawaiian cultural history, and this, fortunately, is reasonably adequate. None of these aspects—technology, forms, or functions—can be discussed in complete isolation from the others, and a fourth consideration must be dealt with in context with each of them: the particular meanings and symbolism involved in the production and use of the sculpture.

TECHNOLOGY

Wooden objects comprised the major part of Hawaiian technology. The making of houses, canoes, food bowls, implements of many kinds, weapons, and tools required of every male some ability at working with wood. The sculptors

of the religious images were specialists, but their tools, materials, and methods were similar to those of other wood carvers.

A few sculptured figures in materials other than wood (such as stone, bone, coral, sea urchin spines, and ivory) do occur, but they are not common. Except for three small images carved from the spines of the pencil urchin, the style of these miscellaneous stone figures is not particularly similar to the wood sculpture styles. In stone sculpture production was limited, the workmanship was less expert than in wood carving, and no significant tradition seems to have been established as it was in the Marquesas, Easter, Society, and Austral islands. However, stone representations of the great gods, particularly Kane, were very common. Most of these seem to have been natural stones selected for their odd shapes and at most only slightly carved or retouched. Exceptions to this nonstyle in stone sculpture in Hawaii are the few examples of small stone figures that were found on barren, isolated Necker Island, located about three hundred miles northeast of the main group of Hawaiian Islands. These figures do follow a single style pattern that has little in common with the wood or stone carvings from the main Hawaiian Islands. Except for their rather stiff stature and rectangular volumes, they appear more closely related to the Marquesas' stone sculpture or to the ivory and wood sculpture of Tonga. They do suggest the beginning of a separate tradition in stone figure carving in Hawaii that was never established outside of the isolated Necker Island community.

Of the woods used for the religious figures, especially the temple images, the wood from the 'ōhi'a-lehua tree was the most important. This tree was believed to be one manifestation of the major gods, Kane and Ku, and was therefore thought to have great mana. The trees vary in size, the largest being found only on the high, misty slopes of the mountains, at four thousand to six thousand feet elevation. Here they attain a diameter of four to five feet, are usually fairly straight at the base, and are a hundred feet or more high. These trees were needed for the large temple images. The wood is easily carved with a sharp tool when it is freshly cut or if it is kept wet. It is a very dense wood. A log will sink when placed in water, and this means was used to store and season the material. A possible cause of the sacredness attributed to the 'ōhi'a-lehua may have been its red blossoms, considered sacred to Pele. Another may have been the redness of the wood, which when freshly cut has an appearance strikingly like that of raw meat, thus reinforcing the idea of life and possibly correlating with human sacrifice, which in special cases preceded the carving of an image (see pp. 61, 62). The sacredness of the 'ōhi'a can be discerned from this chant from Malo (1951:177), which was a prayer for the lifting of the kapu imposed during the construction of a temple:

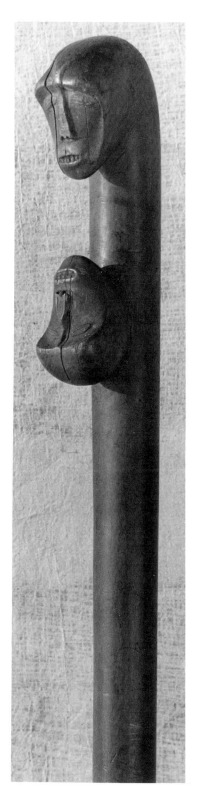

E Ku i ka lana mai nuu!	O god Ku of the oracle tower!
E Ku i ka ohia-lele!	O Ku of the *'ōhi'a* altar!
E Ku i ka ohia-lehua!	O Ku of the *'ōhi'a-lehua!*
E Ku i ka ohia-ha uli!	O Ku of the verdant *'ōhi'a-hā!*
E Ku i ka ohia moewai!	O Ku of the water-seasoned *'ōhi'a* timber!
E Ku mai ka lani!	O Ku from the heavens!
E Ku i ke ao!	O Ku, god of light!
E Ku i ka honua	O Ku, ruler of the land
E ka ohia ihi!	O sacred *'ōhi'a!*
E Ku i ka lani-ka-ohia, ka haku-ohia!	O Ku of the *'ōhi'a* carved by a king, lord of *'ōhi'a* gods!
A ku, alele, ua noa.	The *kapu* comes, flies on, and is released.
A noa ia Ku.	The *kapu* is removed by Ku.
Ua uhi kapa mahana,	Clothed as with the warmth of tapa,
Hoomahanahana heiau.	Relaxed from the rigors of the *kapu* is the *heiau.*
E noa! E noa!	Release! Release!
Amana wale! Ua noa!	Prayer is said! The *kapu* is ended!

Two very hard woods, both called *kauila* and both from the buckthorn family, were also used for some of the small figures. The *kauila* tree has darker wood than the *'ōhi'a-lehua* and is much smaller, only a few inches in girth, but it is tall and straight. Its toughness and straightness of grain made it especially suitable for spears, digging sticks, carrying poles, tapa pounders, and house timbers. The *Colubrina* variety of the *kauila* was preferred for religious usage, such as for the small *akua kā'ai* images and the tall Lono-i-ka-makahiki image. When carved, it has a natural surface luster that the other woods do not have. *Koa*, the wood used for canoe hulls and surfboards, may have been used for some carvings. It was also used for the slop basins, spittoons, and finger bowls of the chiefs, but not for food vessels, as it tended to produce a disagreeable taste. The deep bowl (left) and platter (center) in figure 2 were made from *kou*, a wood that displays a beautifully irregular and contrasting grain pattern when polished. The images in figures 8 and 9 appear to have been made of *kou*.

Although wood was the primary sculptural material, several other auxiliary materials were occasionally used with it. Mother-of-pearl was inlaid for eyes; human hair was often attached to the heads of images; human teeth, usually premolars, or occasionally grooved bone, were used as a naturalistic representation of teeth (figure 52). Oil, stain, and paint were sometimes applied to

2 Hawaiian artifacts. Several objects illustrate the sophistication attained by the Hawaiian craftsman: a large wooden 'umeke (bowl) with faceted surface, an 'aumakua image with fiber skirt, a *lei niho palaoa* (whaletooth ornament), a hanging 'umeke, a wooden platter, and a decorated gourd 'umeke. Bernice P. Bishop Museum, Honolulu.

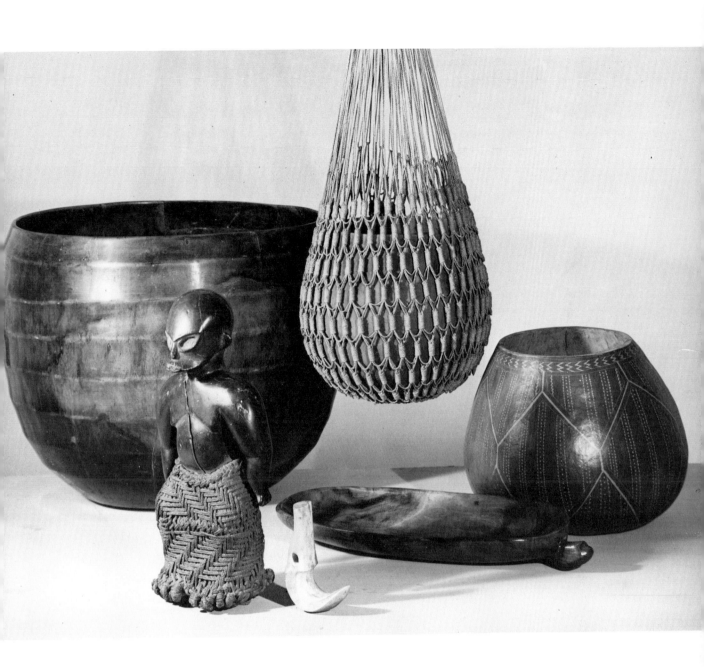

3 Temple image. This image is assembled from a number of separate parts and is the only complete example existing of this type, although there are other torsos and heads that may have been similarly used. The head and torso are separate pieces of wood, and are completely covered with black tapa that has a grooved-beater pattern. The image is similar in construction to the articulated marionettes that were a part of certain hula performances (see cat. nos. *a*, *b*, *I*, and *F*). The arms are uncarved branches, also wrapped with tapa. The two images with upraised arms in Choris's drawing of the Ahuena *heiau* (figure 4) are apparently of this type. Height: 20½ in. British Museum (+249). Cat. no. T31.

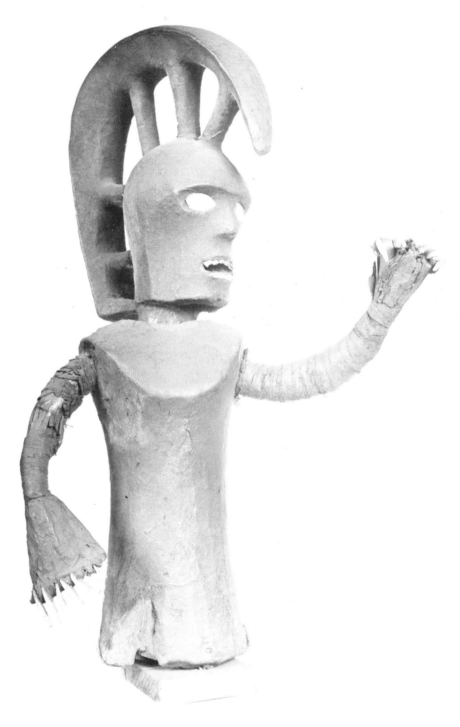

the surface of the sculpture. The harder, darker woods often appear to have been polished, possibly by merely rubbing with the hands, tapa, or bamboo leaves, or with a bit of *kukui* (candlenut) oil or dried breadfruit leaves. These techniques and a number of other polish finishes developed for the finishing of wooden food bowls were probably used on some images. There may have been a preference for the darker tones, as some of the figures of light-colored wood are either darkened with plant juices or oil, or stained with a black pigment, probably charcoal (figure 16). In a few cases, only the head is stained black (figure 15). The use of paint for the delineation of details was rare but does occur on one image in which the eyes and tattoo marks on the face were painted or stained (figure 50).

Part of the ritual surrounding the dedication of an image included the wrapping of the figure with tapa, normally in the form of a *malo* (loincloth). This tapa is still in place on many of the existing images. Some of the small images have cordage attached, which may have been a means of securing feathers to the image as symbols of sacredness. The Lono-i-ka-makahiki image is an assembly of a number of materials—pole, crossbar, lashing, tapa, leis, and dead birds (figure 45). This made an impressive image, which was of considerable size but still readily portable. One complete example remains of another built-up image, shown in figure 3. The entire body and head are smoothly covered with a "skin" of black tapa. The images with arms upraised, at the edge of Ahuena *heiau* in Kailua, Hawaii, as sketched by Choris in 1816, seem to be of this type of assembled image (figure 4).

Of the tools and techniques used specifically by the sculptor, very little is known except by inference and from what is known about woodworking in general. Some of the basic tools are shown in figure 5. For coarse, rough work, preliminary blocking out of the images, and removing large quantities of wood, the most basic and commonly employed tool was certainly the stone adz. This tool consisted of a rectangular blade chipped from dark, compact basalt and ground to a smooth polish. The blade was securely lashed to a long T-shaped handle of wood. Unlike an ax, which has its cutting edge parallel to the axis of the handle, the cutting edge of the adz is normally at right angles to the handle. A special adz with the blade set in a rotating socket was devised for use in working at angles where the standard adz would not function. Although there are no examples of the ancient style of lashing the blade to the handle, the method of attaching is known from early reports, and a number of reconstructions have been assembled. In size, the blades range from large tree-felling types over a foot long and weighing ten or twelve pounds, to very small ones of less than an inch long and weighing but two ounces. The function of the very small adzes has not been very satisfactorily

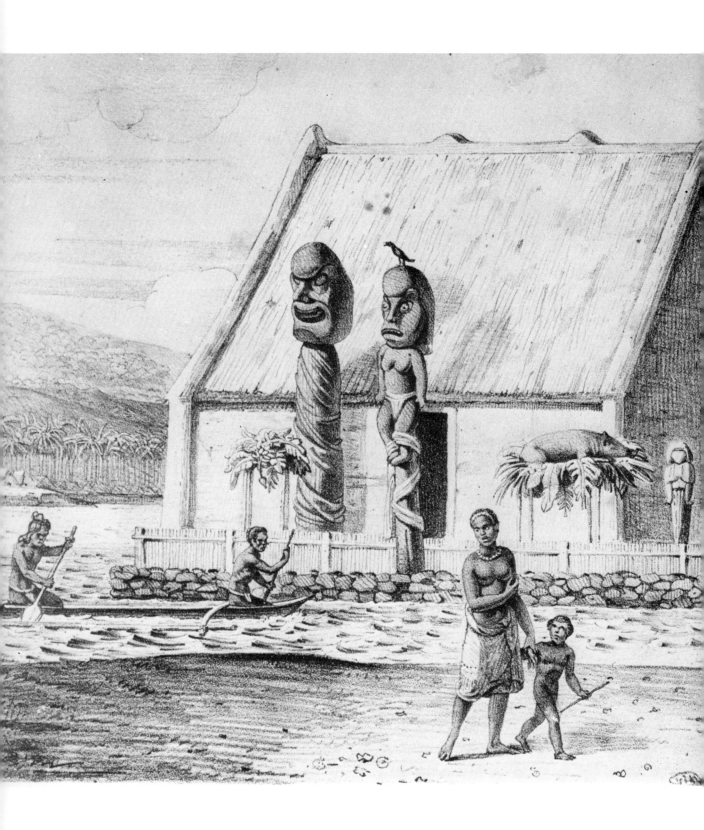

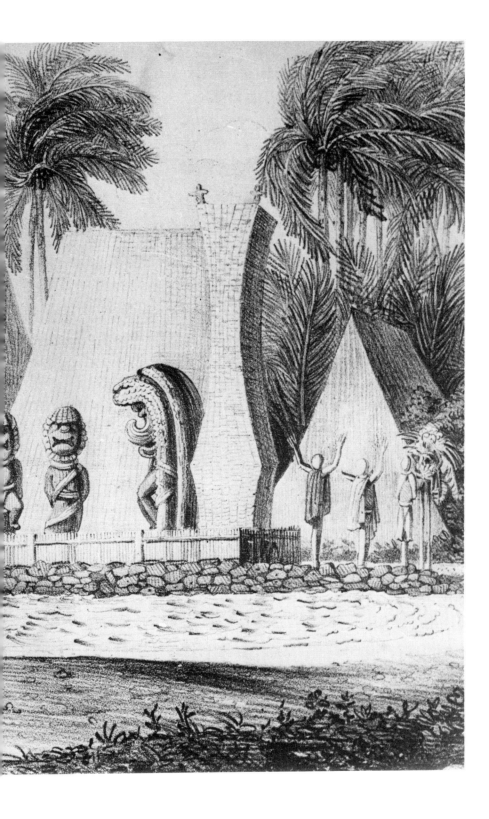

4 Ahuena *heiau,* Kailua, Kona, Hawaii.
Lithograph by Louis Choris. This was the personal temple of Kamehameha I as it appeared in 1816, four years before the destruction of most of the *heiau* and images, which followed closely on the death of Kamehameha. (*Temple du Roi dans la baie Tiritatea.* Choris 1822: pl. V.)

explained. They seem much too light to have been used with a swinging stroke, as the heavier ones were, though in most cases the form is the same. Probably they were tapped with a secondary tool, such as a mallet or a hammerstone, much as a chisel is used.

All of these adz blades are rectangular, roughly quadrangular in cross section, and have a straight cutting edge. Although the general shape of the adz blades varies little, there is considerable variation in the length-width-thickness proportions. Long, narrow, thick blades were probably used for chopping out large quantities of wood; while the short, wide, thin blades were used for smoothing and finishing. Even after Western steel blades and tools had entirely replaced stone for general use, the old Hawaiian canoe artisans preferred their stone blades for the delicate finish work because they could remove thinner shavings with them.

Gouges and chisels were used for cutting grooves or notches and for working in confined places where an adz could not be manipulated. The blades of these resembled small, narrow adz blades, generally rounded in cross section rather than rectangular. The handle was attached as an extension from the butt

5 Woodworking tools. A selection of the basic tools used by the Hawaiian woodworking craftsman:

Small hafted adz, reconstructed (10½ in long)
Thin basalt adz blade
Large hafted adz, reconstructed
Hafted adz with rotating blade, reconstructed
Pump drill with iron nail point
Hammerstone with finger grip depression
Two unhafted basalt chisels
Smooth basalt polishing stone
Coral rubbing stone
Porous basalt rubbing stone
Shark's-tooth knife, facsimile
Basalt flake knife

Bernice P. Bishop Museum, Honolulu, and collection of the author (Cox).

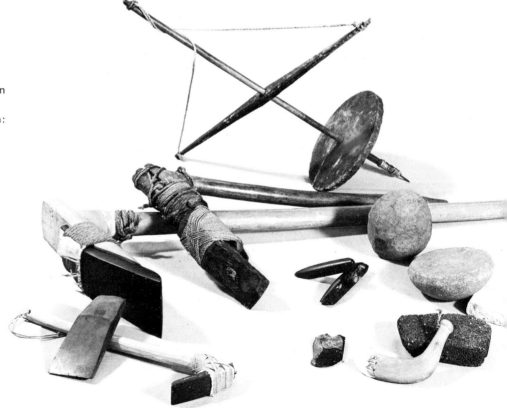

of the blade so that a hammerstone could be applied as a mallet. Thin, flat basalt flakes and sharp chips of volcanic glass, held in the fingers, made razor-sharp knives and gravers. A large shark's tooth, hafted with a curved or L-shaped bone or wood handle, seems to have been a very important carving tool (figure 42, no. 2). The sharp point of the tooth made a fine graver, while in cross-grain cutting the serrated edges of the tooth could actually be used as a fine-toothed saw. Porous basalt stones, chunks of coral, ray and shark skin, and sand were all used as abrasives to remove the adz blade marks. A high-gloss surface could be obtained by rubbing first with charcoal, then with bamboo and breadfruit leaves, followed by a final polishing with tapa. Repeated application of *kukui*-nut oil would provide a varnish coat.

The pump drill was also available for drilling small, deep holes. This tool consisted of a shaft with a bone, stone, or shell point; a circular, wood balance wheel; and a crosspiece attached to the top of the shaft by two cords. By pumping the crosspiece up and down, the cords wound and unwound around the shaft causing it to rotate back and forth. Shaping and drilling the pearl shell inlays were done with stone awls and coral files, the same techniques used to shape the small, circular, shell fishhooks. Teeth were merely driven into drilled holes and held there by fit alone (figure 23). The decorative teeth used on bowls were similarly attached, but were sometimes ground down flush with the smooth, polished bowl surfaces. On the images, hair was attached by first drilling many small holes in the heads, into which bundles of human hair were secured by means of wooden pegs. As the sculpture itself reveals, these tools and techniques were not crude, nor did they in any way hinder the sculptor in the control of his medium. He could achieve delicate surface engraving, execute low-relief carving, as well as remove large volumes or isolate fragile, open forms. In the image sculpture, however, there is a definite preference for heavier and deeper carving rather than for delicate incising.

The carvers of the large temple images, and probably of many of the smaller types, were not mere craftsmen; they were *kāhuna kālai*, priest-sculptors. Although there are no records to indicate how sculptors were chosen and trained, we can assume it was a highly regulated procedure, as was true in the other *kahuna* classes such as medicine, religion, dance, and navigation. The image sculptors were very likely a hereditary class of *kāhuna*, drawing for trainees on the immediate family, relatives, and adopted children. Training would have started early, with the youngster helping in the work, keeping tools in condition, observing and copying the sculptors' habits and practical skills. Since the work was with sacred materials and the objects made were for religious use, an equal emphasis would have been placed on learning proper prayers and rituals of dedication for tools and materials, and the

chants, offerings, and procedures required at each stage of the work, all of which were probably not considered separate from the practical skills.

The task of carving was a sacred rite, each important stage marked by appropriate chants and sacrifices. When a new *heiau* to the great god Ku was to be constructed, or an old one renovated, carving of new images was one important phase of the long series of strenuous dedication rituals. Before starting a carving, the *kahuna kālai* first consecrated his tools by a sacrifice and a chant to insure that sufficient mana was contained in them, consequently insuring the efficacy of the image, "the house of the god." The following chant is from Malo (1951:180):

E Kane uakea	O Kane, white as mist
Eia ka alana	Here is the offering,
He moa ualehu.	A chicken ash-white.
He moa uakea,	A chicken mist-white,
He moa ula hiwa.	A chicken red and black.
He alana keia ia oe Kane,	These are offerings for you, O Kane,
No ke koi kalai,	For the carving adz,
Koi kua,	For the striking adz,
Koi kikoni,	For the smoothing down adz,
Koi lou,	For the rotatable adz,
He koi e kai e kalai ai ke kii,	An adz to direct, to carve the image,
He koi ou e Kane ke akua ola.	Your adz, O Kane, god of life.
Ke akua mana,	God with mana,
Ke akua noho i ka iuiu,	God dwelling in the unfathomable heights,
Ke akua i ke ao polohiwa.	God in the glistening clouds of darkness.
E ike iau ia . . .	Look upon me . . .
Ke kahuna kalai kii,	The carver of images,
A ku ke kii o Lana-i-ka-wai,	Let the image of Lana-i-ka-wai stand,
O ka wai ola loa a Kane.	The water of eternal life of Kane.
E Kane eia kou hale la, o Mauliola.	O Kane, here is your house, life-that-lives.

Descriptions of the carving of the temple images and the ritual that accompanied the carving are incomplete and add very little to an understanding of the technical process of carving. It is not clear from the three available descriptions whether an image was made by one carver or by several (see pp. 60, 61).

Nor is it possible to say how long it took to complete the carving of a large image. The sequence of events in the three accounts differs as much as one to five days in the time that it would have taken to complete the image. One account has the carving finished at the *heiau* site; in the other two the image is finished in the mountains at the site of the tree felling. Copies and reproductions of images that have been made recently for the Bishop Museum in Honolulu and for the restoration of the *heiau* at Hale-o-Keawe, Honaunau, Hawaii, indicate that a period of from three to five weeks is needed for one carver to finish a large image.

At the rededication of an existing temple, the old images were probably reused, realigned in place, and dressed in tapa. Possibly a new central image would have been made and dedicated. It is unlikely that any recarving was done on old images. The *'ōhi'a* wood becomes extremely hard when dry and would be very difficult to resurface with stone tools. When steel tools became available, some recarving may have been done, though at the present time it would be difficult to detect.

The high incidence of artistic creativity or talent (as distinguished from the craftsman's skill) is, as always, difficult to account for. We must merely accept that the *kāhuna* professors knew creative talent when they saw it and had the talent themselves to teach, by allowing and even encouraging independent judgment and innovation, while at the same time maintaining the traditional forms and conventions.

SPECIALIZED SCULPTURAL FORMS

Polynesian art forms are usually characterized by two dominant traits. The first is a fundamental ornamentation, which is usually achieved by the use of small motifs repeated over the surface of the object. The other, and seemingly opposite characteristic, is a tendency toward strong formalism through excellent craftsmanship, regularity, order, and an inclination toward "pure" form. In reference to Polynesian sculpture, it is possible to find both of the traits in a single object, though in most instances when surface ornamentation is used, it dominates the underlying volumes. A truly excellent piece making use of both characteristics is rare. Surface ornamentation gives an elegance and visual richness, unifies the areas of the surface, and exploits a sense of virtuosity. However, it also makes the surface of the object something separate from the body or volume over which it is laid. It is a linear or modular skin and is distinct in idea from the volumetric qualities of the form. Such objects appear to be first shaped and then surfaced. The disunity of the combination produces a kind of "a-sculpturality" which cannot be compensated for, even by the most expert craftsmanship.

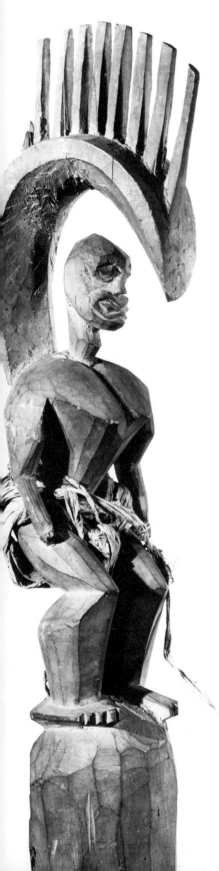

Surface richness and elaboration is most noticeable in the arts of the Maori of New Zealand, the Marquesans, and the Cook and Austral islanders. True sculptural form had its place in these cultures as well, especially in the Maori and Marquesan carvings, but such form was seldom dominant to the surface decorations. The sculpture of Hawaii, Easter Island, Mangareva, Tonga, and Nukuoro, which emphasizes volume rather than surface, seems to have developed in the opposite direction. The Hawaiian sculpture is distinguished even further by adding to the emphasis on sculptural volumes the inclination toward sculptural movement and axial dynamics. Furthermore, the Hawaiians never decorated a material that could be manipulated as sculptural movement. In media in which sculptural shaping was impossible, such as on the natural surface of a gourd, on the human body, and on tapa, the Hawaiians did apply surface decoration, but even then usually with delicacy and restraint.

In a number of other ways Hawaiian sculpture differs from the usual Polynesian figures. There is a greater range of types of figure sculpture in Hawaii than there is in any other Polynesian area. Either the tradition was more flexible or the sculptors more prone to innovation than was true in most of Polynesia. Curiously, a number of examples of Hawaiian images occur in pairs (figures 6, 7; 8, 9; 32, 33). These are not simply coincidences of two pieces of similar style being saved from many, but pairs undoubtedly made as such, by a single artist, and probably intended for use together. There are at least ten of these pairs in existence, some of which were found together. There is no known explanation for this phenomenon.

Many of the style characteristics of Hawaiian sculpture are also found in other Polynesian areas. But a few style traits are unique to Hawaii—elaboration of the head, dislocation of the eyes, the protruding jaw-mouth-tongue, the wrestler's posture, and faceted surfaces.

Elaboration of the Head

An almost universal trait of the sculpture of primitive peoples is the emphasis on the head through increased size and the proliferation of motifs on and around it. Different meanings are attached to this elaboration of the head in different societies, but the basic compulsion may have common roots. In Hawaii, as in some other cultures, the source of mana is in the head. Of the high chiefs, and consequently the gods, all things related to the head were sacred. Interpreted symbolically in the sculpture, the helmet, hair, and facial features, especially the eyes, conveyed the special meanings appropriate to the gods. Some motifs were extensions of actual forms of the dress, style, facial expressions, and posture of the ali'i, connoting attributes of the gods (figures 3, 32). The arching crests on the sculpture clearly represent the feathered mahiole (helmet), a ceremonial headdress of the nobility. The series of

6, 7 Temple images. Although there are no records as to where or when these images were collected, it is probable that they were carved by the same sculptor and used together. The exaggerated surface planes, the small head contrasted with the large *lei palaoa*-shaped crest, and the rich pattern of the vertical comb are combined here in a dramatic design. The exaggerated chest line has led some to consider these images to be female gods (the image in figure 6 is designated as the goddess Pele), but this is simply a stylization, similar to the thickening of the calves and other volume expansions. Heights of figures: 6, 21 in; 7, 15¾ in. 6, Musée de l'Homme; cat. no. T25. 7, Temple Square Museum; cat. no. T26.

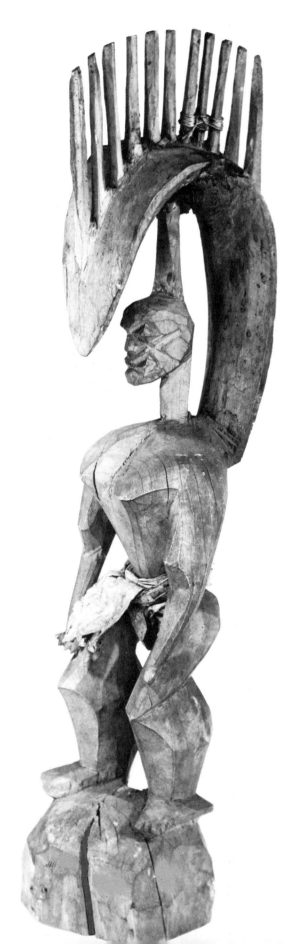

8, 9 *Akua kā'ai* images. This pair of *kā'ai* images is the largest and best example of this class of portable image. They were taken from a burial cave near Kawaihae, Hawaii, along with a number of other fine examples of Hawaiian carving. Heights of figures and headdresses: 8, 27½ in; 9, 27¼ in. Bernice P. Bishop Museum. 8, cat. no. K2; 9, cat. no. K3.

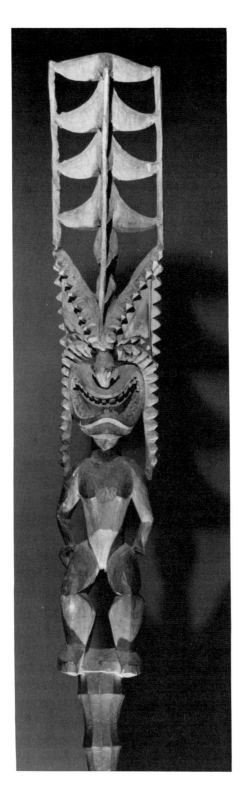
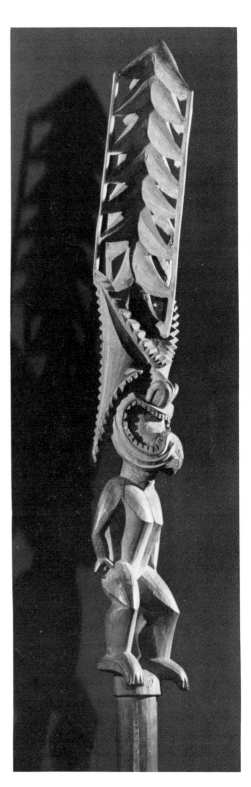

notches extending down and back from the brow is an abstraction of long tresses of hair, often with supplementary wigs, that were sometimes worn by persons of extremely high rank (figure 34). The historian David Malo, in describing a ceremony for the lifting of *kapu* after a *heiau* dedication, refers to a man representing a deity with hair done up in the fashion of *nīheu* (elaborate hair style), in which the hair, and often a wig, was mixed with red clay and skewered on top of the head (1951:163). Facial expressions in the sculpture may be read simply for what they appear to be—gestures of defiance, contempt, anger, scorn, power, haughtiness. All of these gestures were practiced in play, war, sport, and ceremony.

Not all of the headdress forms had a counterpart in actual life. Some seem to be abstractions for symbols associated with the gods or proliferations developed simply for dramatic effect. It has been suggested that the towering crests represent the rainbow, which was a symbol of the presence of a deity, or that the notches on the crests are the "eight foreheads" of Lono (figures 8, 9, 31). The "eight foreheads" of Lono is a reference to the god Lono-ka-'eho (Lono-the-stone) who is featured in a legendary battle with the pig god Kama-pua'a, whom he attempts to batter with his eight stone foreheads. Lono-ka-'eho is killed by Kama-pua'a, and therefore is apparently not an aspect of the major god Lono, who could hardly be vanquished by an adversary (Elbert 1959:212).

The frontal nob in the hair pattern seen in figure 10 is carved in the form of a pig's head, and the form is continued in the adjoining nobs along the lower row in an increasingly simplified symbol of the pig. The entire mass of the hair may have been intended to symbolize a multitude of pigs. The meaning of this is obscure, but it may have referred to the sacrifice of pigs at the dedication rituals, the number of pigs being "infinite," as fitting the power of the god. Pigs were a major factor in the Hawaiian economy, as well as in ritual, and were demanded as tribute by the *ali'i*. Since some aspects of the temple worship seem to reflect and symbolize the feudal power of the chiefs over all wealth of the land (see Davenport 1964), the pig symbol on this image may possibly relate to economic power. This image and others like it have been considered to represent Ku, god of war, but the pig forms here raise the possibility that it may be an image of Lono, since the pig was a symbol for Lono. The image pole, or "long god," which was carried in the tribute-collecting procession is Lono-i-ka-makahiki, another aspect of Lono. If it is Lono, the temple image with pigs as hair is not connected directly with the *makahiki* aspect, but would be relegated to the year-round rituals on a temple dedicated to Lono.

The comb patterns in some of the crests suggest a cockscomb. The chicken and several species of wild birds were at times associated with the gods and

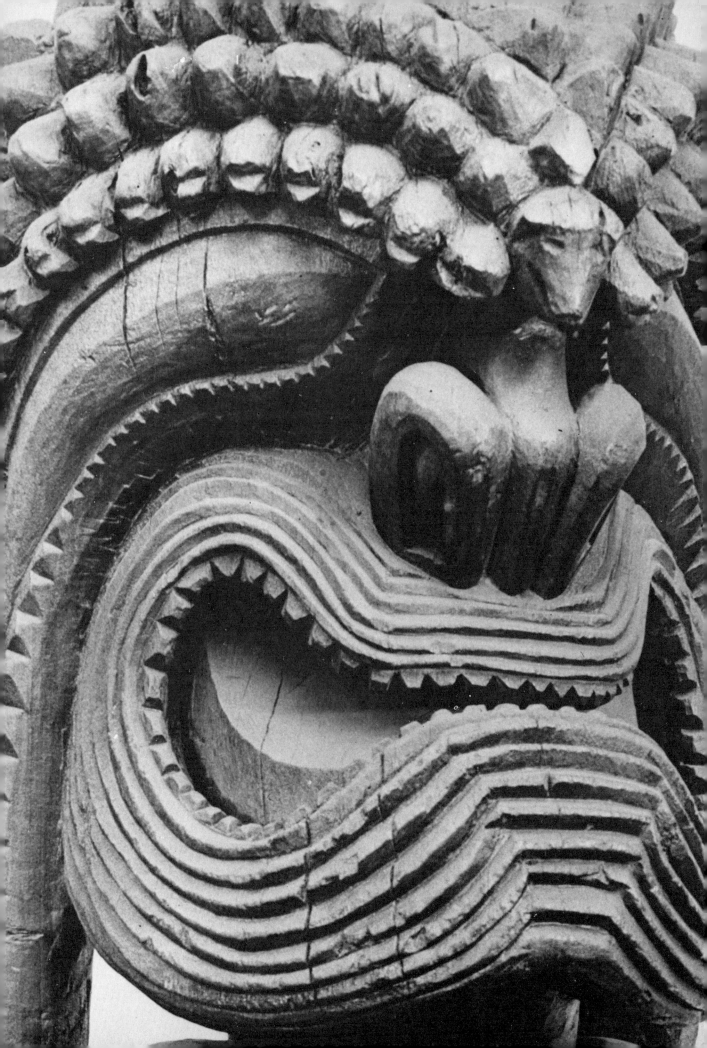

10 Kona-style temple image. Most of the distinguishing features of the classical style of Hawaiian sculpture can be found in this image. The organization of the elements of the head is a notable sculptural achievement. Symbolization of the hair as "heads of pigs" causes some reconsideration of the meaning of the hair patterns in other images and also of the classification of this image as the war god Ku. This image may have been taken to England by King Litholiho (Kamehameha II) in 1824, as a gift to King George IV. Height: 79 in. British Museum. Cat. no. T5.

the spirit world (figure 16). Feathers were particularly valued, and, as in other Polynesian areas, red feathers were considered the ultimate symbol of sacredness. Possibly the extended vertical towers on the heads of some images symbolize feathers, or represent the *kāhili*, a royal standard of feathers, or, as Pukui and Elbert describe it (1965:105), a "segment of a rainbow standing like a shaft" (figures 15, 41).

Kamakau, a native Hawaiian historian, says of the images to which men were offered as burnt sacrifices to Ku (1964:12):

These symbols were wooden images below, enveloped in layers of tapas of *'oloa, 'ape'ula,* and *ha'ena* varieties. On the head was a very fine feather, which drooped and streamed down to cover the head. When the god revealed his approbation, the feather stood straight up, twisting about like a water-spout, as if full of lightning, and flew from its place and rested on the head of a person and fluttered about his head, his arm, or his shoulder. These were signs that the god said he would help, *kokua,* and would give him his blessing in war, or in the prospering of the kingdom.

Dislocation of the Eyes

Dislocation of the eyes, a trait peculiar to Hawaii, occurs only in the Kona-style images (see pp. 77–81). In these few images, the eye is located off the face in the hair pattern and is elongated, dropping to a point where it follows the downward sweep of the hair (figures 10, 18). In others of the Kona style, the eye is a triangle within the hair design, and the rear points are elongated vertically (figure 11). The hair pattern in these images is merely a frame for the eye and might better be described as representing eyelashes and eyebrows, since it is both below and above the eye.

Protruding Jaw-Mouth-Tongue

Of all the specialized forms invented by Polynesian sculptors, the curving tongue shape in the *'aumakua* images of Hawaii is the most striking and significant abstraction. In its ultimate abstract shape, it is translated into the whaletooth ornament, *lei niho palaoa* (figure 12). The form occurs in several variations on the head crests of images, drum base designs, helmets, and as a two-dimensional pattern on the feather capes and cloaks. A number of meanings might easily be applied to it as a pure symbol. It is well known that the *lei niho palaoa* was a badge of rank, its use strictly limited to the *ali'i*. Malo names the *lei palaoa* as the object of second greatest value in ancient Hawaii, second only to the feather capes and cloaks (1951:77).

The Hawaiians did not invent the use of the artificially shaped whaletooth as an ornament. It was widely spread throughout Polynesia, always as a symbol of position or wealth, and was surely brought to Hawaii in a simple form with the first settlers. The final form in Hawaii, the forward thrusting tongue shape,

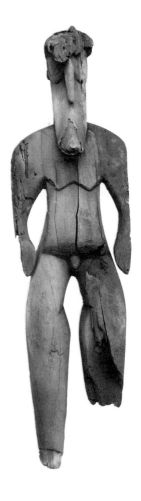

'Aumakua image. This is an image in which the forward-thrusting jaw-mouth-tongue complex dominates the head form. The brow crest originally came forward over the face and was topped with a spiked comb. Height: 29 in. Bernice P. Bishop Museum. Cat. no. A12.

11 Kona-style *akua kā'ai* image. This image is possibly one of the finest of the small Kona-style images, presenting all of the dynamic qualities of the style and the abstraction of the headdress, hair, and eyes, which, in this instance, are triangular, faceted elements set into the hair pattern. Height of figure and crest: 8½ in. Pitt-Rivers Museum. Cat. no. K8.

is not very old. Archaeological finds, so far, establish it as evolving just prior to the discovery period (see Cox 1967:412–19). The form appears, full-blown, probably as an adaption of a form developed in the *'aumakua* images, which were being produced in considerable numbers contemporaneously with the emerging *lei palaoa*.

The tendency toward the chin-mouth-tongue complex in the image sculpture results in a wide range of treatments indicating that the sculptors were free, or expected, to invent variations within a certain acceptable style range. The limits of the range seem to have been anything from a comparatively naturalistic head form, always with the mouth open and tongue protruding (figures 54, 55), to something similar to the *palaoa* form, all understood as having similar meaning (figures 13, 14). Possibly the intensity of this meaning increased with the distortion toward the abstract, and the ultimate symbol (the *lei niho palaoa*) carries the pure essence of such meaning.

12 *Lei niho palaoa*. The *lei niho palaoa* is a hook-shaped ornament of whale ivory suspended from the neck by two bundled coils of braided human hair. It was worn only by the *ali'i* (the nobility). Sizes of the *lei palaoa* vary considerably (from 1 to 6 in) but, as a group, the shape is particularly standardized. At the right is a stone food pounder, made in a similar form. Bernice P. Bishop Museum, Honolulu.

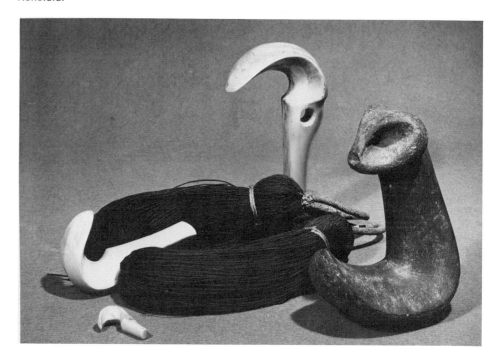

13 *Aumakua* image. The use of sennit plaiting on this image may
be related to the practice of enclosing the bones of deified ancestors
in basketlike netting of fiber. The carving is apparently complete
beneath the skirt. The toes are represented by knotting the fiber at
the base. Height: 15½ in. Bernice P. Bishop Museum. Cat. no. A1.

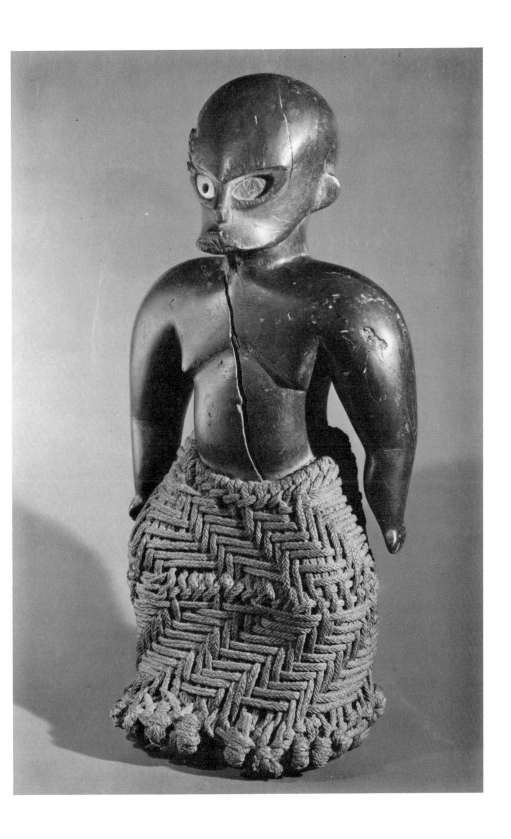

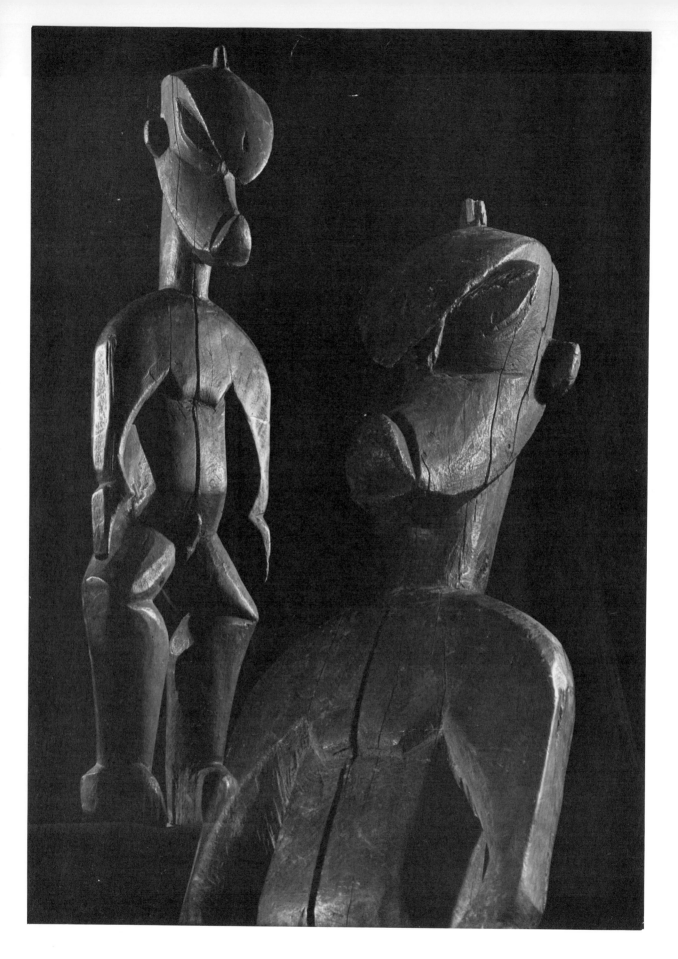

14 'Aumakua image. The abstract form of the lei palaoa is applied
here in both the jaw and the brow crest. The unusual linear counter-
rhythms in the body probably result from a reinterpretation of the
wrestler's posture to a more abstract arrangement than is normally
followed in the images. Height: 21 in. Bernice P. Bishop Museum.
Cat. no. A17.

The tongue is a significant element in other Polynesian images, notably the
protruding tongue of the commemorative figures of New Zealand tribal ances-
tors, which is said to signify the fierce and violent fighting expressions of the
warrior chiefs. The protruding tongue also appears in Cook Island god images
and in Marquesan sculpture, but in a much more placid form. In none of these
is the jaw line extended so far forward as it is in the Hawaiian images in
which the tongue protrudes to terminate the forward-sweeping curve. The
grimace that this represents must have had a special significance, an indication
of an attribute of the gods, a gesture of superiority, defiance, and contempt.
In some instances, as in the striking image from Maui (figure 15), the protrud-
ing jaw form may have been a symbolization of the demigod Kama-pua'a
(the pig god), a man-boar who was one of the most picturesque embodiments
of the god Lono. One aspect of Ku, Ku-waha-ilo (Ku-maggot-mouth), a man-
eater and the god responsible for the introduction of human sacrifice, is
described as having a mo'o (lizard) body with flashing eyes and thrusting
tongue. The tongue shape or anything similar to it was probably taken by the
Hawaiians to mean the presence of abundant mana. Once it had become an
accepted shape in the repertoire of the sculptors, the shape was used, both as
a symbol and as an aesthetically desirable form, in a number of different ob-
jects. The crescent and half-crescent patterns worked in brilliant red, yellow,
and black feathers on the capes and cloaks are probably the most strikingly
beautiful of this tongue-shaped mana symbol. The objects, such as the capes,
carrying this tongue shape were associated with the gods, mana, and the
sacredness of the ali'i (see Cox 1967:421–424).

Wrestler's Posture

Much of the sense of vitality and aggressiveness in the Hawaiian images is
due to the stylization of the arms and hands. The arms are more clearly
separated from the torso than is usual in Polynesian figure sculpture, and,
whether the hands are free or touching the thighs, the open space between
arm and torso is generally shaped to thrust the elbows out and back. As a
consequence, the upper arm is massive and the shoulders wide and rounded
to accommodate the arm position (figures 16, 18). The sculptors' feeling for
form relationships is particularly noticeable in the shaping of the hands. Al-
though usually small and seldom detailed, they are sensitively designed to
terminate the arm thrust by cupping the palms downward and out away from
the legs, thus complementing the curve of the thighs (figures 34, 54). This
combination of elements, with the feet apart and knees flexed, expresses
potential action, muscles tensed on the threshold of aggression. This posture
is one taken by wrestlers and boxers preliminary to a match. It is illustrated by
the pair of athletes at right center in the lithograph by John Webber of a con-

15 Temple image. This remarkable example of the hooded crest structure was found in 1963 in a cave on Maui where it had probably been hidden in 1820, after the abolition of the *kapu* system. The head and crest are stained black. The three-inch-diameter post on which the figure stands is corrugated for its entire length (35 in) with cordlike rings. Height of figure: 36 in. Bernice P. Bishop Museum. Cat. no. T28.

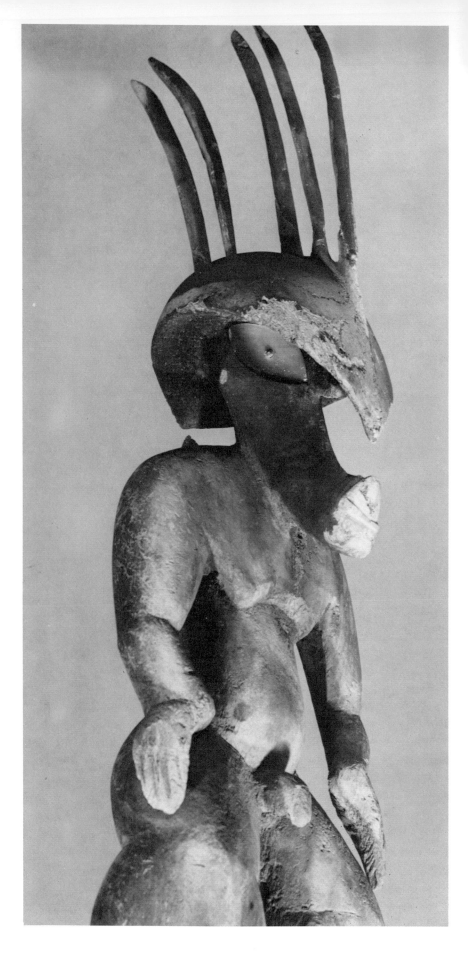

16 *Akua kā'ai* image. The usual
abstract symbol for the cockscomb
is replaced here with a naturalistic
representation. The head forms of
the small images vary with each
individual piece, while the body
style is much more standardized.
The head of this image is stained
black. Height: 8 in. Bernice P.
Bishop Museum. Cat. no. K19.

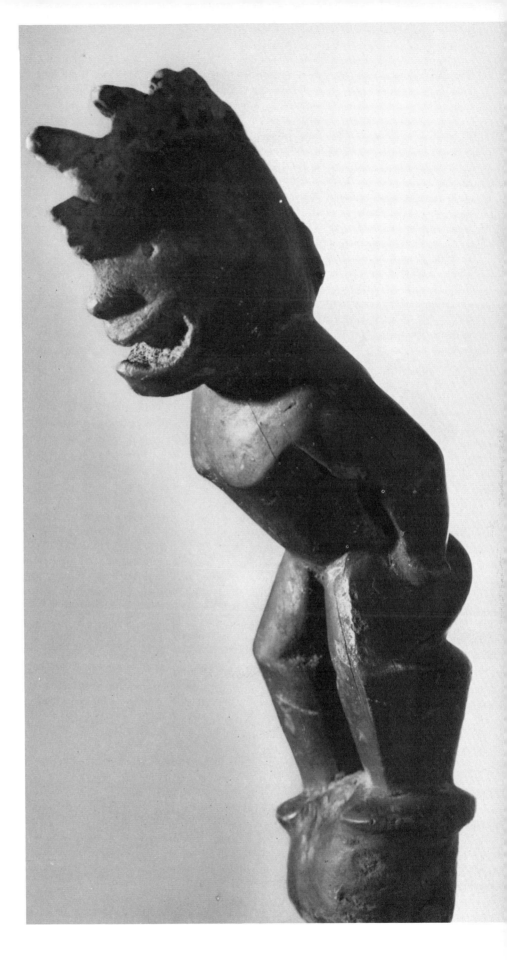

18 Kona-style temple image. This is one of the best examples of carving in the classical temple image style. It is a particularly fine illustration of the sculptural value of surface faceting as a means of enhancing form definition. The carefully controlled parallel facets and the precision of the ridges and depressions at the joints unquestionably enrich the perception of the volumes. Height of figure: 29¾ in. British Museum. Cat. no. T6.

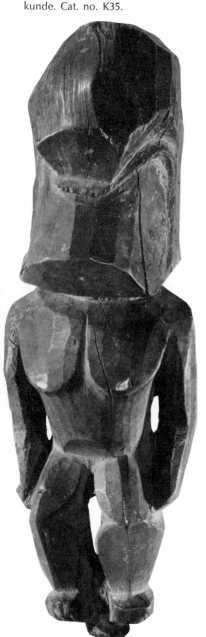

17 *Akua kā'ai* image. This small image exhibits a remarkable abstraction of the protruding tongue, which here comprises the lower half of the head and dominates the features to the exclusion of the nose and eyes. It also shows the faceted planes developed as a refinement of form and surface. Height 9 in. Museum für Völkerkunde. Cat. no. K35.

test during the *makahiki* festival (figure 45). The posture here appears to be stylized and is no doubt associated with a position in the *hula ku'i Moloka'i*, a vigorous male dance imitative of athletes' taunts, with foot stamping, heel twisting, thigh slapping, dipping of knees, and doubling of fists as in boxing (Pukui and Elbert 1965:83). In the sculpture, the pose is another application of an abstraction from a cultural trait functioning as a symbol for an attribute of the gods.

Faceted Surfaces

The surfaces of Hawaiian sculpture are finished either by grinding and polishing or by faceting (leaving the adz marks exposed). Faceting is found on all types of images and on other carvings such as house posts, tools, and canoe fittings. It seems to have been developed and perfected as an aesthetically acceptable finish, along with the smoothed and polished finish. Faceting required a great deal of control by the sculptor. The faceting, a series of bands running parallel to the axis of the volume, was made not by a single adz cut nor by a planing action, but by a carefully controlled series of advancing adz strokes that lifted the chips away almost in one piece. As the final act of the sculptor, it was a critical point in the work, exposing his craftsmanship and virtuosity. He very likely savored the act as a gratifying accomplishment.

Faceting, as a sculptural technique, probably originated in the making of the large temple images for which the time element in production was more apt to be limited. Deadlines occurred not at the discretion of the sculptor but to fit a rigid schedule of rituals. To satisfy this demand without compromising quality, the sculptors adjusted the final adz marks to best reinforce the volume movements and left them exposed. All the temple images that are not too eroded by exposure show the adz-marked surface, and it is probable that all of them were finished in this way. The adaption of this method for finishing many of the smaller images, on which a polished surface would have been relatively easy to achieve, indicates that sometimes the faceting was preferred even when time was not a factor (figure 17). The faceting does not become a decorative surface, and it is apparent that the sculptors did not think of it as such but as a means to produce the form. When viewing the images, one does not separate the perception of the facet pattern from the sense of the volume that it produces, as is the case in most of the Marquesan images and in Maori carving.

The best examples of faceting are on the large temple image in the British Museum (figure 10) and on the pair of *akua kā'ai* images in the Bishop Museum, Honolulu (figures 8, 9). Another "pair" of small temple images, one at the British Museum (figure 18), the other in a private collection in

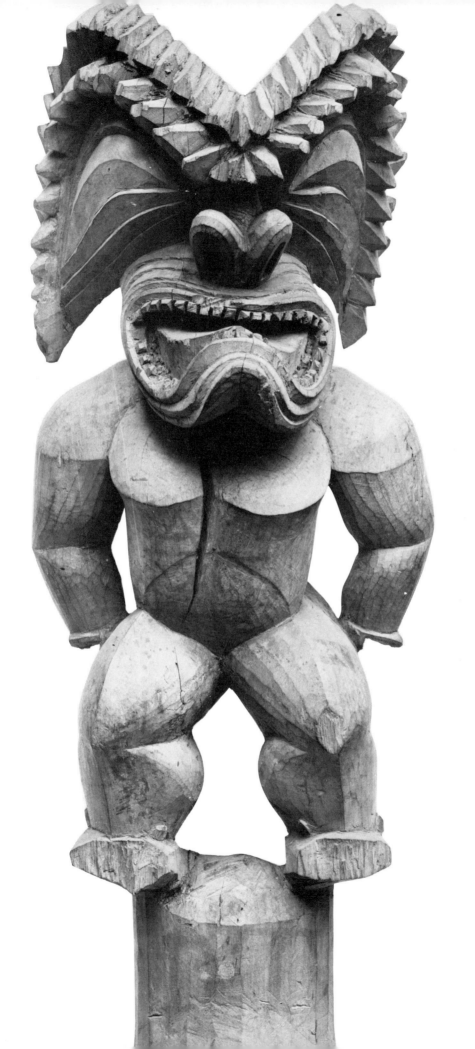

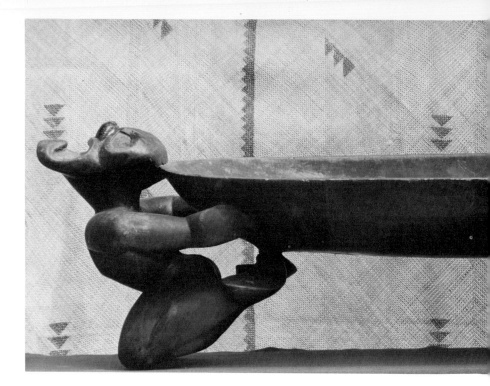

19 Kona-style temple image. This image is apparently not an authentic Hawaiian piece but a copy of the one shown in figure 18. Therefore, they were not made as a pair. This example lacks the clarity of form and refined surface faceting of the original. The size and directions of the facets are random, resulting in forms that are soft, lacking in clarity and crispness. Height: 24 in. Collection of Madam Olberechts, Wezembeck, Belgium.

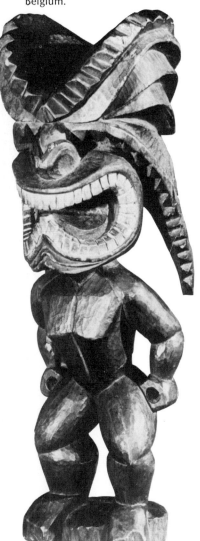

Belgium (figure 19), reveals the sculptural value of the parallel-faceted surface. Although almost identical in size and in general features, the two small temple images are not strictly a pair. The Belgian image is apparently a copy of the one in the British Museum, but it was not carved by the same sculptor, possibly not even by a Hawaiian sculptor. Although the volumes themselves are reasonably comparable, the Belgian piece lacks the crispness of form and lively surface rhythms. This is due mainly to the random patterning of the exposed adz marks, which scatter the light across the surface, producing soft, inert volumes and poorly defined ridges and joints, a weakness not exhibited in the British Museum example. These features are sufficient to raise the question of its authenticity.

TYPES

The sculpture of Hawaii can be divided into four general classes of images, one secular and three religious. The secular class is comprised of the support figures, although some of these are auxiliary forms such as lugs rather than true supports. The three classes of images clearly related to religious practices are temple images, *akua kā'ai* images (stick images), and *'aumakua* images. The *'aumakua* group includes the so-called sorcery images. These four types of images represent, at least nominally, a functional classification, but the information concerning the context in which many of the pieces were used is no longer available. Where the functional classification is in question, often a morphological trait will suffice to place the piece in its proper class. This grouping is then not entirely arbitrary but takes into account both the known cultural patterns and the factors of size, shape, and specialized forms—it is a functional-morphological classification.

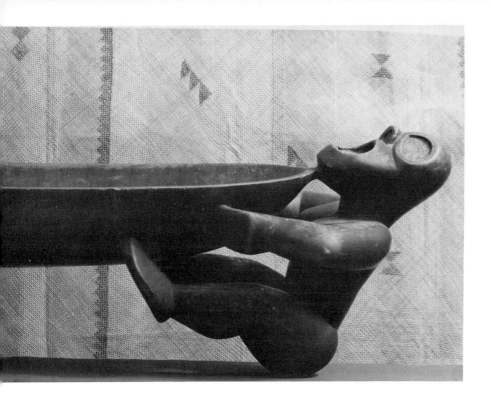

20 (left and below) Platter. The beautiful integration of the figures with the contour and volume of the bowl is a striking example of the Hawaiian artists' sculptural sensibilities, just as the control of the forms and surfaces is testimony to their masterful craftsmanship. Length: 45½ in. Bernice P. Bishop Museum. Cat. no. S1.

Support Figures

A great number of practical objects such as food bowls, carrying poles, drums, and spear and pole racks for fitting to canoes were enhanced with carvings of human figures. These support figures have an ingenuity of composition, charm, and informal treatment that is completely lacking in the better-known religious images. They were carved with the fine craftsmanship that is typical of the *kahuna* carver, and some examples surpass the average religious image in sculptural quality. It is quite possible that the sculptors responsible for the better religious images were also the carvers of many of these secular objects. The figures are by no means merely decorative or applied to the surface, but are ingeniously structured into some functional aspect of the object and are usually quite vital to that function, as in the large platter in which the knees of one figure and the buttocks of the other form the support for the bowl, and the mouths are open cups for condiments (figure 20).

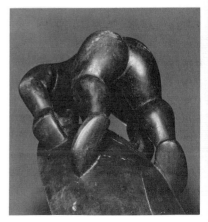

These images are clearly the result of attitudes and meanings far removed from the severe and formal requirements of the temple and 'aumakua sculpture. Even the simplest of 'aumakua figures and the very small stick images are strictly formal, aloof, and regal. They tend to overwhelm the viewer with their jutting chins, snarling mouths, or magnificent crest decorations as symbols of mana. The support figures are informal, suggesting the buffoon, the acrobat, or the playful imp. They exhibit neither noble bearing, pride, nor manifestations of mana. Instead, they are eternally committed to humble work, which they do lightly and with a cooperative and playful spirit.

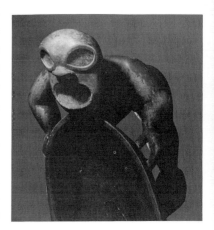

As far as is known, these carvings were entirely secular, having no part in religious ceremony or ritual, but they were nevertheless highly valued possessions. Carvings were not to be found on everyday food bowls or on the

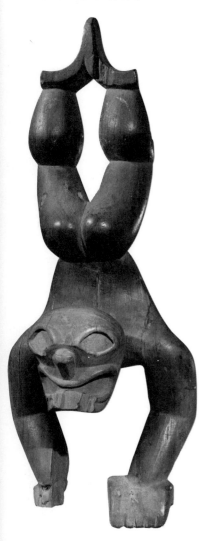

21 Support figure. The sculptural quality attained in the support figures is generally as high as in the religious images. In some cases, they were probably carved by the same sculptors. In use, this image was in the position shown, with the hands lashed to a bar. The objects to be secured, such as poles or spears, were tied into the U-shaped yokes which formed the feet of the figure. These are now broken away on both sides. Height: 15½ in. Bernice P. Bishop Museum. Cat. no. S34.

ordinary fisherman's canoe. Rather, they were heirlooms of the *ali'i*, to be passed on to succeeding generations as objects of high value. Occasionally, they were hidden away in caves with the burial of their owners. Long association with the royal ancestors and with the bodies of the dead would of course give them the mana that was the birthright of their owners. This is probably as near as they came to having any ritualistic significance.

The sculptural forms employed in these support figures, though arranged differently, are the same as those used in the religious figures. The style itself, however, can easily be recognized by the treatment of the head (figure 21). The forehead is always low and recedes strongly from the brow; the heads are bald and smooth; the noses are short, buttonlike, and turned up at the nostrils. These features are emphasized by the backward tilt of the entire head, so that on some images the head appears to be between the shoulder blades (figure 22). The images are carved as acrobats and tumblers, standing on hands, playing strange games, and twisting into unlikely positions.

Most of the characteristics of the support figures match so well with the Hawaiian's conception of the *Menehune*, the mythical little people of Hawaiian folklore, that a relationship is immediately suggested. Katharine Luomala, an expert on Polynesian folklore, has this to say about the *Menehune* (1955:125):

Menehunes are extremely stout, strong and muscular. Opinions differ as to whether or not they have hairy bodies. Their faces are red and ugly; their noses are short and thick; and their hair hangs down over a low protruding forehead and tangles with their eyebrows, which hang like crags over large eyes. Their arduous, rigidly disciplined work gives the little people a set, serious and determined look which Hawaiians say is frightening.

. . . Silent as they are when toiling on a heiau, they make up for it off duty, for they play as hard as they work. They chatter and laugh merrily and endlessly causing such a racket at times that fish in the sea leap into the air in fright and birds on neighboring islands are terrified. The little people know all the games that the Hawaiians play and occasionally they organize a festival, when—like the Hawaiians at the makahiki celebrations—they spin tops, throw darts, box, wrestle standing up and lying down, race around the island, slide the grassy hillsides on ti leaves, and play "hide the pebble."

. . . Yet the menehune most enjoys the simpler, less organized, impromptu diversions like carrying rocks from the mountains to throw into the sea and diving after them. They love to roll down hills, especially when the sea is at the bottom and they can splash into the water.

The stories of the *Menehune* probably gave the Hawaiian common people a release from the oppression and complete domination of the *ali'i* over their lives. The stories provided vicarious participation in glamorous adventures, playing the impish hero and making fun of the haughty nobles. A similar relaxation of formal and traditional controls was allowed the sculptor as he

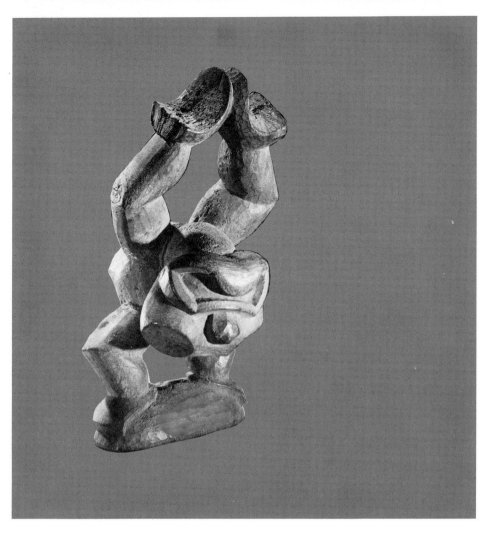

22 Support figure. Schematic distortion of the acrobatic pose is not unusual in the support figures. In this example, legs are greatly shortened and the head is enlarged to the size of the torso and thrown back so far that it seems to be attached to the center of the back. Height: 9 in. Chicago Natural History Museum. Cat. no. S35.

Spear rack. This holder for spears or poles was probably fitted to the outrigger boom of a canoe. It is a striking example of the integration of functional features with the human heads. The eyes are inlaid with pearl shell held in place by wooden pegs. Length: 13 in. Museum für Völkerkunde. Cat. no. S25.

Spear rack. This rack was used for securing fish spears or fish poles to the outrigger boom of a canoe. It was lashed to the forward boom through the slot in the base. The spears or poles were tied in the slots with the ends resting on the rear boom. Height of heads: 3 in. Bernice P. Bishop Museum. Cat. no. S26.

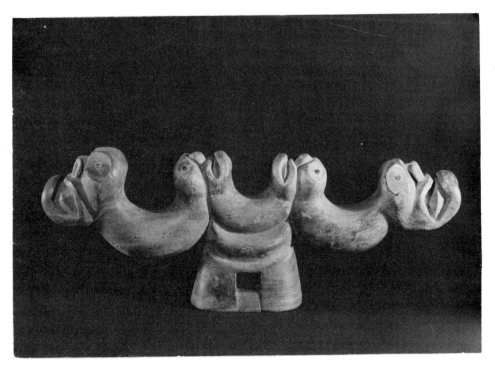

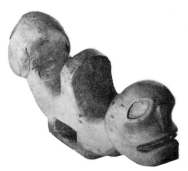

Game board. A game called *kōnane,* using black pebbles and white
coral as pieces, was played on this game board (*papamū*). The game
had some of the characteristics of checkers and of the Japanese game
Go. The use of the arms of two incomplete figures as supports is
a device also found on some Hawaiian food bowls. Height: 8 in. Ha-
waii Volcanoes National Park Museum. Cat. no. S15.

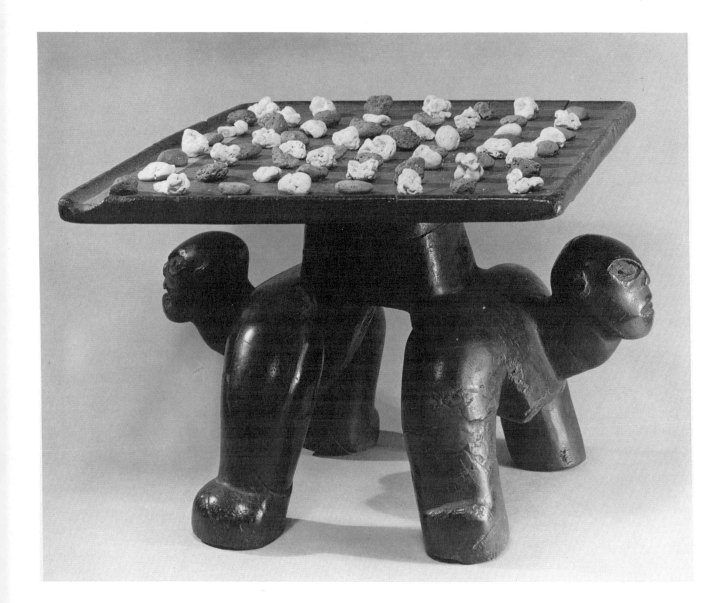

23 Scrap basin. Two female figures emerge from the bowl surface, their heads forming lugs for the cord handle. The human molars set into the surface are, in this case, probably those of a slain enemy and signify the contempt of the victor for the victim. Height: 9¼ in. Bernice P. Bishop Museum. Cat. no. S14.

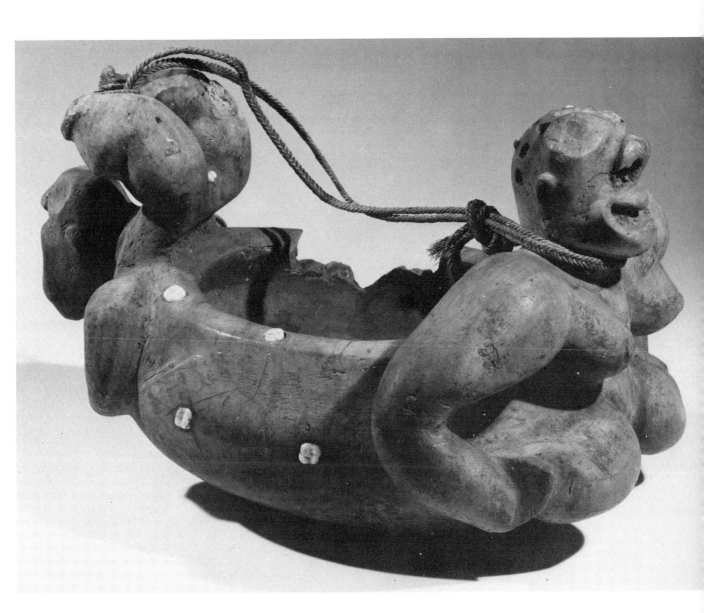

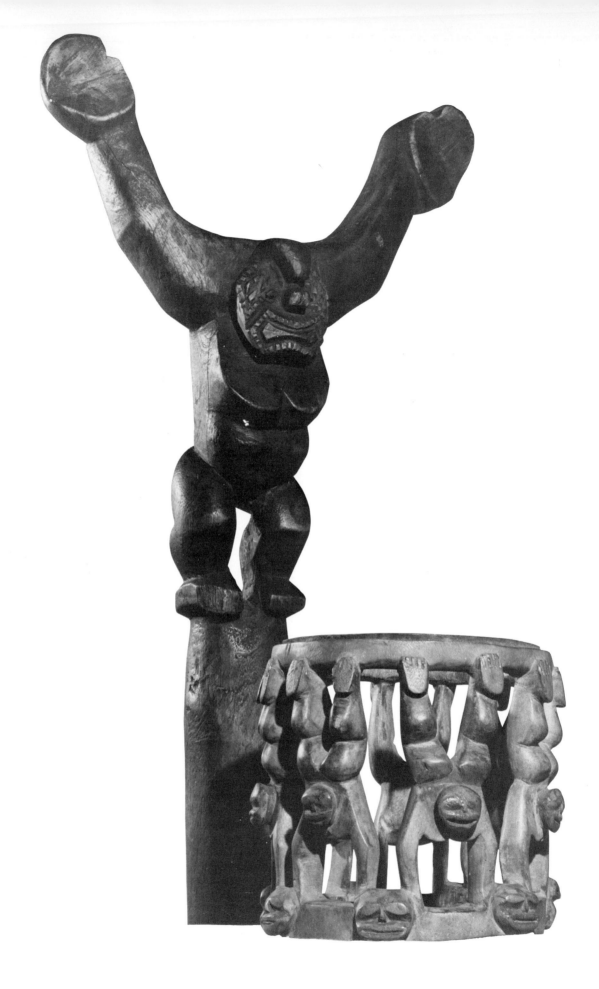

24 Support image and drum base. The support image is one of a
pair which were probably used together with arms supporting a sacri-
fice altar, or possibly some object was held in the yoke between the
arms of the two images. Height to the shoulders: 9¾ in. Bernice P.
Bishop Museum. Cat. no. S31. The detached drum base supported by
seven acrobatic figures suggests the spirit of play that is typical of
the support figures. The heads functioned as lugs for the tympanum
cords. Height: 7 in. Bernice P. Bishop Museum. Cat. no. S29.

carved these works. Artistically, these figures demonstrate the achievement of
a nicely balanced set of choices between two opposite forces confronting the
artist: the safe and accepted conventions of tradition, and the urge toward
inventiveness and individual expression. In the religious images only the
former was possible, but in the support figures, which were released from
strict conventions and the *kapu* of religious symbolism, the sculptors were free
to invent new compositional arrangements and postures and to improvise in
structural details, even though the basic forms, volumes, and methods were in
line with tradition (see Cox 1960).

Although there seems to have been no religious or ritual use attributed to
the support figures, the Hawaiians were not so unimaginative that stories and
specialized meanings would not be associated with many of the carvings. It
is recorded (with questionable authenticity) that the images on the large plat-
ter in figure 20 represent Kahahana, a chief from Oahu, and his wife Kepua-
poi. When the chief Kahekili of Maui defeated Kahahana in war, he had the
platter made representing the defeated *ali'i* in the servile position of holding
Kahekili's food platter. The mouths of the defeated chief and his wife were
used as containers for seasonings such as salt and seaweed. Such disrespect
and degradation of an enemy would naturally convey status to the victor. In a
similar manner, the molars of enemies set into refuse containers and spittoons
were a mark of dishonor to the enemy (figure 23). However, in other bowls
used for less repugnant purposes, the teeth of ancestors or venerated persons
were inset as symbols of respect and honor (catalog number S10).

The pair of images with upraised arms, one of which is shown in figure 24,
have generally been assumed to be stick images or small temple images. How-
ever, in some ways they are similar to the support figures that are designed
as pole or spear racks, although they are larger than any of these. The heads
are so placed that they would not obstruct the base of the rack opening if
the figures were used as cradle-type supports. If the pair were set into the
ground some distance apart, the U shape of the upraised arms could hold an
object such as a small canoe, a roll of matting or tapa, a wrapped image, a
large bowl, or possibly a platform or altar for offerings. In this latter function,
the pair could be compared to a very similar support, from Mangareva, that
had two outstretched arms on a post (without a head or body) that were used
to support the biers of corpses left to dry on the temple site in preparation
for the funeral ceremony (see Buck 1938:497).

Temple Images

The most significant physical evidence of a high chief's power was the *heiau*.
This temple complex and much of the ceremony that took place in it were
symbolic of the chief's spiritual, economic, and political control. The rituals

accompanying the building and dedication of the temple were performed mainly to reaffirm the chief's sanctity and his right to rule on behalf of the gods. The *heiau* were stone platforms, often terraced and enclosed by massive stone walls or, in the case of the smaller temples, by a wooden fence. The temple images were set into holes in the stone paved platform. At times they were also placed on the top of the surrounding walls or as extensions of the fence posts. Their large size, ranging up to fifteen feet or so, and the supporting posts on which they stood are what distinguish the temple images from the other types.

David Malo describes the two kinds of *heiau* used by the chiefs, the *luakini* dedicated to Ku and the *māpele* dedicated to Lono (1951:159–160):

It was a great undertaking for a king to build a *heiau* of the sort called a *luakini*, to be accomplished only with fatigue and with redness of the eyes from long and wearisome prayers and ceremonies on his part.

There were two rituals which the king in his eminent station used in the worship of the gods; one was the ritual of Ku, the other that of Lono. The Ku ritual was very strict (*oolea*), the service most arduous (*ikaika*). The priests of this rite were distinct from others and outranked them. They were called priests of the order of Ku, because Ku was the highest god whom the king worshipped in following their ritual. They were also called priests of the order of Kanalu, because that was the name of their first priestly ancestor. These two names were their titles of highest distinction.

The Lono ritual was milder, the service more comfortable. Its priests were, however, of a separate order and of an inferior grade. They were said to be of the order of Lono (*moo-Lono*), because Lono was the chief object of the king's worship when he followed the ritual. The priests of this ritual were also said to be of the order of Paliku.

If the king was minded to worship after the rite of Ku, the *heiau* he would build would be a *luakini*. The timbers of the house would be of *ohia*, the thatch of *loulu* palm or of *uki* grass. The fence about the place would be of *ohia* with the bark peeled off.

The *lananuu-mamao* [oracle tower] had to be made of *ohia* timber so heavy that it must be hauled down from the mountains. The same heavy *ohia* timber was used in the making of the idols for the *heiau*.

It was indeed an arduous task to make a *luakini*; a human sacrifice was necessary; and it must be an adult, a law-breaker.

If the king worshipped after the rite of Lono, the *heiau* erected would be a *mapele*; or another kind was the *unu o Lono*. The timber used in the construction of the house, the fence around the grounds, and in constructing the *lananuu-mamao* was *lama* and it was thatched with the leaves of the *ti* plant. There were also idols. . . .

The *mapele* was a thatched *heiau* in which to ask the god's blessing on the crops. Human sacrifices were not made on this *heiau*. Any chief below the king in rank was at liberty to construct a *mapele*. The right to build a *luakini* belonged to the king alone. The *mapele*, however, was the kind of *heiau* in which the chiefs and the king himself prayed most frequently.

One of the many images on a *heiau* was designated as the *akua mō'ī* (lord of the god image) or *haku 'ōhi'a* (god of the *'ōhi'a*). This image was the last to be set in place in the center of the group of images facing the altar. Its dedication on a *luakini heiau* was marked by a human sacrifice; the victim was buried in the hole in which the image stood. It was also the most elaborately carved of all the images. In his account of Captain Cook's visit to Kealakekua Bay in 1779, James King describes the images on the *luakini heiau* at Kakooa (Kekua) (Cook 1784, 3:6):

At the entrance we saw two large wooden images with features violently distorted, and a long piece of carved wood, of a conical form inverted, rising from the top of their heads; the rest was without form, and wrapped around with red cloth. We were . . . led to that end of the *Morai*, where the five poles were fixed. At the front of them were twelve images ranged in a semicircle form, and before the middle figure stood a high stand or table, exactly resembling the *Whatta* of Otaheitie. . . . [The *kahuna*] then led him [Cook] to the images before mentioned, and having said something to each in a sneering tone, snapping his fingers at them as he passed, he brought him to that in the center, which, from its being covered with red cloth, appeared to be in greater estimation than the rest. Before this figure he prostrated himself.

When a *heiau* was not in use or under a *kapu*, the supplementary images were not regarded with value or respect, although the central one was apparently still considered sacred. Further in King's account, the collecting of the *heiau* fence for firewood is described (Cook 1784, 3:25):

. . . and the wood was readily given, even without stipulation for anything in return. Whilst the sailors were taking it away, I noticed one of them carrying off a carved image; and, on further inquiry, I found, that they had conveyed to the boats the whole semicircle. Although this was done in the presence of the natives, who had not shown any mark of resentment at it, but had even assisted in the removal, I thought it proper to speak to Kaoo [the *kahuna*], on the subject; who appeared very indifferent about the matter, and only declared, that we would restore the centre image, I have mentioned before, which he carried into one of the chief's houses.

Of the temple images remaining today, only three can be designated as central images—the large image in the British Museum and similar ones in the Bishop Museum and the Peabody Museum at Salem, Massachusetts (figures 10, 34; catalog number T4). Some of the other large and more completely carved temple images existing today may have been major images on some of the smaller or less important temples. The greater number of existing examples were, however, probably auxiliary or secondary images. These would have been placed flanking the central image, at the entrance gate, on the walls, as fence posts, or outside the *heiau* enclosure (figure 1). Although these secondary images were not the central focus of the ceremonies, as was the

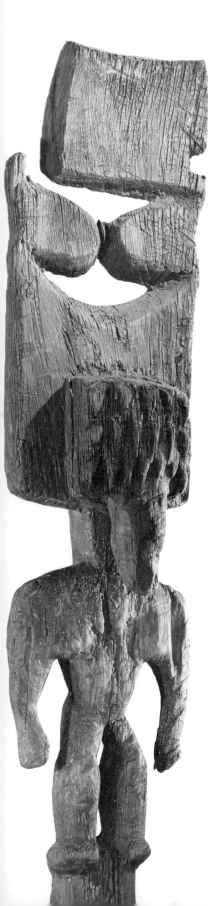

Slab-type temple image. It is typical of the slab images that the head protrudes forward from the body and the headdress. The open crescent design on the slab is similar to that found on the feather capes and cloaks and is possibly related to the *lei palaoa* shape. The notches for attaching tapa streamers are still evident near the top of the slab. Height of figure: 38 in. Bernice P. Bishop Museum. Cat. no. T20.

central image, they were not merely decorative or a proliferation of the major image. Each one would have been known by a specific name, and each probably had some particular part to play in the temple ceremonies or demarcated a specific ritual space. Whether the variety of forms found in the existing images is due to this variety of meaning and function or to individual and area style differences is not known.

If a temple was to be rededicated, its walls and platforms rebuilt, and its houses and altars renewed, the central image may have been the only one of the images to be replaced. The supplementary ones were probably retouched, re-dressed, and renamed, with the dedication of the new central image symbolizing the renewal of all of the others. There are three accounts of the carving and dedication ceremonies of temple images: David Malo (c. 1835), John Papa Ii (c. 1869), and Capt. Charles Wilkes (c. 1841). They all refer to the central image of a *luakini heiau* and provide evidence for the significance of this image. But the accounts do not agree on all points, probably because none of them are reports from firsthand experiences. The discrepancies may also represent minor differences in ceremonial practice. Each account does indicate the elaborate, precise, rigorous, and symbolic nature of the rituals. Malo's account, with his description of the *luakini*, is the most complete of the statements relating to the carving of the central image. He describes activities that continue for about twelve days, and he says this about the carving and dedication of the central image (1951:162–174):

After the stone wall of the *heiau* was completed, they proceeded to build the *lananuu* [oracle tower]; first setting up the frame and then binding on the small poles (*aho*): after this they set up the idols, of which there were a good number. Some of them were *makaiwa* images [images with pearl shell eyes], of great height. In the midst of these images was left a vacant space, in which to set up the new idol that was to be made, called the *moi*. . . .

. . . That night (Hoaka), still another *kahuna* conducted the service called *malu-koi* [adz taboo], in which they consecrated the axes that were to be used in hewing the timber for the new idols; and laid them over night (in the little house, *mana*). A fowl was baked for the use of the *kahuna*, another for the king, and a third for the deity; and then slept for the night.

The next morning (Ku-kahi), the king, chiefs, people and the priests, including that priest who conducted the service of *malu-koi*, started to go up into the mountains. The priest who performed the *malu-koi* service with the ax was called *kahuna haku ohia*, because *haku ohia* was a name applied to the idol which they were about to carve. Another name for the idol was *moi*. That day, the *kahuna haku ohia* began a fast which was to continue for six days.

In going up they took with them pigs, bananas, cocoanuts, a red fish (the *kumu*) and a man who was a criminal, as offerings to the deity.

A suitable *ohia* tree had previously been selected—one that had no decay about it,

because a perfect tree was required for the making of the *haku ohia* idol—and when they had reached the woods, before they felled the tree, the *kahuna haku ohia* approached the tree by one route and the man who was to cut the tree, by another; thus they stood on opposite sides of the tree.

The *kahuna* having the axe and the king having the pig, the people remained at a respectful distance, commanded to preserve strict silence. The *kahuna* now stood forth and offered the *aha* prayer called *mau-haalelea* [a prayer for ceremonial perfection].

On the completion of the prayer, the king uttered the word *amana* (equivalent to amen) and then killed the pig by dashing it against the ground, after which he offered the pig as a sacrifice. This done, the *kahuna* inquired of the king, "How was this *aha* of ours?" If no noise or voice, no disturbance made by the people, had been heard, the king answered, "The *aha* is good." Then the *kahuna* declared: "To-morrow your adversary will die. The incantation (*aha*) we have just performed for your god was a success. On the death of your adversary, you will possess his lands, provided this business is carried through."

The *kahuna* having first cut a chip out of the tree, the criminal was led forth: and the priest, having taken his life by beheading, offered his body as a sacrifice. The tree was then felled, the pig put into the oven, and the work of carving the idol taken up and carried to a finish by the image carver. The pig, when cooked, was eaten by the king and people; and what remained after they had satisfied their hunger was buried, together with the body of the man, at the root of the tree from which the image had been made. The man used as a sacrifice was called a man from *mau-haalelea*. Thus ended this ceremony.

The people then went for *pala* fern, making backloads of it, and they gathered the fruit and flowers of the mountain apple, the *ohia*, until the hands of every one were filled with bouquets. Then, some of them bearing the idol, they started on their way down to the ocean with tumultous noise and shouting.

They called out as they went, "O Kuamu, O Kuamumu. O Kuawa. O Kuawa-wa. I go on to victory (*u-o*)." Thus they went on their wild rout, shouting as they went; and if any one met them on their way, it was death to him; they took his life. On arriving at the *heiau*, they put the image on the level pavement of the temple court, and having covered it with *ieie* leaves, left it.

That evening they measured off the foundation of the house (*mana*) and determined where it should stand, where should be its rear, its front, and its gables. A post was then planted at the back of the *mana*, directly opposite its door of entrance. This upright was termed a *nanahua* post, and it marked the place where the image of Luamu was to be set. A post was also planted between the *makaiwa*—images of Lono—at the spot where the image called *moi* was to be set up. This post was called the pillar of Manu (*ka pou o Manu*). . . .

. . . The houses were then thatched, the drum house, the oven house, the *waiea* [a small house near the *heiau* entrance where the '*aha* (cord) was stretched], and the *mana*, after which the people brought presents of pigs, cocoanuts, bananas, red fish, also *oloa* [fine white tapa] to serve as *malo* [loincloth] for the idols, braided sugar cane for the thatch of the *anuu-mamao* (same as the *lana-nuu-mamao*) as well as for the *mana*. This accomplished, all the people returned to their houses.

That same evening, Kulua, the *haku-ohia* idol, was brought in from the paved terrace, *papahola*, and set in the place which had been specially reserved for it, that being the spot where the pillar of Manu had been planted.

The post hole in which this idol (*haku-ohia*) was set was situated between the *makaiwa* images, directly in front of the *lana-nuu-mamao* and close to the *lele* [altar], on which the offerings were laid. There it stood with no *malo* upon it.

At this time none of the idols had *malo* girded upon them; not until evening, when this image, the *haku-ohia* idol, had been arrayed in a *malo*, would the rest of them be so covered. While in this unclothed state, the expression used of them was, "the wood stands with its nakedness pendent" (*ua ku lewalewa ka laau*).

Then a priest stood forth and conducted a service for the setting in its place of this idol, which service was styled *ka poupouana*. A man who was a criminal was first killed, and his body thrust into the hole where the idol was to stand. The man was sacrificed in order to propitiate the deity; and when the service was done the chiefs and the priests returned to their houses, keeping in mind the work to be done that night. . . .

. . . The next morning they put a long girdle of braided cocoanut leaves about the belly of the *haku-ohia*, calling it the navel cord from its mother.

Then the king and the priests came to perform the ceremony of the cutting of the navel string of the idol; and the priest recited the following prayer:

O ka ohe keia o ka piko o ke aiwaiwalani.	This is the bamboo for the navel string of the wondrous heavenly being.
O ka uhae keia o ka ohe o ka piko o ke aiwai-walani.	This is the splitting of the bamboo for the navel string of the wondrous heavenly being.
O ke oki keia o ka piko o ke aiwaiwalani.	This is the cutting of the navel string of the wondrous heavenly being.
O ka moku keia o ka piko o ke aiwaiwalani.	This is the severing of the navel string of the wondrous heavenly being.

The priest then cut the cord, and having wiped it with a cloth, made the following prayer:

Kupenu ula, kupenu lei,	Sop the red blood, wear it as a wreath,
Aka halapa i ke akua i laau waila.	To the grace and strength of the deity.

The king then uttered the *amana* [prayer to lift *kapu*] and the service was ended.

The next day, Ouekulua, took place—the great feast. The chiefs contributed of their pigs, as also did the people. . . . When all the pigs had been contributed and oven-baked, the king and all the priests assembled for the ceremony of girding the *malo* [loincloth] upon the *haku-ohia* idol. . . .

Slab-type temple image. The slab images were generally limited to the northern islands of the Hawaiian Chain. However, this one was found on the now uninhabited island of Kahoolawe. Height: 43 in. Bernice P. Bishop Museum. Cat. no. T18.

The whole body of priests recited in unison the *pule malo*, a prayer relating to the *malo* of the deity:

Hume, hume na malo e Lono!	Gird on, gird on the *malo*, o Lono!
Hai ke kaua, hailea, hailono e!	Declare war, declare it definitely, proclaim it by messengers!

At the conclusion of the prayer, they arrayed the idol in the *malo* and a new name was given to it, Moi, lord of all idols. After that all the idols were clothed with *malo*, and each one was given a name according to the place in which he stood.

The ritual of cutting the navel cord of the images is almost identical to that which was used by the *kahuna* at the birth of a ruling chief's sacred first son who might one day be named his political successor (Malo 1951:137). Cutting the cord was symbolic of the birth of the image, and it was not until this time that the image was ready to represent the deity.

The temple cult with its rigorous rituals and human sacrifices may have been a relatively late importation from the Society Islands. According to Hawaiian traditional history, one of the last voyages from the Society Islands was made by Pa'ao, a high priest from Ra'iatea. Estimates based on genealogy chants from both Hawaii and the Society Islands in which Pa'ao is named indicate that his arrival in Hawaii was about twenty-five generations before the chant was recorded (A.D. 1250?). Pa'ao brought to Hawaii the form of the *heiau*, the order of Holoa'e *kāhuna*, human sacrifice, and other important ritual innovations. It is said that the first such temple was Waha'ula (red mouth), the remains of which are still visible near the village of Kalapana on the island of Hawaii. (The drawing of figure 1 is based on this structure.) The temple was said to have been so *kapu* that mere contact with smoke from its fires was sufficient cause to sacrifice the contaminated person on the temple altar.

The temple images display a rather wide range of style treatments, but they can be grouped into three general types—a slab style, a post style, and a more general category of fully sculptured figures which include the elaborated Kona style.

Slab Images. The slab-type images are quite distinct in treatment from the other forms, tending to have a two-dimensional cutout body and a panel extension above the head that usually has a carved relief design or a cutout pattern. One or two examples show a slight three-dimensional treatment of the body. In most cases the slab images are in very deteriorated condition and the original forms are not completely evident. A consistent element on the crest

25 Slab-type temple image. This is the only remaining image of this type, although they were in use on Kauai when Captain Cook discovered the Islands in 1778 (see figure 26). The notches on the outer edges of the crest panel are remains of the slots through which strips of tapa were tied. This is possibly the prototype for the full-figure slab images. Height: 66½ in. Bernice P. Bishop Museum. Cat. no. T24.

panel is the slotted holes cut on the outer edges of the panel. In most existing images these holes have been broken away so that they appear as notches (figure 25). They were originally tying points for tapa streamers, which were tied on during the dedication ceremonies. In Webber's drawing of the *heiau* at Waimea, Kauai, the tapa streamers can be seen on the five slab images set into the paved platform (figure 26). Comparing the images in this drawing with a similar image at the Bishop Museum (figure 25) gives one a clearer idea of what Webber undoubtedly saw. The features of the head, eyes, nose, mouth, and hair are defined mainly by lineal means and are not strongly sculptured forms. Although the mouth and nose do thrust forward, they are constrained as a surface condition of the basic half-cylinder form. The large, circular eye shape is not common in Hawaiian sculpture, possibly because, though effective in two dimensions as it is here, it does not lend itself to a dynamic three-dimensional form.

The slab type of image is possibly the oldest of the styles found in Hawaii. It may be a development from the upright slabs that are a major feature of the temple sites of central Polynesia. In his study of the Tuamotuan stone structures, Kenneth P. Emory discusses the terms applied to these stones (1934:10–11):

The upright stone slabs on the *ahu* [altar] and out on the court are called *pohatu* at Vahitahi and Napuka and probably at many other islands. At Anaa, Fagatau, Fakahina, Takakoto, Reao [Tuamotus] and undoubtedly at other islands, they are called *keho*. *Keho* in the Marquesas is a term applied to a "basalt column planted in the ground to serve as a backrest." In the Society Islands an *aho* (*'aho?*) is a certain stone set up in the *marae* where the priest set up his *tapa'au* (coconut leaf twisted to represent a man). Henry records that these *aho* of Tahiti were only certain small uprights in the rear part of the court. It is probable however that the word *aho* is related to the Marquesan and Tuamotuan word *keho*, meaning a backrest in the Marquesas and a marae memorial stone or backrest in the Tuamotus. In Hawaii *'eho* means a stone idol representing Lonokaeho, a collection of stone gods, or a stone pillar set up as a monument.

. . . Herve Audran, speaking of ceremonies at Napuka maraes, says: "The elders went with great pomp to the marae, taking their lances and grouping themselves in a semicircle, each with his back against his special stone (*te pofatu*), at the foot of which was *te nohoga*, the smooth and shining stool made in one piece from the trunk of the *tou* tree."

. . . Motiton calls these *ahu* uprights "idols." This does not rule out their use as seats, for they may have served, as I am convinced they did, as seats (backrests) for the ancestral gods.

The upright slabs of the Tuamotus are of coral limestone and in most cases are not carved, though some are slightly shaped to suggest human figures. Like

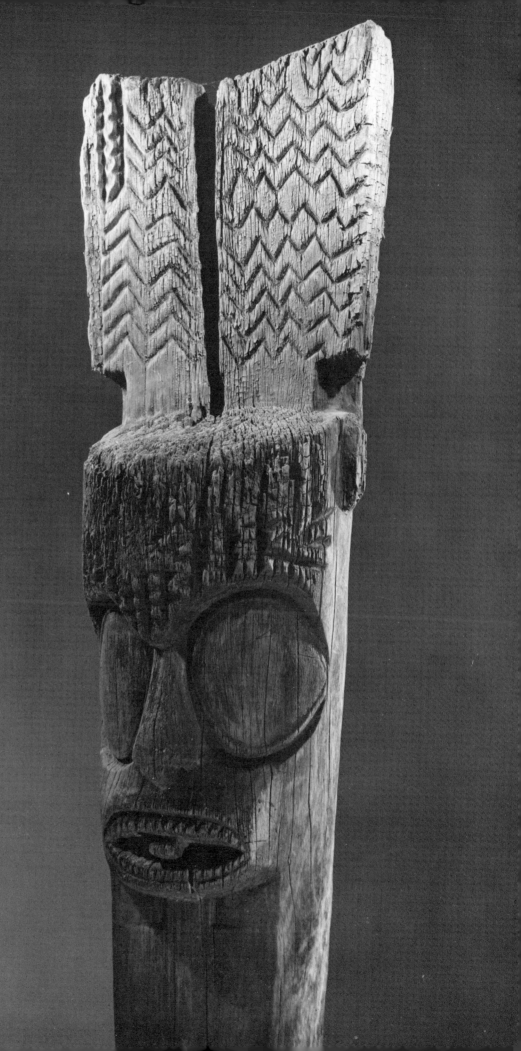

66

26 *Heiau* at Waimea, Kauai. Engraving by John Webber. This engraving represents the very first view of Hawaiian sculpture by an outsider. The occasion was the arrival of Capt. James Cook at Waimea, Kauai, in January 1778. The five slab images are the same type as in figure 25. The faces and carved crest patterns on them are barely discernible, but the tapa streamers tied into the slots at the sides help to identify them. Other objects—two posts, a triangular stone slab, and one of the stick bundles—are also tied with tapa streamers, a symbol indicating that they, too, are sacred or *kapu*. The central post image is carved with a figure at the base and another near the top. (*View of a Morai or Burial Place on Atooi [Kauai] one of the Sandwich Islands.* Cook 1784, Atlas: pl. 33.)

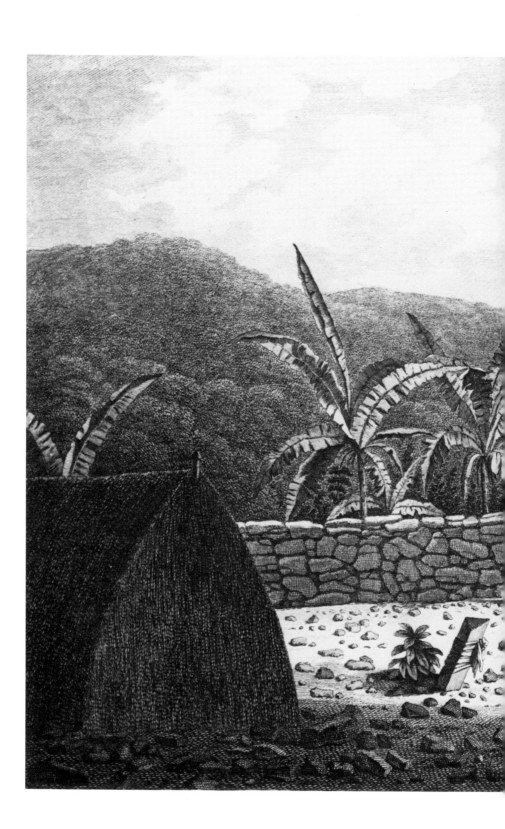

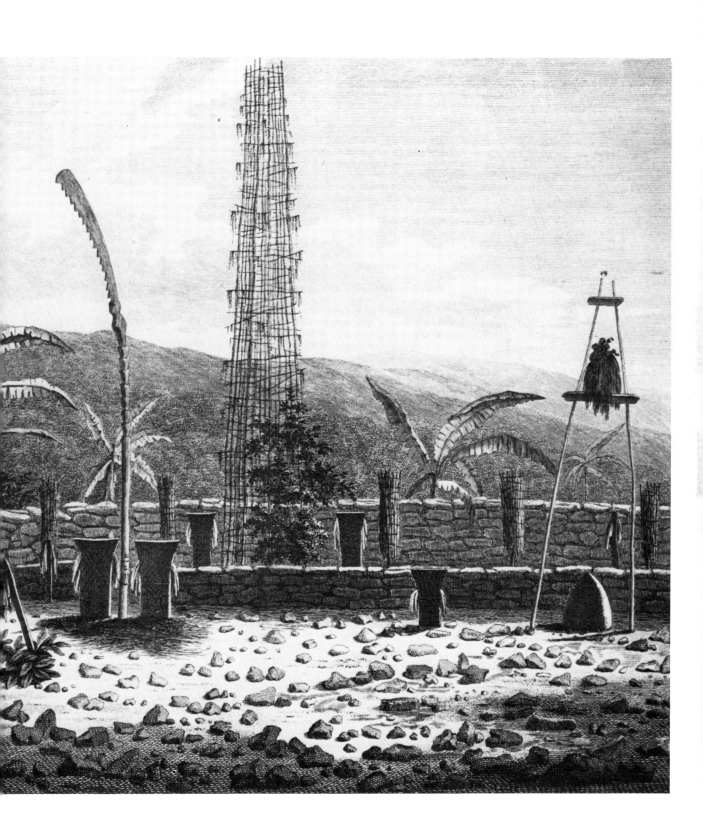

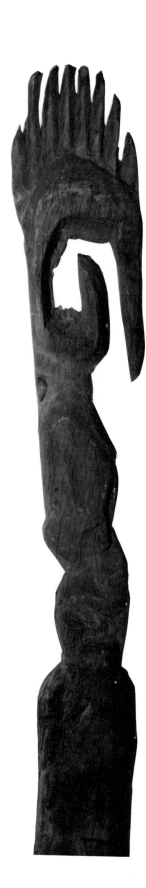

27 Post-type temple image. The rough adz work and simple blocking out of the figure is typical of the post-type images. In this example, the extreme development of the curving jaw and overhanging crest becomes a complete abstraction. There may have been a small head in the center open space, as in the image shown in figure 37. Height of figure: 29½ in. Bernice P. Bishop Museum. Cat. no. T27.

some other Polynesian objects, they seem to represent a step in the development of a form from a functional object to a symbolic one. Originally the purpose of these upright stones was to function as seats or backrests for the chiefs on the temple compound. The position of the stones was significant; it was probably established by the rank of the chief. In the case of an especially sacred *ali'i*, the position would retain the chief's mana even after he was dead, and for this or some similar reason the slab could become a memorial or "seat" for the spirit of the ancestral chief. Eventually the position and the slab were designated as places for the ancestral gods.

If this chain of events connected with the Tuamotuan images has echoes in the Hawaiian slab images, it means that the slab type has survived a considerable term of isolation from its original source in the Society Islands area. The slab type of image has been found only on Kauai and Oahu. It was apparently limited to the northern end of the chain of islands, which reinforces the belief that this area, especially Kauai, was more conservative and retained some of the more ancient forms of the culture.

Post Images. The post-type temple image is not so clearly a separate style as is the slab type. And it does not have a distinctive characteristic of form that separates it from the fully sculptural style, unless it is a factor of incompleteness. The post images seem to have a potential for a fuller, three-dimensional state; they are summary statements rather than completely realized sculpture. Although it would probably be inaccurate to say they are unfinished, some of them do indicate the first roughing-out stage in the process of making an image. It is clear that this was not a process of extending a relief treatment into the full round, nor was it a process of conceiving of the forms first in terms of line (figures 27, 28). The first cuts into the cylinder were directed to change the form, direction, and scale of that cylinder into volumes descriptive of the human figure. The natural form of the tree trunk, however, is maintained and the vertical axis of the whole is dominant. There is little opening up of negative spaces as in the fully sculptured style; the arms are not separated from the body and the space between the legs is not broken through.

These images would certainly have been the secondary or supplementary ones on a major *heiau*. Many of them are small in diameter. These might have been elaborated ends of fence posts, guarding the perimeters of a temple compound (figures 29, 30). The post type, however, is represented in some of Webber's drawings as being the principal images of some temples. In the engraving *An Offering before Capt. Cook, in the Sandwich Islands* (figure 31), Webber shows two post-type Lono images, wrapped in tapa, just outside the *heiau* gate (and possibly three others—the gateposts and a corner fence post).

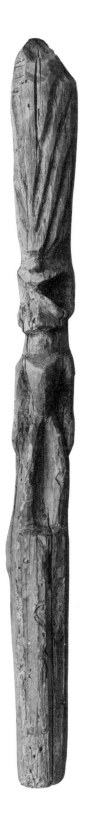

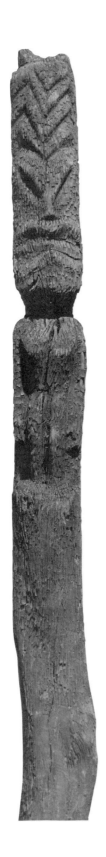

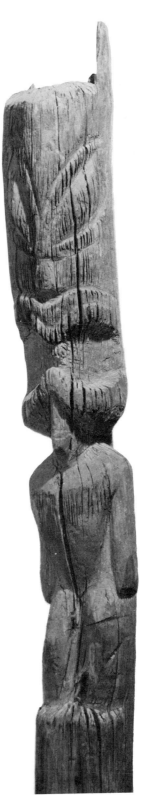

28 Post-type temple image. Most of the post images were left in a roughed-out state, and even though they are finished, they give some indication of how the sculptors began the process of carving for the more completely sculptured figures. This image possibly was carved as a *heiau* fence post. The eyes are incorporated into the headdress. Height of figure: approx. 20 in. National Museum, Copenhagen. Cat. no. T9.

29 Post-type temple image. This image was probably set into a fence surrounding a *heiau* compound. The summary treatment of the body volumes of the post images indicates the preliminary cuts made by the sculptors in the process of carving. Height of figure: 33 in; height of entire post: 7 ft 7 in. Bernice P. Bishop Museum. Cat. no. T13.

30 Post-type temple image. The post images generally conform to the cylindrical shape of the original tree trunk. Forms are not deeply undercut or opened between the legs or under the arms. Features of the face and head are carved in relief. Height of figure: 33½ in. Bernice P. Bishop Museum. Cat. no. T23.

31 *Heiau* at Napoopoo, Hawaii. Engraving by John Webber. The area within the stone wall and fence is a temple dedicated to the god Lono. The two tapa-draped carvings outside the gate are post-type images of Lono. A small image may be seen as a finial on the corner fence post, and possibly another at the gate. (*An Offering before Capt. Cook, in the Sandwich Islands.* Cook 1784, Atlas: pl. 60).

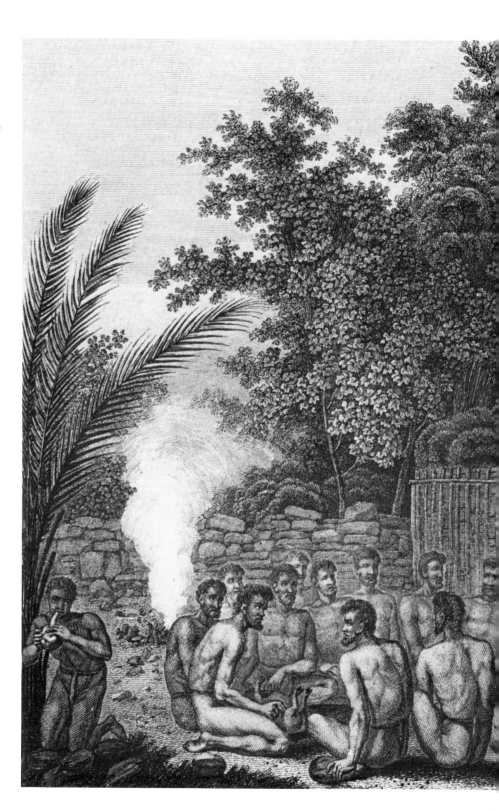

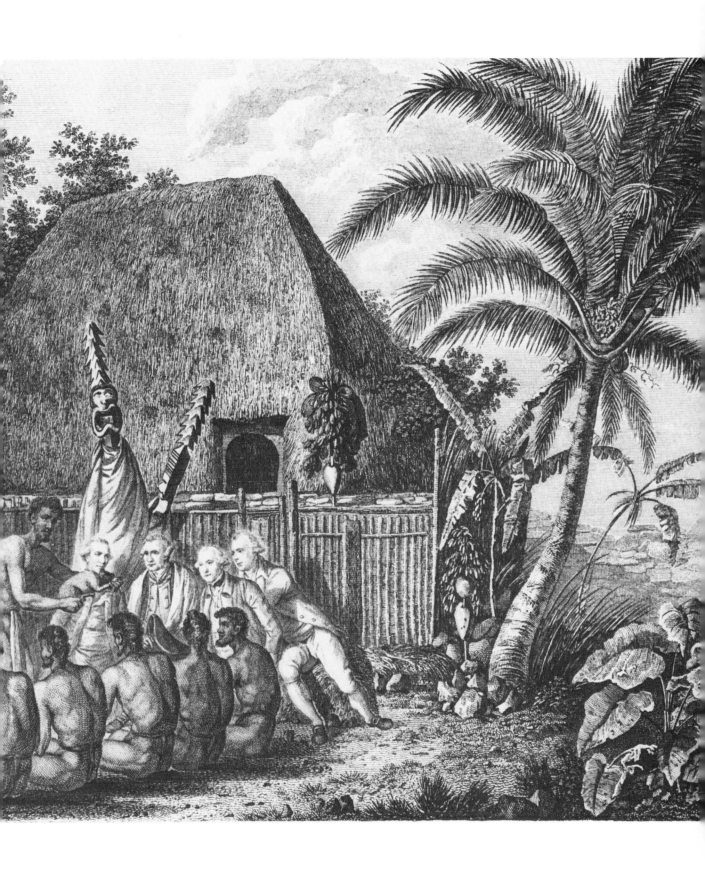

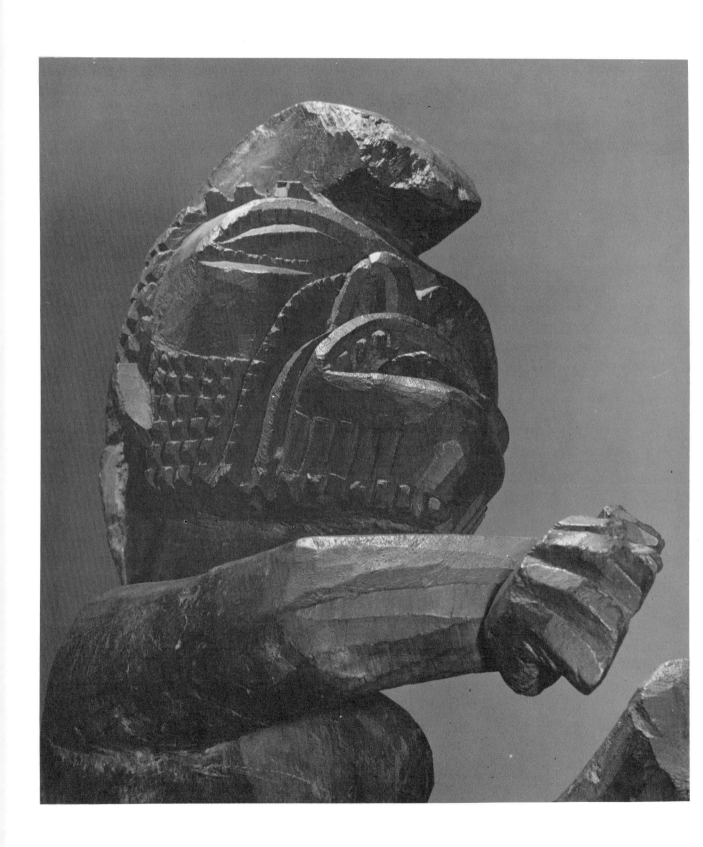

32 (page 72 and page 74), 33 (page 75) Temple images. This is a
pair of images from Hale-o-Keawe at Honaunau, Hawaii. Two features
of these images are unusual—the stylized representation of the beards
and the position of the hands. They exhibit, particularly in the heads,
the effectiveness of the faceted surface in modulating the light.
(Photograph on facing page is detail of figure 32.) Height of figures:
32, 52 in. 33, 49¼ in. 32, Bernice P. Bishop Museum; cat. no. T1. 33,
Chicago Natural History Museum; cat. no. T2.

And in his drawing of the *heiau* at Waimea, Kauai, the central image is ap-
parently of the post type (figure 26). It must have been sixteen feet or more
in height. There is a small figure near the base of the post between the flanking
slab images, and another with a tall, notched head crest near the top. An
image in the Peabody Museum (catalog number T10) closely resembles the
top part of this image in both size and form.

Fully Sculptured Images. The remainder of the temple images, the fully
sculptured type, include those in which three-dimensional sculptural expres-
sion reaches its climax. Except for the natural limits of the tree trunk, the
figures exist as forms practically independent of the original shape of the ma-
terial. In these, the three-dimensionality that was latent in the post images is
fully exploited. The counterplay of directions and tensions set up by the axes
of the forms, especially emphasized where the opposing forms meet, creates
a dynamism within what is otherwise a static, frontal, formal symmetry. This
in itself is a notable sculptural achievement. The heads are typically elabo-
rated, generally in a richly ornamented hair pattern or with a helmetlike en-
closing crest.

A pair of very striking images (figures 32, 33), of somewhat more natural
proportions than the usual temple images in both the head and body, were
taken from Hale-o-Keawe, a royal mausoleum located on a *heiau* at Honaunau
on the island of Hawaii (figure 43). They exhibit the remarkable dexterity of
the carver in the deceptively casual appearance of the final adz cuts. Two
unique features are also used on these images—the forward position of the
arms and hands, which appear to be designed for some specific function, and
the patterns representative of beards. Beards otherwise occur only on the
Kona-style images, where they appear as parallel ridges rather than the cube
and pyramid forms used here. This pair did not function in the same way as
the usual temple image. Although designed with a base post to be set into a
stone platform, they were found inside of the house on the *heiau* along with
the bundled bones of the high chiefs of the Keawe line, the ancestors of
Kamehameha. They were images of the personal gods of the chiefs and acted
as guardians of the deified remains. Hale-o-Keawe was not an ordinary *heiau*.
As a depository for the remains of kings, it held a special status and was ap-
parently exempt from the royal order of Liholiho (Kamehameha II) to destroy
all *heiau* and images. The entire structure, including about twenty images on
the *heiau* platform and several other smaller ones inside the house, was still
intact in 1825, six years after the overthrow of the old religion and the order
to destroy the temples. Apparently Liholiho and his regent, Queen Kaahu-
manu, refrained, or were restrained by reactionary *kāhuna*, from destroying

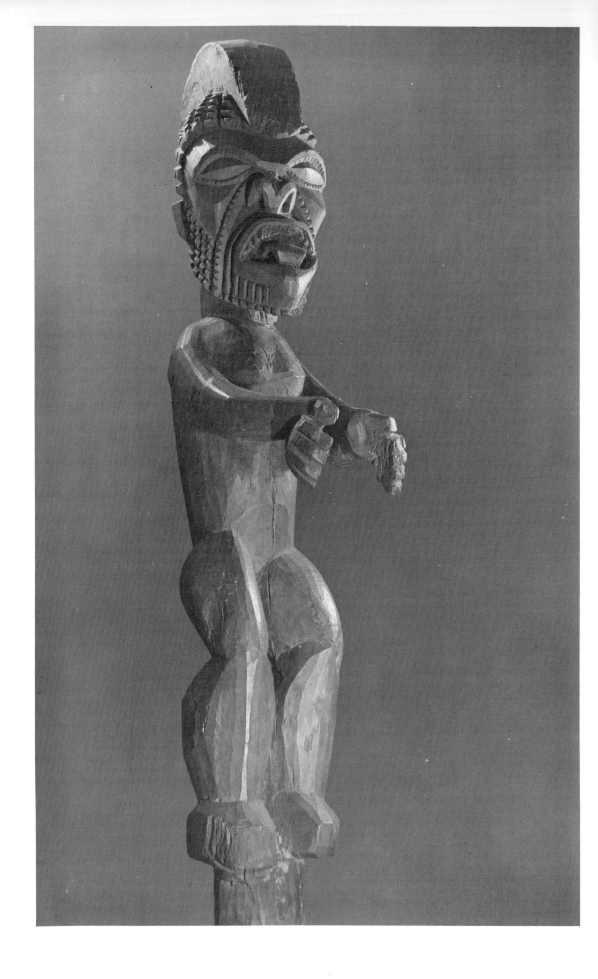

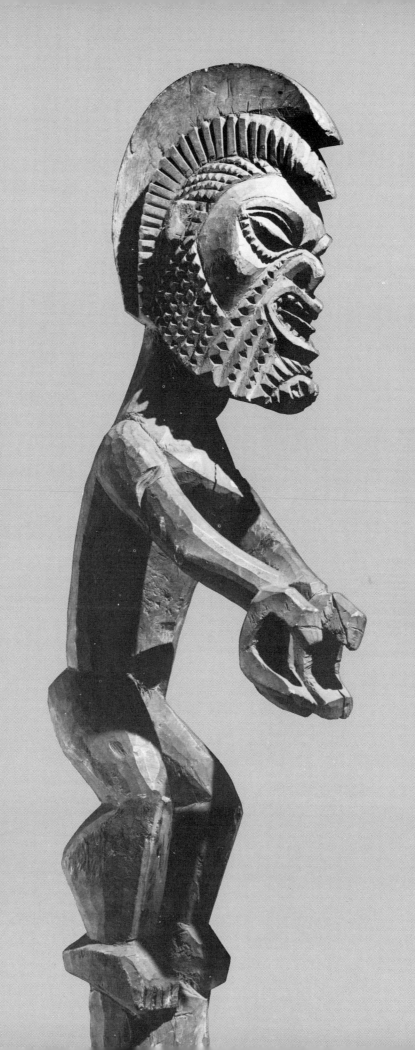

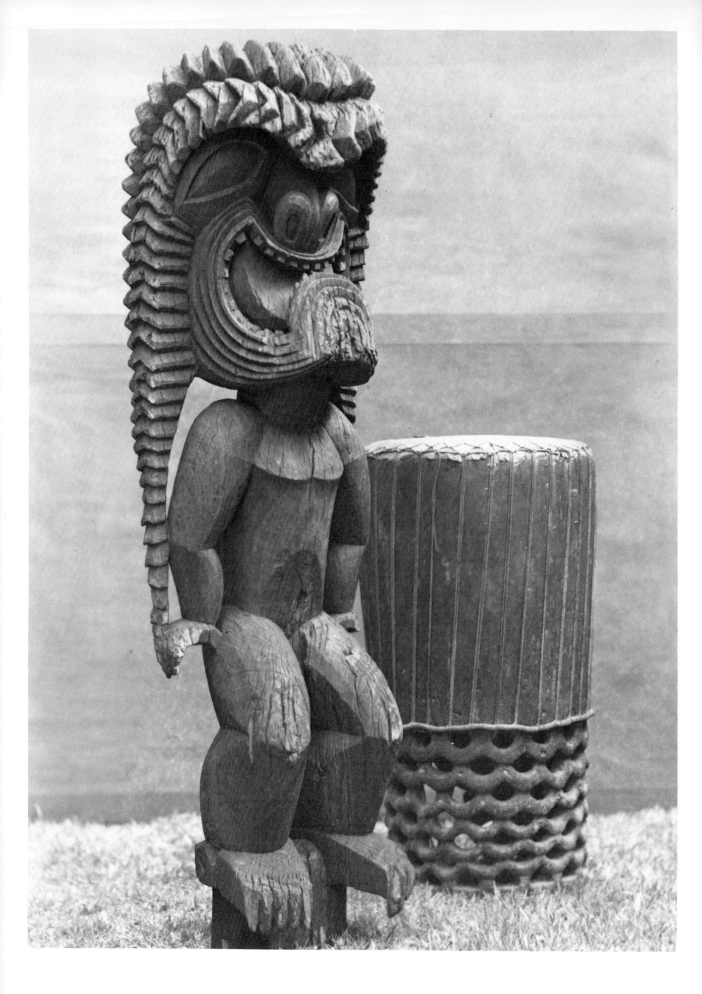

34 Kona-style temple image. This is a classical Kona-style image, probably from Kailua on the island of Hawaii. Images of this type were the central or major images in the temple compounds. Only three of this size remain today. Height: 77 in. Bernice P. Bishop Museum. Cat. no. T3.

this site. These two images, along with several others taken at the same time, are among the few examples of Hawaiian sculpture for which an exact provenance is known.

Some of the images from Hale-o-Keawe were collected by Andrew Bloxam, the naturalist from Lord Byron's ship, H.M.S. *Blonde*, that visited Hawaii in 1825. Bloxam writes (1925:74–76):

It [the *heiau*] is about three miles south of Karakaikooa [Kealakekua], close to the shore in a small sandy bay and near a grove of cocoanut trees. Karaimoku [a chief] had given permission to Lord Byron to visit it and take out any curiosities he chose. No white person had heretofore been allowed to enter the threshold, it is strictly guarded by a person who had the care of it. It is tabooed from the natives, as it contains the most precious relics—the bones of most of their former kings. We were accompanied by Kuakini and Naihe, the two principal chiefs. The *morai* [*heiau*] is built like a large native thatched hut, thirty by fifteen feet, with a very high roof and one low door. It is placed in a square, paved with large stones and surrounded with thick wooden stakes and palings. Outside this fence are ranged without order or regularity about twenty wooden idols rudely carved and of various uncouth forms, most of which are now fast rotting and decaying. In the interior of the palisades on one side is erected a kind of stage, about fourteen feet high, of strong poles on which the offerings were formerly placed. At the bottom lay a considerable number of decaying cocoanuts. We entered the building itself by a small wooden door about two feet high arched over at the top, the only light the interior received was from this, and a few holes in the dilapadated roof. Before us were placed two large and curious carved wooden idols four or five feet high, between which was the altar where the fires were made for consuming the flesh of victims. On our left were ranged ten or twelve large bundles of tapa each surmounted by a feather or wooden idol, and one with a Chinese mask, these contained the bones of a long succession of kings and chiefs whose names were mentioned there. The floor was strewn with litter, dirt, pieces of tapa, and offerings of every description. In one corner were placed a quantity of human leg and arm bones covered over with tapa. In two other corners were wooden stages, on which were placed quantities of bowls, calabashes, etc., containing shells, fishhooks, and a variety of other articles; leaning against the wall were several spears, fifteen or sixteen feet in length, a small model of a canoe, two native drums with an English drum in good preservation. This, one of the chiefs took with him. In the sides of the building were stuck several small idols with a calabash generally attached to them, one of these we opened and found the skeleton of a small fish, it was therefore probably the offering of a fisherman.

The natives and chiefs who were with us seemed to have but little regard for anything there, and willingly granted whatever we were desirous of taking. The only one who seemed to grieve at the loss of so many apparent treasures was the old man who had charge of them. He was, however, soon consoled by presents of knives, scissors and an old suit of clothes, etc., given by several of us.

The Kona Style

The only localized style of Hawaiian sculpture that can be documented developed on the Kona coast of the island of Hawaii in the late 1700s and

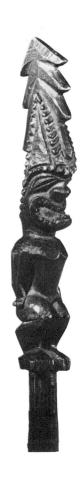

Kona-style *akua kā'ai* image. In this small example of a Kona-style image the eyes are not dislocated into the hair pattern as in the other Kona-style images, although they are elongated and conform to the line of the hair. Height of figure: 9 in. Honolulu Academy of Arts. Cat. no. K13.

early 1800s. By 1790, Kamehameha had unified most of Hawaii and Maui under his rule and was planning war expeditions to the other islands. To insure the success of his undertakings, he enlisted the support of the gods by building a number of *luakini heiau* in the Kona district. He had established his personal god, Ku-ka'ili-moku, as the principal deity of the kingdom and dedicated the temples in honor of the god. The resulting stimulation toward one effort, the unity of purpose and concentration of production by a limited number of *kahuna* sculptors in a relatively small area, seems to have resulted in the dramatic Kona-style images, examples of which are shown in figures 10, 18, 34, 35. This is the classic style of Hawaiian sculpture, and its influence was certainly felt by carvers of nontemple images. Similarities in posture, articulation, form, and surface treatment are reflected in many of the *akua kā'ai, 'aumakua,* and support figures.

The main features of the Kona style are an increased head size and hair elaboration, faces dominated by snarling mouths and extended nostrils (there are no underlying bone structures, cheeks, foreheads, or chins), parallel grooves to represent beards, and eyes dislocated into the volume of the hair. Body and limbs are simple elliptical or conical volumes finished by parallel adz faceting. The body units are clearly defined and separated, knees are flexed, calves are heavy. There is a sense of tensed muscles and aggressive power (figures 8, 9, 18). It cannot be assumed, however, that all of these features were invented for use with the Kona images. That some of the elements were in use at the time of discovery is proven by two sketches made in 1783 by Laura Stone in London from specimens that were then in the Leverian Museum. (The drawings are reproduced in Force and Force 1968:79.) It is almost certain that these images were collected during Capt. James Cook's third voyage in 1779, when the islands were discovered. One of these sketches shows an *akua kā'ai* with eyes that are located in triangular units within the headdress. It is not significantly different from the Kona-style *kā'ai* images collected during the 1820s. The other sketch appears to be of a temple image with a heavy cylindrical headdress, of which the lower side units curve down to the shoulders. Although it is not a Kona-style head treatment, this feature approaches the stylization of the downward-sweeping hair design of the Kona images. Elements and special features of a number of the image types, such as the *akua kā'ai,* the post images, and temple forms, were refined and standardized in the Kona style, particularly in the distinctive and elaborate head pattern. Although there is no direct evidence for it, the contact with Europeans and the introduction of iron tools may have contributed to the change in sculptural style.

Only twelve obvious examples of the Kona style remain today, six of which

35 *Heiau* at Kailua. Engraving by Jacques Arago. This engraving by
Jacques Arago, who visited Hawaii in 1819 as the artist of the French
exploring expedition on the ship *Uranie*, shows a temple in temporary
disrepair. The *heiau* were reconditioned prior to periodic dedica-
tions or for special occasions requiring communication with the gods.
(*Iles Sandwich, Vue du Morai du Roi a Kayakakoua [Kailua]. Sur l'ile
Owhyhi [Hawaii].* Arago et al. 1825: pl. 87.)

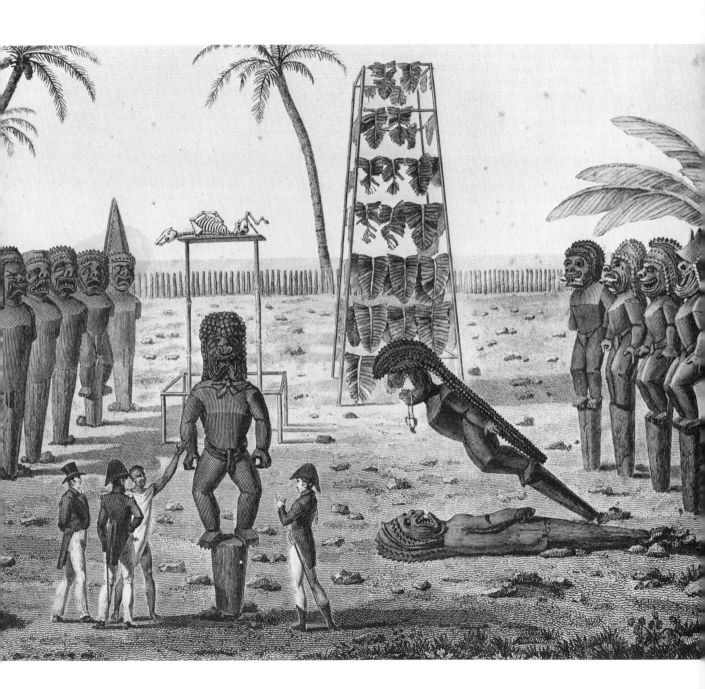

36 Images. Drawings by Louis Choris. Louis Choris, draftsman for the Von Kotzebue expedition in 1816, made a number of sketches at Kailua, Kona, Hawaii. They include several portrait sketches, views of Ahuena *heiau* (figure 4), and these drawings of thirteen separate images. The images were probably in, or associated with, the Ahuena *heiau,* although none of them are recognizable in his general view of the temple. Seven of the images (a, b, c, d, e, f, h) are of the Kona style or variations of it. Two (l, m) may not be temple images but of the *'aumakua* type, similar to figure 13 and figure on p. 15. Apparently none of the images sketched by Choris survived the abolition of the *kapu* system in 1820. The original drawings are at the Honolulu Academy of Arts (nos. 12,151 and 12,152).

a, b/f/j, k c, d, e/g, h, i/l, m

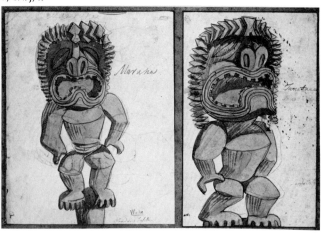

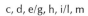

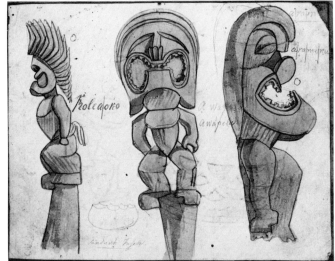

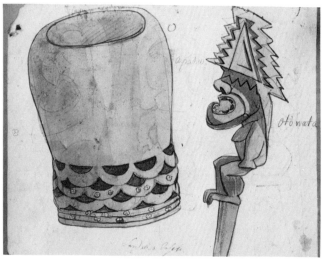

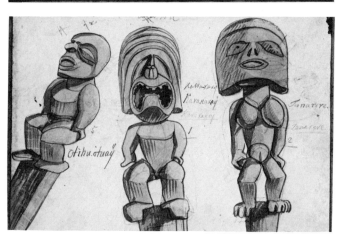

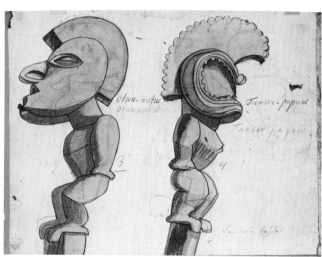

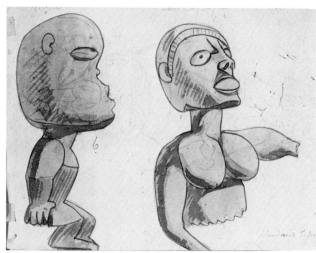

are temple images and six *akua kā'ai*. Although the origin of all of them is not known, there is sufficient information to indicate that they are from the Kona area. Records of the collectors of some of the images and drawings by the artists who visited the Kona coast—Louis Choris (1816), Jacques Arago (1819), and the Reverend William Ellis (1823)—clearly establish that this style was localized and flourishing in that area during the early 1800s, the final years of Kamehameha's reign (figures 4, 35, 36, 43). John Webber and William Ellis (the surgeon) made drawings of thirty images in 1779, well before Kamehameha's rule, seventeen of which were made in the Kona district. Although evidence from Ellis's drawings is inconclusive, for he was clearly an amateur artist, none of the images shown are of the Kona style. Hence, the suggestion that the style had not yet developed.

Akua kā'ai *Images*

The term *akua kā'ai* refers to what are usually called stick images (figure 37). Peter Buck's name for them is "images with pointed props" (Buck 1957:478). The term *kā'ai* is used here because there are a number of references to *akua kā'ai* by early Hawaiian authors, always referring to what seem to be portable images; however, there are no definitive descriptions of the images. *Kā'ai* means sash or girdle; a sennit container for the remains of a chief; a protective cloth wrapped around an object; or to bind, tie around. In reference to the images, *kā'ai* could possibly refer to the *malo* or other clothing that was always ritually applied to an image when it was in use. The tapa is still in place on some images; but since tapa was applied to all types of images, this is an unlikely explanation for the special name. Two of the *akua kā'ai* also have fragments of sennit or other cord tied at the feet, but this is too rare an occurrence (two out of forty-five) to suggest that it was a widespread practice that might account for the name; however, it may have some relevance to the question. A good many of the *akua kā'ai* have notches or other ringlike patterns on the shaft (figure 38). This shaft or prop has been cut off of many of the images, probably by the collectors, so it is not possible to say how many of them originally had the notch pattern, but the percentage was probably fairly high. It is suggested that this tradition of notching the support is the key to the term *akua kā'ai,* and that this type of image (though probably differing in some details from present ones) was of ancient origin, with possible antecedents in southern Polynesia.

It is well known that feathers have a special significance in Polynesian symbolism. The proper kind of feather used in the right way was believed to hold the very essence of sacredness. The reason for this belief is obscure. Is it because of the ethereal nature of birds? The magic of flying? The mystery of space? The question dips into remote and unknown areas of primal meanings.

37 *Akua kā'ai* images. These three *kā'ai* images indicate the range of style within this type. The head within an enclosing crescent, at right, is a unique treatment. Originally, the top element continued forward in front of the head and was topped with a slotted crest. Heights of figures: left, 10½ in; center, 5¾ in; right, 9¼ in. Bernice P. Bishop Museum. Cat. nos.: left, K27; center, K12; right, K15.

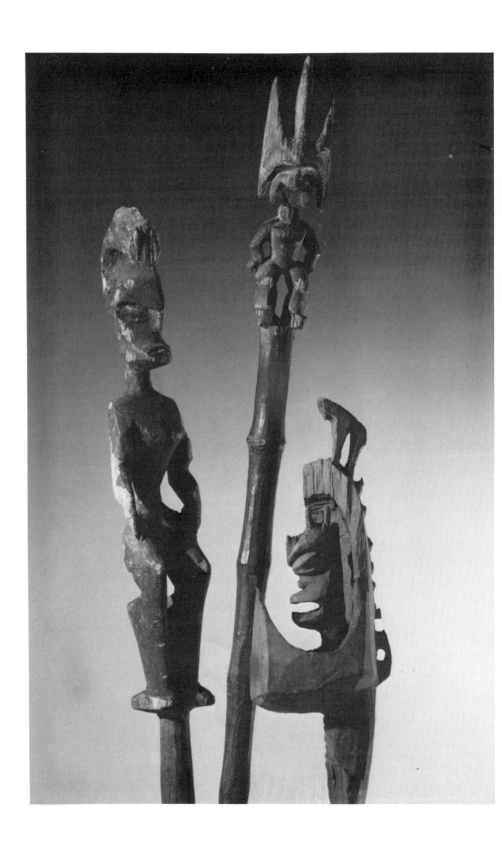

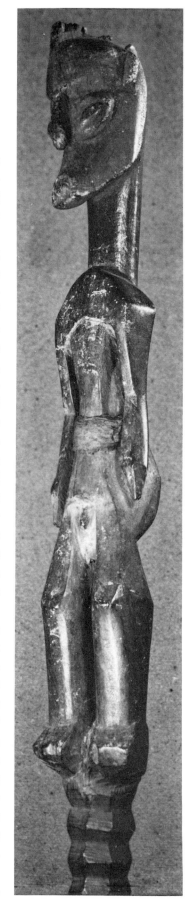

The god-spirit, represented by red feathers, was symbolically bound to the earthly realm by ritual. Physically this relationship took three actual forms—feathers, fiber, and wood. The wood (or stone, or bone), a solid physical presence symbolizing man, was bound to the sacredness of the feathers by fiber cordage, a spirit lifeline, an umbilical cord from the gods to man.

This arrangement of elements, or variants of it, can be found throughout all of eastern Polynesia. The existing examples are relatively recent, as are the Hawaiian images, and are end products of long and independent developments. The *to'o* of Raiatea and Tahiti is the classic example. It is a shaft of wood completely bound within a casing of fiber, with the outer cords sometimes suggesting human features. On this base red feathers were tied. The *to'o* was a symbol of the god 'Oro-rahi-to'o-toa (Great-'Oro-of-the-toa-image), the principal god of Tahiti and the tutelary deity of the Areori society (Kooijman 1964:112). Other examples of similar assemblages are the various staff gods, slab gods, and tapa and fiber gods of the Cook Islands, all of which are basically supports for feathers. The Cook Island staff gods are striking achievements of wood sculpture. They are of ironwood, from two to thirteen feet in length, with a head carved at the top, and a series of small figures carved along the shaft near the head and near the lower end, which is a phallus. The carved forms are highly stylized and usually beautifully finished. The center of the shaft was left plain. Feathers were attached at various places on the image, which was then wrapped with tapa bound on with fiber. Much of the intricate carving on the slab and on other wooden gods of the Cook Islands is figurative but is designed specifically to accept cords that hold the feathers (see Buck 1944:316–379).

The only true god image of the New Zealand Maori was the god stick, a wooden shaft about a foot long with a human head carved on top. The shaft was carefully bound with cord, often in intricate and regular, crossing, diagonal patterns. Feathers were invariably attached to this cordage (Barrow 1961:218). These Maori god sticks are the closest in form to the Hawaiian *akua kā'ai*. With this similarity noted, the notch patterns on the sticks of the *kā'ai* images can be more easily explained. One Hawaiian image (figure 39), which was at the Staatliche Museum in Berlin but is now unfortunately lost, had on its base support a carved pattern that was a clear representation of cordage lashing. Since the Hawaiian carver had no compulsion or inclination merely to decorate surfaces, this and the simpler shaft patternings on the *kā'ai* images must have a more pregnant origin. These notches, rings, and node patterns are echoes of cord designs, a survival from a distant and probably forgotten relationship of forms, and also the source of the term *kā'ai*.

If the *ka'ai* images have their roots in central Polynesia—along with the slab-

38 *Akua kā'ai* image. The notched, or noded, staff is a typical feature of many of the portable *kā'ai* images. This image was found on Puukohola *heiau,* Kawaihae, Hawaii. Height of figure: 4¾ in. Bernice P. Bishop Museum. Cat. no. K14.

Below, right: *Akua kā'ai* image. This is one of the smallest of the figure carvings. The crest is a representation of an *ali'i* warrior's feather helmet. Height of figure: 3⅞ in. Bernice P. Bishop Museum. Cat. no. K25.

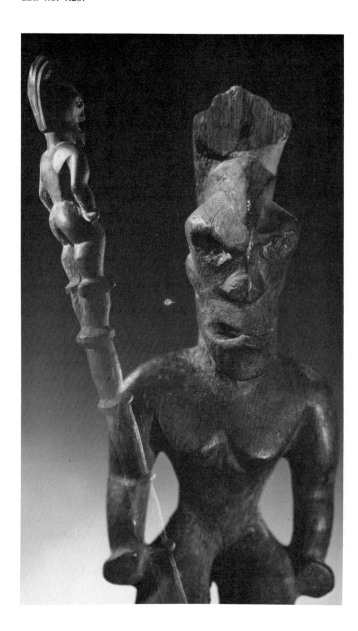

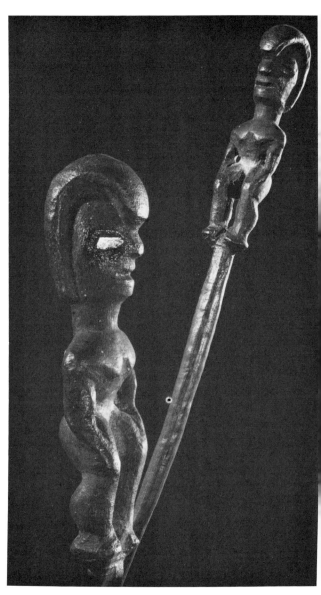

type temple image—they could have been the forerunners and models for the sculptured style of monumental temple images, rather than the opposite, as is generally assumed. This, to some extent, would also help to explain the two rather distinct styles in temple images—the slab and the sculptured post. They each seem to have had separate antecedents; the slab images developed from the upright stone seats, and the sculptured post images from the wood, fiber, and feather images. The symbolism of the three elements—feathers, fiber, and a permanent solid (especially the reference to fiber or cord)—may also clarify the meaning of some other Hawaiian forms and practices, such as the sennit caskets for the bones of chiefs (pa'a i ke kā'ai), the 'aumakua image with a sennit skirt (figure 13), the feather images (sometimes called akua kā'ai) (figure 42), the ceremonial cutting of the navel cord of images, the tying of tapa streamers to images, and the sacred royal girdle (made of fiber and feathers and inset with human teeth).

The distinguishing characteristic of the kā'ai images is their generally small size; the figures (not including the shafts) range in size from three to twenty-four inches. They are not freestanding—the feet are continuous with the shaft. In this as well as in many other respects they are like the temple images. The shaft allowed them to be easily carried and to be stuck into the ground or into the wall thatch at the household altar. Otherwise, style characteristics specific to the akua kā'ai are not readily separable from those of the other types of images. Variations in form treatment are quite wide, noticeably in the heads and faces, where the distinctive personality of each piece is established. The sculptural quality of the ka'ai images is by no means uniform, but it can be said that in the best of them the sculptors have shown a concern for the refinement and finish that is somewhat less frequent in the 'aumakua type and does not occur in the temple images. The small scale and the type of hardwood usually used naturally fostered this formalistic attitude and possibly stimulated many of the inventive variations. The craftsman could turn and hold the work in any position in order to carve difficult areas, and in doing so he could examine and refine form relationships, which on a larger scale might have been of less concern. Surface finish was clearly an important factor, and the surface faceting of the sculptured volumes, when used, seems to have been developed to some extent as a stylization of form rather than as a means of producing form (figures 8, 9). As compared to the temple images, the original shape of the wood presented fewer limitations to the sculptor, and there were no time limits for carving dictated by the schedules of temple rituals.

It is not possible to say whether or not the unusual features and configurations in some of the akua kā'ai are due to creative inventiveness or to specific

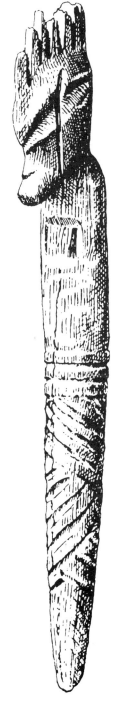

39 *Akua kā'ai* image. This image was in the Museum für Völkerkunde in Berlin, but has been lost. The support was carved to represent cord lashing around a staff, relating it to the god sticks of the Maori of New Zealand, which were so wrapped. The occurrence of cord designs on Hawaiian sculpture presents a possible explanation of the notch patterns on the supports of many of the portable images. (Barrow 1961: fig. 4. The drawing was originally published in Behm-Blancke 1955.) Cat. no. A.

40 *Akua kā'ai* image. This image may be intended to represent a chicken or a lizard *'aumakua*. The comblike crest, which has been broken off, is a common form for many images, and the curving shape of the head is similar to the *lei niho palaoa*. Height of figure: 5½ in. Bernice P. Bishop Museum. Cat. no. K16.

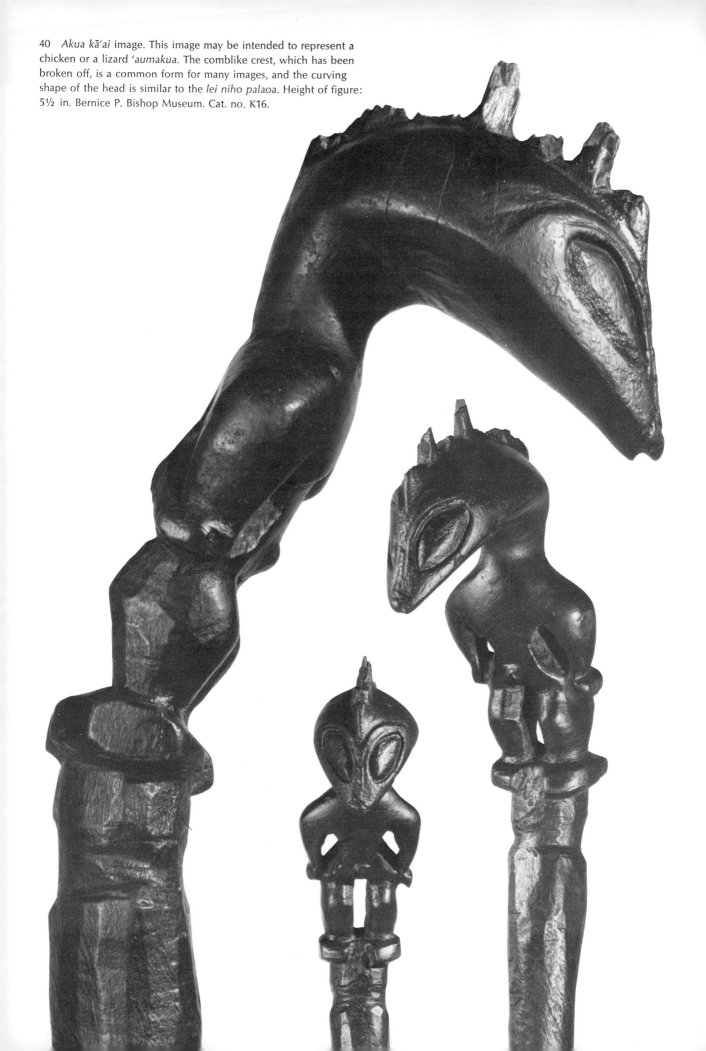

41 *Akua kā'ai* image. The hunker posture is rare in Hawaiian sculpture, although it occurs in the petroglyphs and in stone relief carving. The single forearm, without connection to the shoulders, is also an unusual feature. Height of figure: 7½ in. Bernice P. Bishop Museum. Cat. no. K17.

87

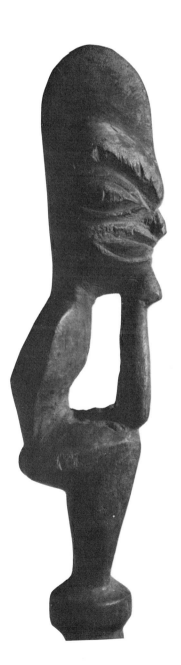

intentions related to meaning. In about 1835, David Malo wrote on this subject (1951:83):

The only gods the people ever saw with their own eyes were the images of wood and of stone which they had carved with their own hands after the fashion of what they conceived the gods of heaven to be. If their gods were celestial beings, their idols would have been made to resemble the heavenly.

If the gods were supposed to resemble beings in the firmament, birds perhaps, then the idols were patterned after birds, and if beings on the earth, they were made to resemble the earthly.

If the deity was of the water, the idol was made to resemble a creature of the water, whether male or female. Thus it was that an idol was carved to resemble the description of an imaginary being, and not to give the actual likeness of a deity that had been seen.

Meaning, then, may have determined some of the variants, such as the lizardlike or birdlike head (figure 40), the images standing on a second head, or the figures in a crouched position with hands at the chin (figure 41)—the only occurrence in Hawaii of figures in this posture except for rare instances in petroglyphs.

It is generally assumed that the portable images functioned primarily on a personal and private level, and that they indicated a set of individual values and practices reflecting those publicly ritualized in the imposing temple cult. However, the use of the *akua kā'ai* was not always a private affair, although the images were privately owned. At two points during dedication of a *luakini heiau*, the *kā'ai* images were brought into use. Those belonging to the chiefs of the district were carried to the *heiau* by their keepers. The images were tied with tapa streamers and the keepers sat holding the images aloft during a lengthy chant. The keepers then formed a line while a naked man representing the god Kahoali'i ràn in a circular course, followed by the keepers carrying the *kā'ai* images. They stopped in front of the *kahuna*, who recited a chant that assigned the land to Ku and ratfied its control by the chiefs. Toward the end of the *luakini* ceremony it was required that the governing powers of the supreme chief be confirmed and sanctified by the successful completion of a special ritual. This event was followed by another use of the *kā'ai* images in which they were carried in a procession to the mountains to procure branches of *koa* trees for building a small house on the *heiau*. On the return from the mountains, the group set up a great noise and uproar, just as they did when the principal image was brought to the *heiau* (see p. 61). In this instance, the *kā'ai* images seem to have functioned as substitutes for the temple image. On the following morning, the *kā'ai* images were taken to the beach and set into the sand while the priests, chiefs, and commoners bathed in the ocean.

An occasion is related by Malo where the *akua kā'ai* of a young chief might

42 Feather image and other objects. Engraving by John Webber. The fiber and feather images were apparently a special type, symbolizing the personal 'aumakua god of King Kamehameha's ancestors. This god was usually called Ku-ka'ili-moku. On the image drawn by Webber, the basketry fiber base is covered with brilliant red feathers except for the crest, which is yellow. The sculptural relationship to some of the crested wooden images can be seen, particularly in the open structure of the upper part. This image is now in the British Museum. (*Various Articles*, at the Sandwich Islands. Cook 1784, Atlas: pl. 67.)

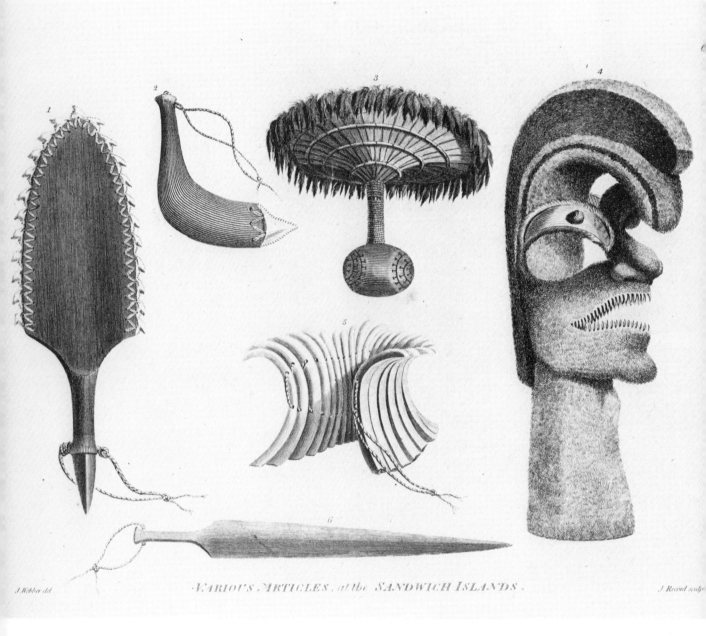

VARIOUS ARTICLES, at the SANDWICH ISLANDS.

act as a fertility god to ensure that an heir would be born (1951:135). Preparations for the ceremony were made by setting up a tapa shelter in an open area, and, after a period of confinement, the young couple was brought together:

When the princess had recovered from her infirmity and had purified herself in the bath, she was escorted to the tent made of *tapa* which had been set up in an open place in sight of all of the people.

To her now came the prince, bringing with him his *akua kaai*. This *akua kaai* was set up outside the tent, where the multitude of people were keeping watch, and the assembled priests were uttering incantations and prayers that the union of the two chiefs might prove fruitful.

A chief's *kā'ai* image was carried into battle by a custodian who enjoyed special immunity from the enemy because of the sacred nature of his task, although his chief might be killed and the image captured. The *akua kā'ai* of paramount chiefs were not carved. They were sculpture modeled in basketry over which netting was stretched to which precious red feathers were tied to cover the surface in much the same fashion as on feather cloaks. Some features of the image face and head were indicated by contrasting black feathers, pearl shell, dog's teeth, and human hair. By this special technique the *akua kā'ai* of paramount chiefs were made to be distinguishable from all others (figure 42). Several *kā'ai* images have been found in caves with burials, and three were taken from the royal mausoleum at Honaunau. Their function in relation to burials is not entirely clear, but those at Hale-o-Keawe were considered to be guardians of the remains of the chiefs and were probably the personal gods of those chiefs during their lifetime. Burial with them had connotations beyond that of being simply valued personal possessions placed in the grave out of respect. The practice was not confined to *akua kā'ai*; both feather images and *'aumakua* images have been found with burials. In 1823, the Reverend William Ellis visited Honaunau and described the interior of Hale-o-Keawe, which is shown in figure 43 (Ellis 1963:112):

We endeavoured to gain admission to the inside of the house, but were told that it was tabu roa, (strictly prohibited), and that nothing but a direct order from the king or Karaimoku could open the door.

However, by pushing one of the boards across the doorway a little to one side, we looked in, and saw many large images, some of wood very much carved [figures 32, 33], others of red feathers with distended mouths, large rows of sharks teeth, and pearl-shell eyes [figure 42].

We also saw several bundles, apparently of human bones, cleaned, carefully tied up with cinet made of cocoa-nut fibres, and placed in different parts of the house, together with some rich shawls and other valuable articles, probably worn by those to whom the bones belonged, as the wearing apparel and other personal property of the chiefs is generally buried with them.

43 Hale-o-Keawe. Engraving by the Reverend William Ellis. The drawing for this engraving was made in 1823, which was three years after the abolition of the *kapu* system and the destruction of *heiau* and images. This site, because it was the burial place of the Keawe kings (Kamehameha I's ancestors), was still under *kapu* and was fairly intact. At least seven of the images now in existence were collected from inside the house on this *heiau* by members of the Andrew Bloxam party in 1824. (*The Depository of the Kings of Hawaii, adjoining the Place of Refuge at Honaunau.* Ellis 1827: pl. 84.)

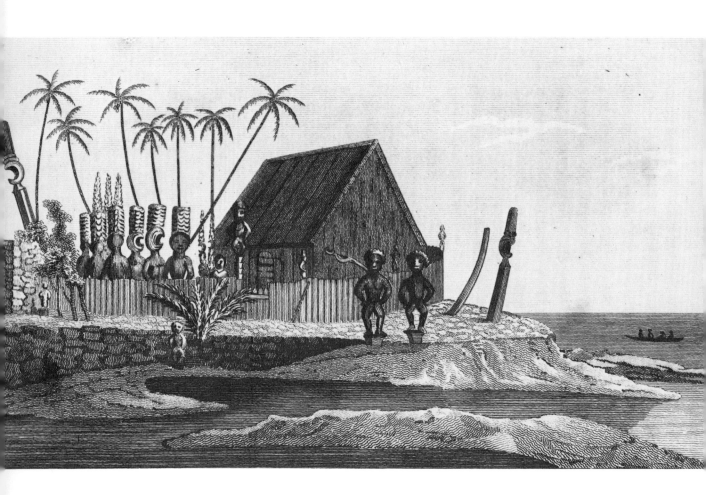

44 Lono image. The god Lono-i-ka-makahiki was symbolized by a
tall staff with a crosspiece secured near the top, from which tapa,
feathers, and other materials were suspended. The image was carried
in a ceremonial procession beginning the annual *makahiki*. A similar
image representing the god of sports (*akua pā'ani*) overlooked the
sport's arena during the *makahiki* (see figure 45). This is the only
remaining example of this type of image. The depression and ring at
the neck supported the crosspiece. Length of pole: 10 ft 2 in; height
of head: 2¾ in. Bernice P. Bishop Museum. Cat. no. K1.

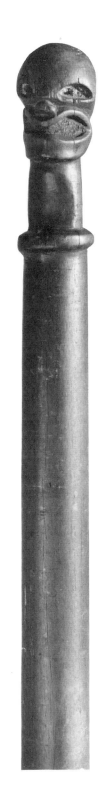

Ellis was apparently not able to see the small wooden *akua kā'ai* that were
removed two years later by the Bloxam party.

Makahiki *Images.* Three types of portable images were used during the
makahiki season, a period of three months when all war was suspended, as
were the strict observances to Ku and Kane. There were feasts, secular danc-
ing, athletic contests, and tribute collections. The images were featured in a
procession that made a circuit of the island, at which time property that was
levied by the chiefs was assembled at the land boundaries. The major image
was the god of the *makahiki*, Lono-makua, also called *akua loa*, or long god
(figure 44). *Akua pā'ani*, god of sports, was of the same kind, a long pole with
a crosspiece at the top from which tapa and feather streamers were hung.
One of these is shown in a lithograph by John Webber (figure 45). It was set
up, after completion of the procession, at the sports area overlooking the vari-
ous contests and games. The third image used in the procession was *akua
poko*, god of a small land division, or "short" god. This was no doubt a small
image with a shaft for carrying, an *akua kā'ai* (figures 8, 9). There must have
been a number of these small images used during the circuit, at least one for
each land division, representing the chief of each area. It was carried in the
procession only as far as the boundary of the district and then returned,
probably to the chief's *heiau*.

It is not surprising that only one example of an *akua loa* remains today,
since the total number in existence at any time was very small. Apparently
only two of this type were used at each *makahiki* festival. They were then
declared *kapu* and put away in a house on the *heiau* to be brought out again
for use the following year. It would have been impossible to identify the one
existing example without the description offered by David Malo in his account
of the *makahiki* (1951:143–144):

The Makahiki idol was a stick of wood having a circumference of about ten inches
and a length of about two fathoms. In form it was straight and staff-like, with joints
carved at intervals . . . it had a figure carved at its upper end.

A crosspiece was tied to the neck of this figure, and to this crosspiece, *kea*, were
bound pieces of the edible *pala* fern. From each end of this crosspiece were hung
feather *lei* that fluttered about, also feather imitations of the *kaupu* bird, from which
all of the flesh and solid parts had been removed.

The image was also decorated with white *tapa* cloth made from *wauke kakahi*,
such as was grown at Kuloli. One end of this *tapa* was basted to the crosspiece, from
which it hung down in one piece to a length greater than that of the pole.

The coincidence of Capt. James Cook's arrival at Kealakekua Bay at the
makahiki season resulted in Cook's being identified as the god Lono. The white

45 Boxing match. Lithograph by
John Webber. The pole with cross-
bar and streamers, at the left, is
the symbol of Lono as the god of
sports (*akua pā'ani*). The boxers are
probably performing postures of a
stylized, taunting dance often per-
formed before a contest. The pos-
ture is evident in many of the
images. (*Boxing Match before Capt.
Cook at Owhyhee [Hawaii] Sand-
wich Islands, Thursday, Jan. 28th
1770 [1779].* A lithograph from an
unpublished drawing by John Web-
ber published by Francis Edwards,
London. The original drawing is at
the Bernice P. Bishop Museum in
Honolulu.)

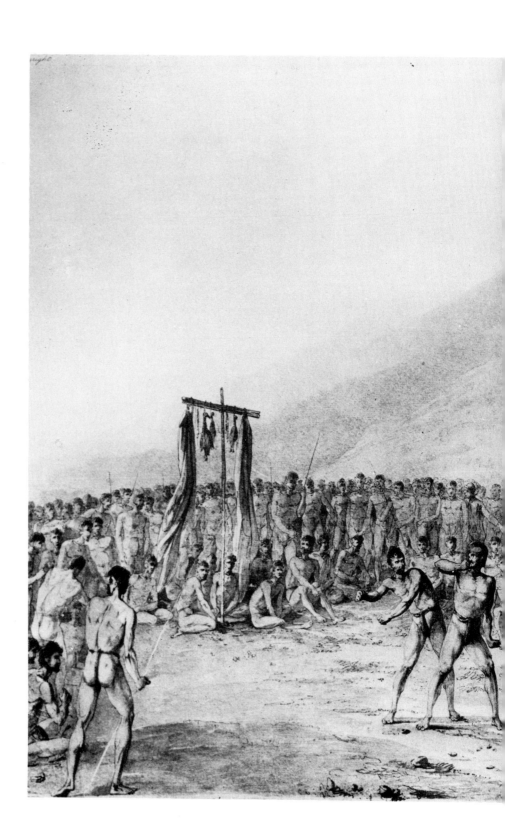

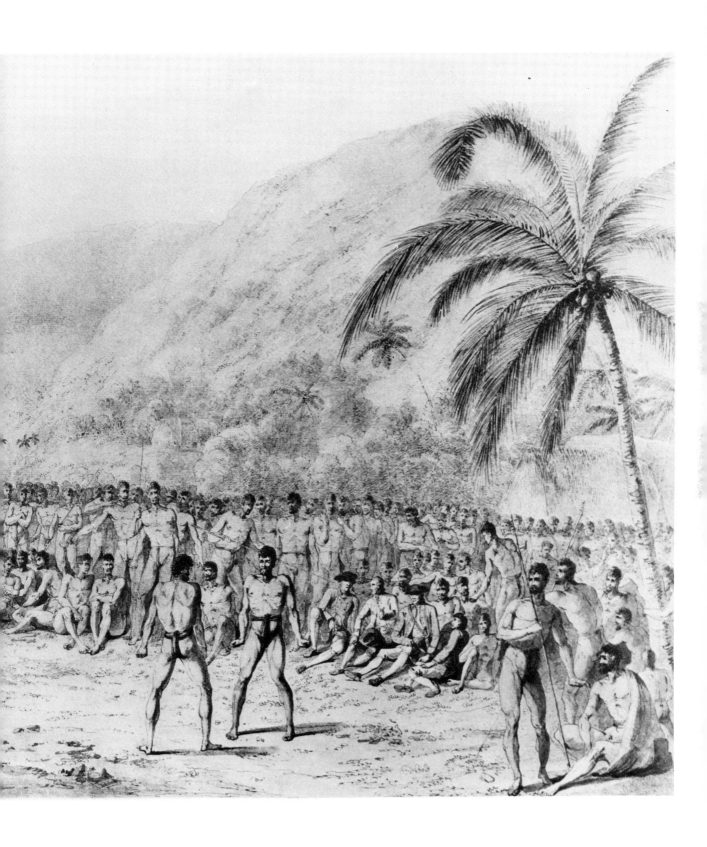

sails of his ship looked much like the *akua loa*, the symbol of Lono, and to the Hawaiian chiefs and priests, Cook was obviously a great chief descended from Lono. He was immediately given the name of Lono and was asked to participate in the ceremonies on the nearby *heiau* (figure 31). When Cook was killed the following year in a skirmish at Kealakekua Bay, his body was quickly moved to a *heiau* and presented to the gods as an offering, just as the body of any great chief slain in battle would have been treated.

'Aumakua *Images*

The *'aumākua* were family or personal gods (figure 46). They usually functioned as protective spirits, but they could also be malevolent if neglected or if used for sorcery. The pattern of the *'aumakua* concept is described by Beckwith (1970:105–106):

Sorcery was commonly practiced through the use of fetishes made in the shape of an image (kii), which was believed to be possessed by the spirit of a powerful ancestor, or perhaps by a nature spirit, who was worshipped for the purpose of bringing the mana of the god under control of its keeper. Or, the bones of a dead member of the family might be preserved and worshipped in the same manner. . . . Or the body might be dedicated to some powerful god like the shark . . . or of the mo'o [lizard] . . . or of thunder . . . or of the owl. . . . The body of the dead would then be changed into that of a shark, mo'o, owl, or other form, recognizable to the family . . . and into this body the spirit of the dead would enter. If it was then worshipped by the family, it would take that family under its protection, punishing their enemies and providing them with good things. Such protectors were called aumakua.
 . . . because of the strong sense of family descent, every such god became a link in the chain which bound succeeding generations to the kapus imposed by their ancestral guardians, the aumakua born into the family line. . . . Hawaiian antiquarians insist that the image, animal or object, which the god entered had no power in itself but only the spirit that possessed it. Sorcery began when these possessing spirits were sent abroad to do injury to another.

The typing of this group of sculptures as *'aumakua* images is based upon both morphological and functional criteria. The main characteristics of form that set them apart are their size, being intermediate between the *akua kā'ai* and the temple images, and the fact that they are freestanding, that is, not connected to a support post. As to function, the *ka'ai* images could very well have been used as focal points for *'aumākua* or sorcery spirits. The interchange of function is not unlikely since the image was simply an object into which the god could be invoked, and the style of the image itself was not particularly significant in the effectiveness of its function.

There are other characteristics that distinguish the *'aumākua* from the other images. In general they lack the elaborate headdresses, being either bald or having human hair pegged into the head. A number of them have, or had,

pearl shell set into the eyes. The mouth is always open and often jutting forward with the tongue protruding. In some, teeth, real or simulated, are set into the mouth. It is in these *'aumakua* images that the jaw-mouth-tongue complex is abstracted to approximate the *lei niho palaoa* form. The *'aumakua* type is the only group in which there are images that can be clearly determined as female figures. Actually, most of the images of all types are without sex, although it is probable that they were usually thought of as male.

A certain degree of realism prevails in most of the *'aumakua* images in spite of the striking exaggerations and distortions of some of their elements. The combination of these two traits, realism and distortion, certainly increases the vitality of the sculpture and enriches its sense of life. The figures are distinctly aggressive, not only in a representative way through posture and facial expression, but also in an abstract way by the interaction of the various elements, such as the way the forms reflect and modulate the light through subtle or abrupt changes in surface direction, or in the lineal counterthrusts along the contours, or by a kinesthetic empathy with the contraction and expansion of volumes (figure 48).

The realism sometimes comes through as near portraiture, as though the sculptor had a particular individual in mind. However, in one way or another even the most naturalistic of the images go beyond a mere reflection of reality (figure 54). Possibly it is the extent to which they diverge from naturalism that is an indication of their supernatural force. Or, could it be that the more distant the ancestry of the *'aumakua*, the more abstract the image (figure 14)? Does abstraction equate with mana? It seems to have in the temple images, where the central and principal image, through which the mana of the supreme god Ku became available, was more elaborately carved than the others.

A formalism, similar to that evident in the *kā'ai* images, gives the *'aumakua* figures an appearance of anatomical completeness even though the elements of anatomy are simplified and abstracted. This quality is suggested partly because of the thoroughness of surface manipulation, especially at the junction of forms. Skeleton and muscle exist, not as they do in nature, but as intuitive solutions to sculptural problems. Consequently, the forms are convincingly real because the "skin" appears to be stretched over a logical understructure (figure 13).

In only two *'aumakua* images is there evidence of adz faceting. Generally, the surfaces have been ground to a fine-grained finish. Some have been rubbed with oil. The arbitrary or abstract form and the polished surfaces almost negate the wood as a medium. There is little truth in the idea that the Hawaiian sculptor consciously or unconsciously exploited the so-called natural

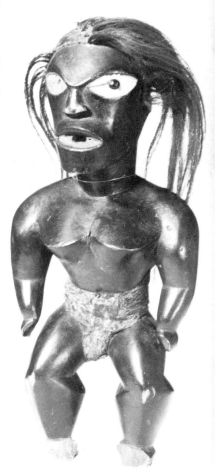

46 *'Aumakua* image. This image is a striking example of the sense of potential action inherent in a posture probably abstracted from the *hula ku'i Moloka'i*, the athletes' dance. Here the figure is formed by a series of upended conical volumes. The axes of the cones expand upward and shift direction in space at each articulation point, with the result that the defining elements—light, surface, volume, space, and contour—are in a state of flux. Height: 16 in. British Museum. Cat. no. A19.

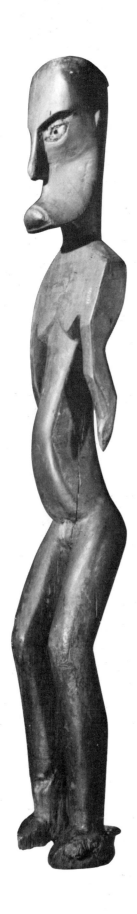

47 'Aumakua image. The elongated body style and curiously articulated arms of this image are both atypical features in Hawaiian sculpture. Height: 38 in. Bernice P. Bishop Museum. Cat. no. A16.

qualities of wood. These qualities, whatever they may be, seem not to have entered into the considerations. Such incidental factors as the shape of the original log, grain pattern, color, texture, and the position of knots and cracks were ignored in the process of structuring the volumes. A fairly complete conceptualization of the form existed in the mind of the sculptor before the work began, and as the carving proceeded the final configuration of the volumes took precedence over all other considerations. Meaning was achieved through form, not through surface appearance. This is, of course, the nature of a formalist attitude in sculpture.

Even when the exterior dimensions of the wood were limiting, the directions of the carved volumes were devised to activate the limited space. This space restriction, along with the sculptors' penchant for the countermovements of parts, resulted in a few examples of a curiously misjointed, unrhythmic, and awkward articulation, often accompanied by the use of angular, flat-surfaced volumes (figures 14, 47). The source of this characteristic is easily traceable to the wrestlerlike postures of the typical round-volumed sculptures. This minor style variation appears to be a symbol for actual body movements, a method used by some less proficient sculptors as a substitute for the dynamic form movements of the usual Hawaiian style.

The nature of the beliefs in 'aumakua spirits seems to have required a physical object as a focus for the ancestral or deified spirit. The objects took many forms, such as animals or even persons; and inanimate things such as a stone, a gourd, the remains of an ancestor, or a carved image were widely used, for these things could be kept in the household and were available when needed. 'Aumakua worship is an ancient practice that prevailed in all levels of society. The carved images, however, could only have been in the possession of families of considerable rank, wealth, and power. They were kept at an altar in the men's eating house, or, in the more affluent households, in the heiau, a separate house for private worship.

Occasions for bringing the image into use were no doubt numerous, some probably following a regular schedule. However, there are only three or four events in which the use of images is specifically recorded. When a male child was to be weaned, he was removed to the men's eating house, where a ceremony was performed establishing the eating kapu for the child, after which he could no longer eat with women. A pig was baked and consecrated, and the head was set on the altar as an offering to the deity. An ear of the pig was placed in a gourd suspended from the neck of the image, the gourd being the symbol for the god Lono. The father then presented bananas, coconuts, 'awa root, and 'awa for drinking to the image, and recited a chant to Lono, Ku, Kane, Kaneloa, and the 'aumakua. A very similar ceremony was performed

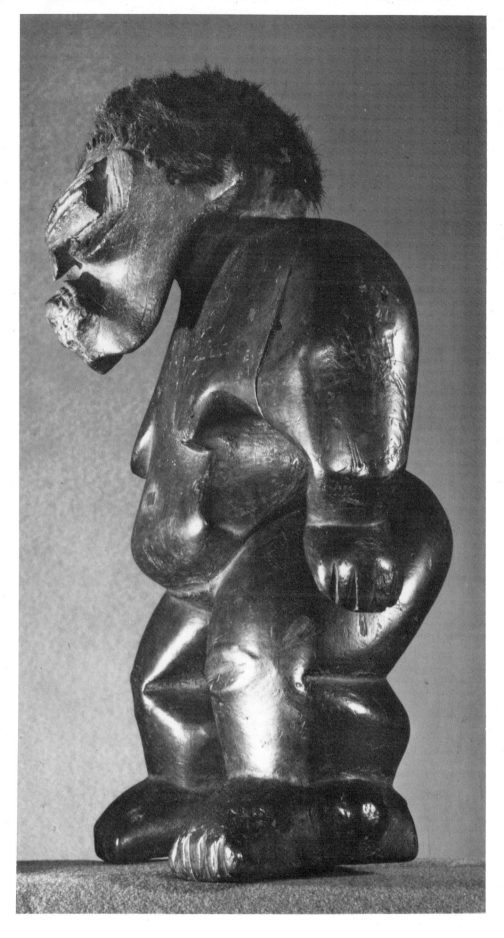

48 (left and page 98) Sorcery image. This image is called "the poison god Kālai-pāhoa," a term referring to a supposedly poisonous wood out of which the first sorcery images were made. Small pieces of the *kālai-pāhoa* wood were used in black magic. This is one of the most powerful and dynamic of the Hawaiian images. A rectangular cavity in the back for holding the sorcerer's magic material has holes at the side for attaching a cover. Height: 14½ in. Bernice P. Bishop Museum. Cat. no. A4.

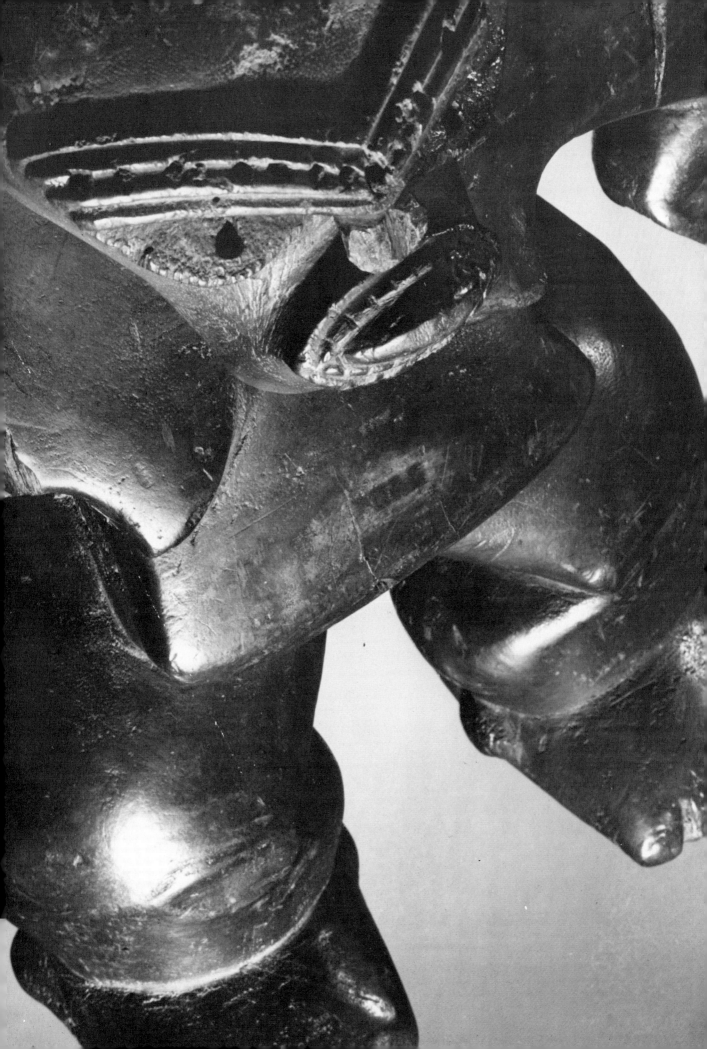

following the circumcision of a child. Offerings of food were placed before the image and a chant was given. If the child was an *ali'i*, the ceremony was more exacting and elaborate, and was performed by a *kahuna* rather than by the father.

David Malo describes activities following the harvest of a crop in which a ceremonial fire was lit and a feast prepared for the community (1951:207). After the food was baked in an underground oven, the people sat in a circle and the food was divided among them. An *'aumakua* image was set up in the center of the circle and the gourd of Lono was hung from its neck. Food was offered to the gods by placing a token of it in the gourd. After this ceremony of fire lighting and offerings to the deity, the produce of the fields were free from *kapu* and could be eaten without repeating the fire ceremony. With each oven of food prepared thereafter, the farmer, before eating of it, would place a bit of potato or taro on the altar in front of the image.

Sorcery 'Aumakua Images. Several of the *aumākua* have a hollowed out cavity in the middle of the back. It is generally assumed that this designates the figure as a sorcery image, the pocket being for the purpose of holding some object associated with the intended victim of sorcery. A bit of fingernail, hair, scraps of clothing, bits of discarded food, or excreta placed in the cavity would give the sorcerer a means of directing the spirit of the *'aumakua* image to bring sickness or death to the victim. On the other hand, the cavity may have also been used to hold some object that represented the source of mystical power from the sorcery deity that charged the image with supernatural potential. It is impossible to designate which of the existing images of any type were used in sorcery and which were not. For instance, it is said that all war gods named under Ku, such as the feather images, were ultimately regarded as gods of sorcery and were invoked to bring death to the enemy (Beckwith 1970:29). The cavities in the *'aumakua* images were possibly just an added convenience as a container for the mana-charged objects, and not actually vital to the sorcerer's practice, or they may have been used for less sinister purposes, such as for containers for offerings to the *'aumakua* gods, similar to the function of the gourd of Lono.

The gods of sorcery were many, but the most famous is Kālai-pāhoa (carved-with-a-sharp-stone), the sorcery god of Molokai, the island that became notorious for the power of its sorcery *kāhuna*. When Kamehameha overthrew the Oahu chiefs and came into control of Molokai, then under Oahu rule, he took the greatest of care to confiscate the *kālai-pāhoa* images and their keepers in order to gain control of the mana of the sorcery gods. There are a number of versions of the story of the origin of the *kālai-pāhao* images, the most com-

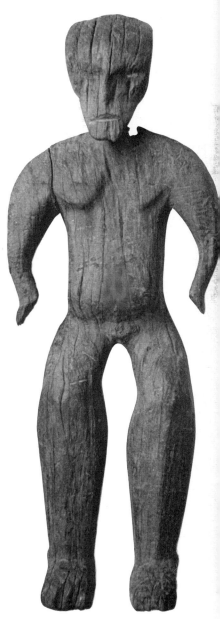

49 Sorcery image. This image, one of several that have been called *kālai-pāhoa*, was probably used as a focal point for a sorcery spirit. There is a hollowed-out recess in the back in which was placed a magic fetish object associated with the victim. Height: 16¾ in. Bernice P. Bishop Museum. Cat. no. A13.

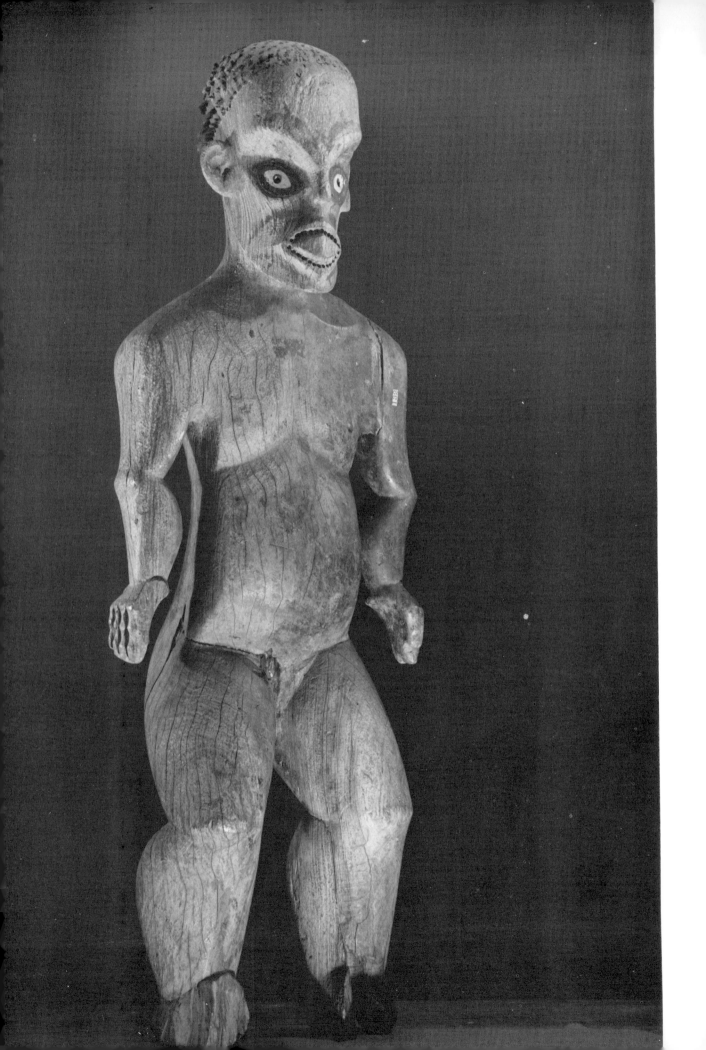

50. Sorcery image. As in the other sorcery images, this figure has a hollowed-out recess in the back. It is called *kālai-pāhoa,* a designation that is common to the sorcery *'aumakua* images. The white of the eyes is a paperlike material, probably tapa. Lizards, representing tattoo designs, are painted on the forehead, cheeks, and chin. Height: 36 in. Bernice P. Bishop Museum. Cat. no. A9.

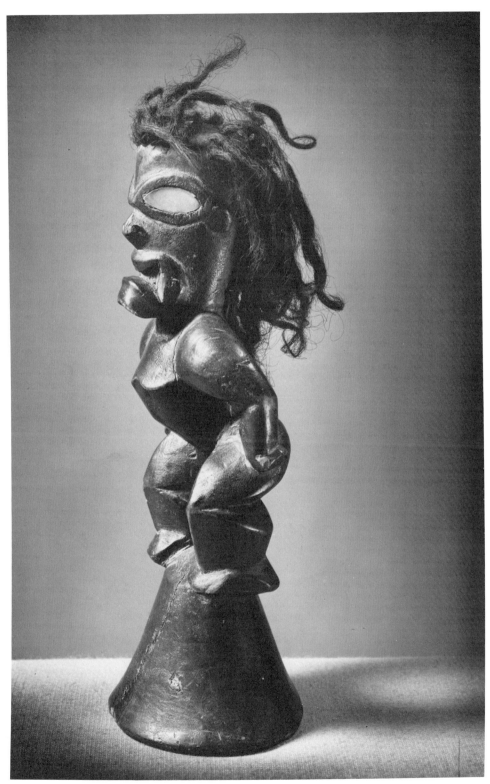

51 Sorcery image. This is an *'aumakua* image that may have been used for sorcery. As in one other image (cat. no. A11), the cavity for the sorcerer's magic material is in the head instead of in the back of the torso as in the other *'aumakua* images of the sorcery type. It is unusual also in that it is on a pedestal and the hands are connected to the thighs, features which are common only in the *akua kā'ai* and temple images. Height: 10¼ in. Private collection, London. Cat. no. A24.

'Aumakua image. In general style this image is similar to the
other female figures, but it is more crudely carved, lacking the refined
definition and clarity of form of the others. Height: 27 in. Bernice
P. Bishop Museum. Cat. no. A10.

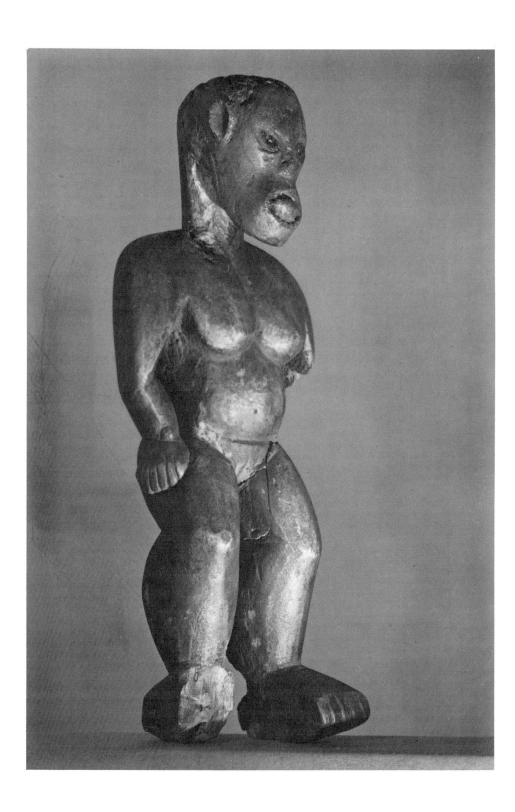

plete being given by the native Hawaiian historian, Samuel Kamakau (1964: 128–138).

It is said that a man of Molokai named Kama-'ai-kama, in a vision or dream, saw the god Kane (Kane-i-kaulana-ala), accompanied by other gods, cause a grove of trees to appear at Maunaloa on Molokai where none had been before. Kane then directed two of the gods to enter two of the trees while he entered another. The mana of the gods impregnated the three trees, rendering them extremely deadly. The chiefs of Molokai had images carved from the trees, under the supervision of Kama-'ai-kama, who had been told by the god Kane-i-kaulana-ala the proper rituals to control the dangerous mana of the wood. After the carving was completed, all of the chips and remains were thrown into the sea because they were so poisonous that anyone who touched even a fragment would die. Kama-'ai-kama became the keeper of these images but it was not until several generations later that they were used for sorcery The *kālai-pāhoa* images and the *kāhuna* who controlled them were greatly feared. Scrapings of the wood of the images were used as poison. Even objects rubbed against them would become charged with their malignant mana and could become carriers for the sorcerer. Through the proper ritual the image could send a streak of light or a white bird to bring death to the victim.

Three of the *'aumakua* images in the collection at the Bishop Museum are designated in the records as *kālai-pāhoa,* a name that was very likely widely used for images that were thought to have been associated with sorcery (figures 48–51). Each of these images has a cavity in the center of the back. In three other images the container is located elsewhere. A kneeling female image from the island of Hawaii, now in the Museum für Völkerkunde in Berlin, has a cavity at the back of the head that may have functioned as a receptacle for sorcery fetish (catalog number A11). It is recorded that when it was taken into a village near where it was found (c. 1880), the entire village was struck with a plague. The small *'aumakua* image on a pedestal in a private collection in London also has a small rectangular cavity in the crown of the head, a feature that indicates it was possibly a sorcery image (figure 51). An *akua kā'ai* image, named Keoloewa, may also have been a sorcery image (figure 52). Connected to its back is a hollow cylinder that could have been used as a container for the sorcerer's fetish material. A small figure is perched on the rim of the cup. Originally, there were two of these figures, but one has been broken off. Were these the messenger spirits for the sorcerer? Martha Beckwith compares Keoloewa, a goddess of Maui, to Pahalu, the originator of the powerful sorcery *kāhuna* of Molokai (1970:114).

Style

From what is known of pre-European Hawaii, it would appear that conditions were favorable for the development of a unified sculptural style. There was a common cultural background throughout all of the islands and communication between the various local areas was fairly fluid. The islands had been isolated from outside influences for several hundred years. The production of sculpture was apparently extensive and continuous. Nevertheless, there is considerable diversity in sculptural style even within the three types of religious images that are available for study. Some local differences are evident, such as the slab image in the northern islands, due partly to the retaining of an ancient form and possibly to some differences in religious practices. Some style variations are likely a result of the apparent freedom of choice allowed to the sculptors, who, due to their *kahuna* rank, were relatively immune to exterior pressures. The diversity of forms may also indicate a period of cultural change, a re-forming of ideas, particularly concerning religion, that may have been taking place just prior to the discovery of the Islands by Europeans.

The main features of the sculpture were already established, possibly stemming from two sources—an ancient temple slab-type image and some prototype of the portable *kā'ai* image. At the discovery period, there may have been a predominance of the post style in the temple images, but with the fully sculptured type also in use, as were the specialized, towering, notched head crest and the helmet forms. There is some evidence that the Kona-style head pattern for the temple images was a slightly later development. Since the tonguelike *lei niho palaoa* is known to be of precontact origin, the protruding jaw-mouth-tongue form of the *'aumakua* images (from which the *palaoa* form evolved) must also be a precontact form.

The following list of traits found in Hawaiian sculpture more fully defines the characteristics of the style and, by comparison to the sculpture of the human figure in other areas of Polynesia, translates these general traits into the Hawaiian idiom. The elements in the list are not necessarily parallel or analogous since some refer to single units, others to a complex of elements, and still others to relationships between elements. It is necessary also to discuss attributes that can only be sensed in the images. Several of the categories listed refer not to formal elements but to conditions of occurrence or use, and therefore are extrinsic to style in the usual sense.

Traits Unique to Hawaii

Fully three-dimensional form; body parts as discrete units. These characteristics combine to form the classical style commonly attributed to Hawaiian sculpture. The emphasis on three-dimensional volume is implemented by the

52 *Akua kā'ai* image. In this image most of the superior qualities of Hawaiian figure sculpture are evident, particularly in the expressiveness of expanding, dynamically articulated volumes. A small figure is crouched on the edge of a bowllike cylinder connected to the back of the image. A second figure on the opposite edge has been broken off. Height of figure: 12 in. Bernice P. Bishop Museum. Cat. no. K4.

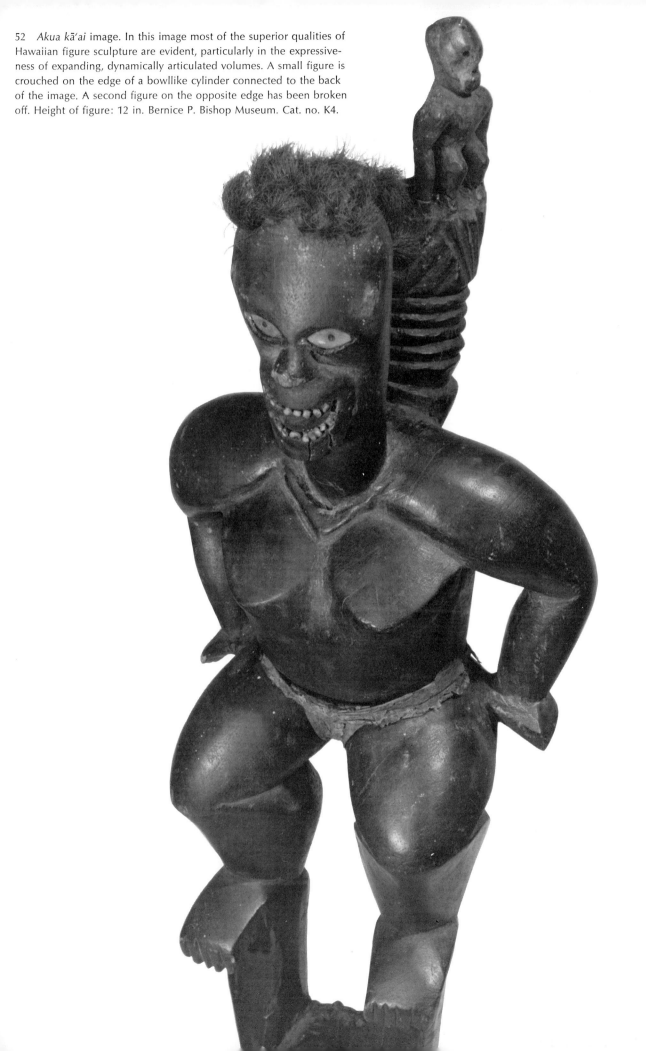

Bowl. The two-figure support system so often used in the Hawaiian bowls is here considerably abstracted. In this unusual example, both figures face away from the bowl with heads and arms thrown back to hold the bowl. The open mouths are small containers for condiments. Length: 38 in. Musée de l'Homme. Cat. no. S3.

manner in which the forms activate the space that they displace. In contrast to the post style, the images are not compressed or restricted by the surrounding space. Both material and space are defined as yielding, flexible, and active media. Volumes are enclosed by rounded, convex surfaces that tend to expand into space, and each separate part, such as a thigh, lower arm, or the torso, exists as a rather discrete unit. The articulating joints, as either ridges or depressions, are clearly defined. The movements and surface rhythms are reinforced by the subtle tensions between the interlocking parts created by the shifts in the direction of the axes in the separate elements against the generally vertical and frontal body axis. These sculptural movements in space account for the feeling of poised vitality that the figures arouse. The expertly finished surfaces, either polished or in facets left by the adz, allow the atmosphere and light to become a sculptural ingredient, defining the structure of the the forms and the space around them. The nearest parallels in other Polynesian sculpture to the surface faceting on the Hawaiian images are found in New Zealand and the Marquesas, where faceting occurs as deeply cut grooves that act as a decorative surface pattern and is possibly related to tattoo design. In Hawaii, the feature is strictly a product of the forming of the volumes.

Elaborate Headdress. At least five distinct forms of headdress occur: flat, patterned panels found in the slab-type images; notched or spiked vertical spires; the helmetlike, forward-curving crest; comblike, vertical spikes; and massive, geometrically patterned hair, sweeping back and down at the sides of the body. These head treatments are found nowhere else in existing Polynesian sculpture. If they have an origin outside of Hawaii, it could be in the towering, feather head ornaments worn by the chiefs of Tahiti, which may have been first symbolized in sculpture in the decorated panels of the slab images.

Protruding Jaw-Mouth-Tongue. This form is confined almost entirely to the nontemple images, and has an obvious connection with the *lei niho palaoa* ornament. Only minor, and almost certainly unrelated, counterparts to this feature occur in Polynesia, such as the *manaia,* the birdlike profile head of New Zealand; the sharp, frontal face ridge of the Cook Islands staff gods; and the pointed, egg-shaped heads of the Nukuoro images. In most of the Polynesian sculpture, except in the west (Fiji, Tonga, and Nukuoro), the mouth is open and the tongue is generally showing, but only in New Zealand does the extended tongue become a dominant feature of the face.

Eye Dislocation. This characteristic occurs only in the Kona-style images. The eye shape and position are adjusted to conform to the hair design. The beveled eyeball, generally with a high point or ridge in the center and taper-

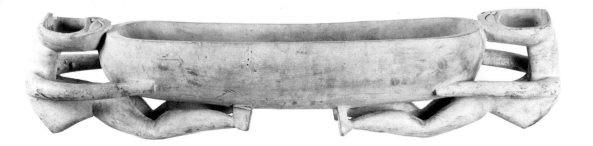

ing to the edges, is a feature found also in the Marquesas and Cook islands sculpture, but this similarity may be coincidental.

Supplementary Material for Teeth, Hair, and Eyes. The use of various materials to represent teeth, such as bone; shell; and dog, shark, or human teeth, is unique to Hawaii. Addition of hair to images occurs outside of Hawaii only in New Zealand in rare examples of freestanding, portable images, which incidently also have some other characteristics similar to the Hawaiian 'aumakua. Shell for eyes in wood carvings was common in New Zealand and Easter Island, but in both cases the eyes were always circular in shape. The Hawaiians used a pointed ellipse for the eye, generally held in place by a wooden peg through the center, which represented the iris.

Traits Not Unique to Hawaii

Arms at the Sides or Separated from the Body. The arm position in Hawaiian figures is essentially the same as that found in the sculpture of Tonga, Nukuoro, Mangareva, and the male wood figures of Easter Island, in which the arms are independent volumes, separated from the torso. It is mainly by this means that these sculptures proclaim a three-dimensionality not found in other Polynesian sculpture. In all other Polynesian areas, the arms are bent at the elbow and lie across the abdomen. In a few cases, the space between the upper arm and torso is open, but in general the arms are defined in relief. In the Hawaiian images, the sense of potential action is accented by the tension resulting from the upper arms being thrust back and by the massive volumes of upper arm and shoulder (figure 52). The stylized, dancelike gesture of the hands, with palms cupped downward and out, is unique to Hawaii, although it is not common to all the images.

Flexed Knees and Heavy Calves. These two traits are widespread in Polynesia (and in Melanesia, Africa, and, indeed, in other primitive art areas throughout the world) as a simple means of expressing action in an otherwise static pose. In Polynesian figure carving, it is only in the Nukuoro images that the knees and calves are not indicated, and in the Easter Island and Mangarevan carvings that the calves are not enlarged. The posture of the Hawaiian images is distinguished by the fact that the knees are usually spread apart as well as flexed, thrusting a movement into the third dimension (figure 18). The contour from the knee to outer thigh, around the lower torso to the buttocks, is also a movement in space that increases the comprehension of the total three-dimensional form. The expanded calf combined with surface faceting often gives rise to a cubistic form, a flattening of the planes of the

53 *Akua kā'ai* image. This shows multiple views of the image in
figure 16.

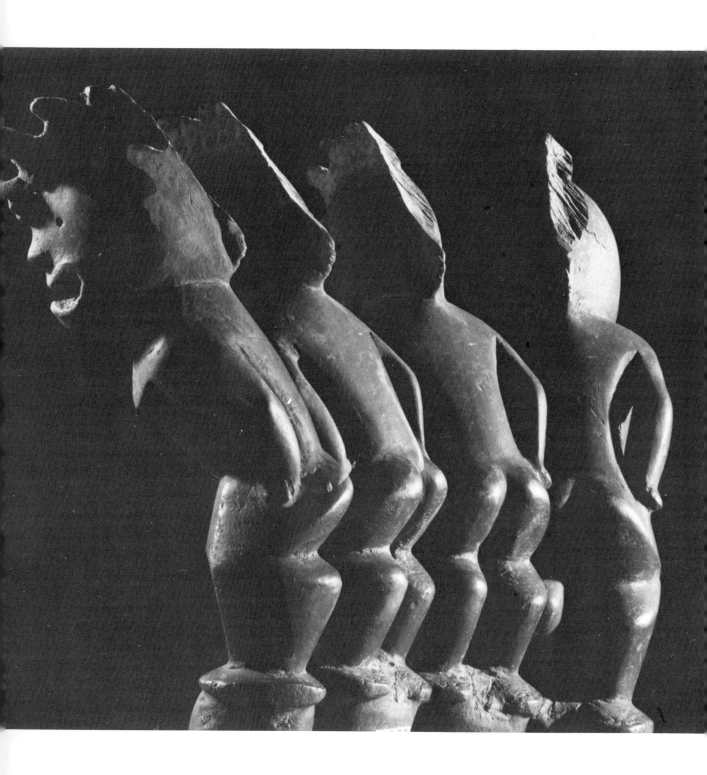

upper calf and lower thighs with a consequently increased visual richness in this area (figure 53).

Natural Proportions, Portraiture. Except for the head size, the vertical dimensions of the Hawaiian images are usually reasonably close to natural proportions. This is a feature shared in Polynesia only with the figure sculpture of Mangareva. In the usual Polynesian figures, the legs are quite short in relation to the rest of the body. The Hawaiian figures are usually greatly exaggerated in bulk, but there are a few examples in which the width and depth dimensions approach natural scale (figure 47), and some in which the character of the forms, even in the head and face, show an attention to natural conditions that suggests a reference to portraiture (figures 54, 55). In Polynesia, this characteristic has its closest parallel in the commemorative figure carvings on the support posts of the Maori meeting houses.

Sex Differences. Most of the Hawaiian images are asexual. Of the religious images, only three are clearly male, and eight, all of which are 'aumakua images, are clearly female. There is no exaggeration of the phallus in Hawaiian figures as is found in Cook Islands sculpture and to a lesser degree in some other Polynesian carvings. The Hawaiian female figures are clearly distinguished by hemispherical breasts. Several images with prominent pectoral ridge lines have been called female but are morphologically asexual and were probably thought of as male (figures 7, 11, 46). The exaggeration of the chest line is a sculptural stylization similar to that employed in the calf-thigh area. Female images are not common in Polynesia, although all of the Tonga and Nukuoro images are female and a separate style was developed for the female figures of Easter Island.

Monumental Scale. In Hawaii, the largest images, larger than life size, were generally limited to those in the main image semicircle that was the focal center for ceremonies on the *heiau* platform. In Polynesia, monumental images were almost invariably related to an architectural orientation—large temple complexes, enclosures, platforms, or, as in New Zealand, large meeting houses. Also, the large images were duplicated and used in groups, such as the semicircle in Hawaii, wall panels in New Zealand, and alignments of stone images on Easter Island. Such replication often accounts for the standardization of styles and in Hawaii was no doubt a factor in the development of the Kona-style images.

Figures as Supports and as Supplements to Utilitarian Objects. The Hawaiian sculptors developed a particularly unique and expressive style in the support figures. The use of supplementary figures is fairly widespread in Polynesia, but only in New Zealand and Hawaii and to a lesser extent in the Marquesas

54, 55 *'Aumākua* images. These portraitlike images are sufficiently alike in style to indicate they were carved by the same sculptor. They were found together in a burial cave near Kawaihae, Hawaii. Human hair is pegged into the heads. Their eyes are of pearl shell. Fortunately, the images were protected in the dry lava-tube cave and are in almost perfect condition. They exhibit the remarkable feeling for sculptural form, fine craftsmanship, and control achieved by the Hawaiian sculptors. Heights: 54, 27 in; 55, 28½ in. 54, Hawaii Volcanoes National Park Museum; cat. no. A3. 55, Bernice P. Bishop Museum; cat. no. A2.

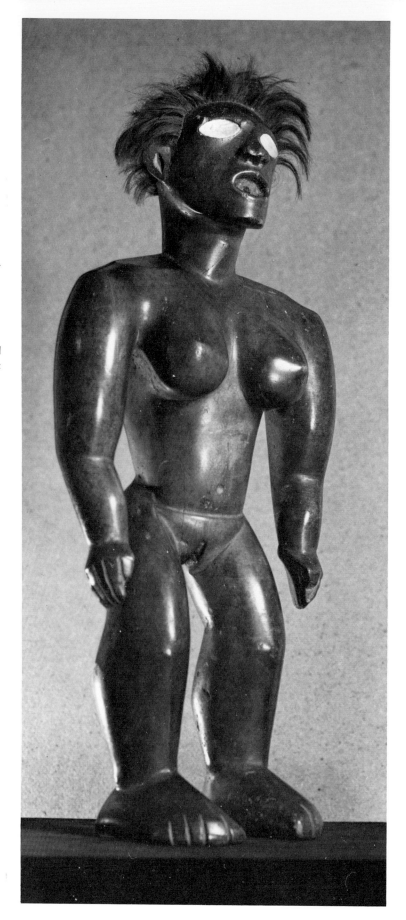

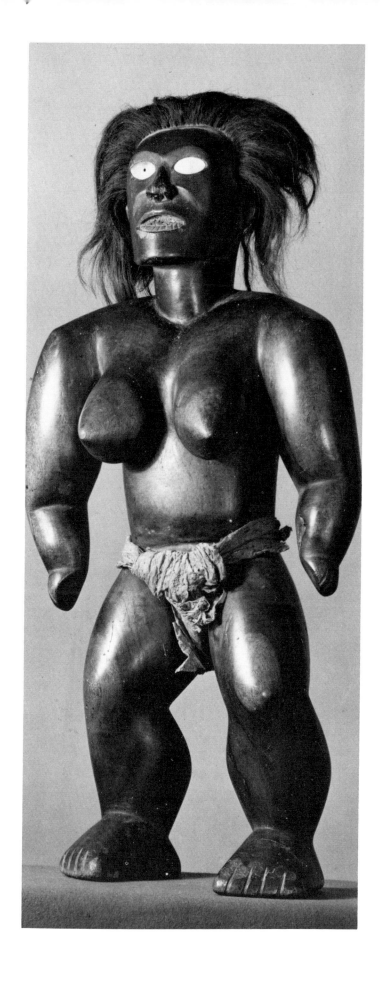

Drum. Eighteen acrobatic figures form the support for this drum. The heads held between the outstretched arms of the top figures serve as alternate lugs for securing the tympanum cords. The eyes of each figure were originally inlaid with shell. This is the most complex example of Hawaiian carving in existence. Heights: drum, 18½ in; top row of figures, average 4 in. Canterbury Museum. Cat. no. S28.

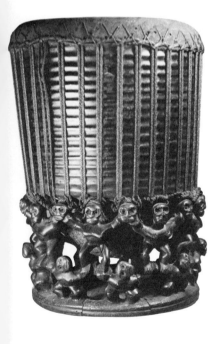

was the production abundant. The Hawaiian and Maori ways of applying the figures to objects have some aspects in common, but the Hawaiian examples are distinguished by their three-dimensionality (the same factor that separates all Hawaiian sculpture from that of the rest of Polynesia in general) and by the fact that they are not pseudosupports but actual functioning elements. The Maori and Marquesan figures are generally used in a decorative way, not as supports actually required by the structure, and are carved in relief rather than in full round.

Although Hawaiian figure sculpture shares a number of traits randomly with the rest of Polynesia, those qualities that give it its distinct character (the open, three-dimensional form; arms separate from the body; a careful attention paid to surface modulation) are common only to a particular area of Polynesia— Tonga, Nukuoro, Easter, and Mangareva. The opposite qualities (closed, compact space; relief form; hands on abdomen) are typical of the rest of Polynesia —the Marquesas, Society, Cook, and Austral islands, and New Zealand. If the distribution patterns of these commonly shared traits are due to ancient Polynesian migrations and lines of contact, the only way to equate the various styles with the present knowledge of contacts is to suggest that the open, three-dimensional style came from western Polynesia (Tonga?) east through the Marquesas to Hawaii, Easter, and Mangareva, but was not retained in the Marquesas; and that the opposite style (compact, hands on abdomen) was developed in eastern Polynesia (Marquesas?) and spread to the Society Islands, Cook Islands, and New Zealand. Hawaii's later contact with Tahiti would then account for those elements it shares with eastern Polynesia.

Some of the specific forms in Hawaiian sculpture can be traced either to objective elements within the culture that are in themselves basically symbolic, such as the helmet shape and the wrestlers' pose, or to abstractions (also symbolic), such as the towering head crests and the *lei niho palaoa* form. The manner in which these forms are presented—the way volumes, surfaces, dimensions, and space are formed and interrelated—in other words, the style, is also partially determined by aspects of the culture, possibly as a reflection of the over-all Hawaiian world view. However, these style-culture links are by no means as clear or easy to define as the correspondence of specific symbolic *forms* to the cultural context. Both the physical forms and the style are ultimately symbolic, an attempt to clarify and present in visual terms the interaction among man, his culture, and nature. In Hawaii, the symbols then relate to such values as a conviction that all things embody a spirit-life; a concern for family and lineage; belief in the power of mana and the accompanying sacredness of *kapu*; a respect for the absolute superiority of rank (that is, the god-

'Aumakua image. This posture is common in the support figures but is unique for the religious images. In both character and quality it has much in common with the two *'aumakua* images in figures 54 and 55, and could be by the same sculptor. Possibly, it was taken from Hale-o-Keawe at Honaunau, Hawaii, by members of a party from Captain Cook's ships, in 1779. Length: 26 in; height: 19 in. British Museum. Cat. no. A6.

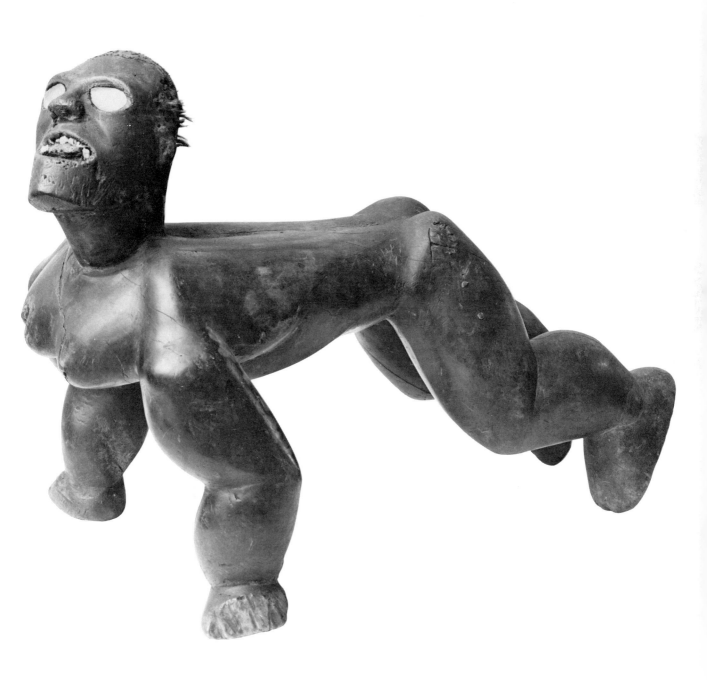

spirit focused in the *ali'i*); and the admiration of power, either physical or spiritual (probably without distinguishing between them). Direct translation of cultural values to sculptural form is unlikely. The symbols and idioms of sculptural style arise from the necessity to bridge the contradictions between belief, social structure, and myth on the one hand, and objective reality and experience on the other. Consequently, elements of incongruity, satire, derision, and humor are as common as the expressions of haughty aggressiveness, formality, and potential power.

As with any viable art form, the sculpture was an active force in Hawaiian society as well as a reflection of it. The sculptors—in their position as *kāhuna*, their close association with the elaboration of religion, and their extraordinary creative adaptability—were very likely responsible for changes in religious thought and practice. The sculptors had considerable control of these changes by innovations in the sculpture itself. By adjusting and elaborating the accepted traditional sculptural forms, the existing associations relevant to them were expanded. The creation of new sculptural forms provided focuses for new symbols and meanings. Although no explicit standards for measuring quality in the arts is possible, intuitive judgment and aesthetic sensibilities will rate Hawaiian figure sculpture a high position on almost any scale. This status is attained not by any single trait but by the fortunate union of many: a unique sense for full three-dimensionality, an inventiveness in techniques but a primary attention to volumes, the translation of symbols to forms in space, and through the sculptor's creative adaptability a high incidence of successful works in a number of types and styles. A high value must be assigned to the innovative aesthetic climate in ancient Hawaii from which emerged (and continued to emerge for two generations into the contact period) a considerable number of admirable solutions to sculptural problems.

Catalog
of Extant Pieces

Preface to the Catalog

The following catalog is a listing of all pieces of Hawaiian figure sculpture in wood that are presently known. The basic grouping is the same as the classification designated in the text: temple images (T series), *akua kā'ai* images (K series), *'aumakua* images (A series), and support figures (S series). Each series is numbered independently to allow for the addition of newly discovered pieces at the end of each series.

For those few pieces that have been lost but for which some records remain, and for a number of fragments and parts that do not form complete, sculptured objects, a supplementary list is appended (*A–H* and *a–m*). Omitted from the catalog have been all those pieces that are apparently not authentic examples of the ancient Hawaiian sculptural tradition, including those that may have been made in Hawaii but show strong postdiscovery influence and those that are clearly copies or fakes.

There is no intention to make the catalog a complete enthnological or historical record, although in many cases the material is as complete as the existing records permit. Physical descriptions of the sculpture have been kept brief since in most instances the photographs are adequate for this information. Quite complete physical descriptions of many of the objects are given by Peter H. Buck in *Arts and Crafts of Hawaii*. To keep the photographs as large as possible, the posts or staff supports of many of the images have not been shown but over-all dimensions are given. The publication references are to those works that feature photographs or drawings of the sculptures. In many cases further discussion and descriptions of the pieces can be found in these publications. Complete titles of these references are given in the Bibliography.

SUMMARY OF COLLECTIONS OF HAWAIIAN SCULPTURE
(Supplementary listings are not included)

	Number of pieces
Bernice P. Bishop Museum, Honolulu	68
British Museum, London	17
Museum für Völkerkunde, Dahlem, Berlin	7
Canterbury Museum, Christchurch, New Zealand	4
Pitt-Rivers Museum, Oxford, England	4
Chicago Natural History Museum	3
Honolulu Academy of Arts	3
Royal Scottish Museum, Edinburgh	3
Staatliches Museum für Völkerkunde, Munich	3
Hawaii Volcanoes National Park Museum, Volcano, Hawaii	2
Musée de l'Homme, Paris	2
National Museum of Ireland, Dublin	2
Peabody Museum, Salem, Massachusetts	2
Roger Williams Park Museum, Providence, Rhode Island	2
Temple Square Museum, Salt Lake City	2
University Museum of Archeology and Ethnology, Cambridge, England	2
Art Gallery and Museum, County Borough of Brighton, Sussex, England	1
Lyman House Memorial Museum, Hilo, Hawaii	1
Museum für Völkerkunde, Vienna	1
Museum of Primitive Art, New York	1
National Museum, Copenhagen	1
Peabody Museum, Cambridge, Massachusetts	1
Rijksmuseum voor Volkenkunde, Leiden	1
University Museum, Philadelphia	1
Private collections	13

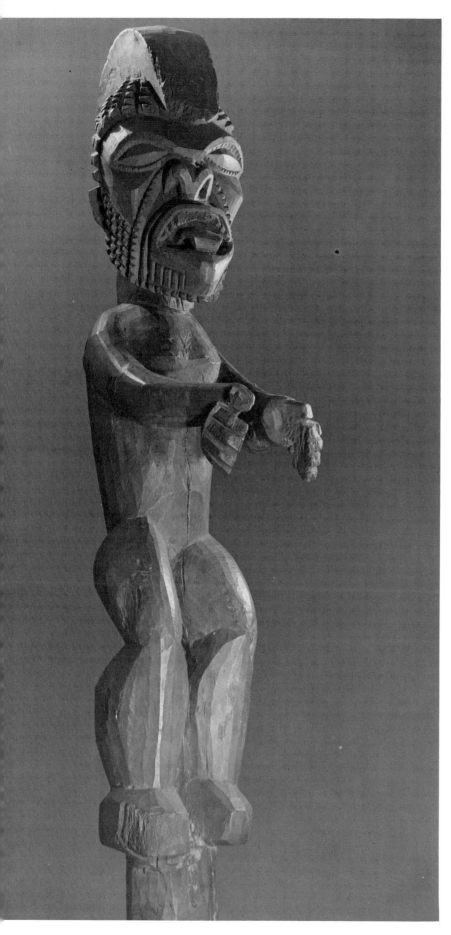

T 1 Temple image
Bernice P. Bishop Museum, Honolulu
(7883).
Height: 63½ in; height of figure: 52 in.
Provenance: Collected by Andrew Bloxam,
naturalist aboard H.M.S. *Blonde*, from
Hale-o-Keawe, Honaunau, Hawaii, in
1825, with cat. nos. T2, K11, K13, K16,
K44, A19. A pair with cat. no. T2 were
very likely central facing images on the
altar in the house.
Photograph: Bishop Museum.
Published: Bloxam, opp. p. 61; Buck 1957,
fig. 309; Davenport, p. 14; Dodd, p. 281;
Luquiens, p. 18.

120

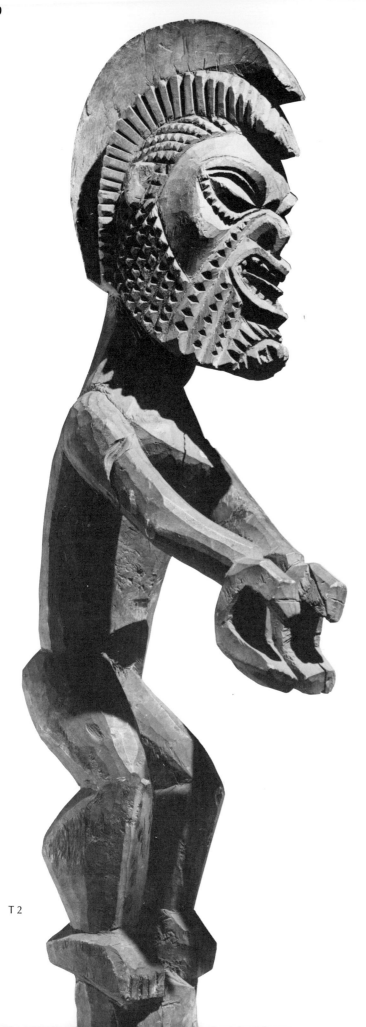

T 2

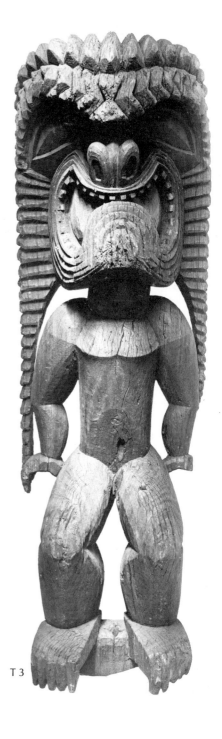

T 3

T 2 Temple image
Chicago Natural History Museum
(272689). From the A. W. F. Fuller
Collection.
Height: approx. 60 in; height of figure:
49¼ in.
Provenance: Probably collected by
Andrew Bloxam of H.M.S. *Blonde* from
Hale-o-Keawe, Honaunau, Hawaii, in
1825, with cat. nos. K1, K11, K13, K16,
K44, A19.
Photograph: Chicago Natural History
Museum.
Published: Brigham 1913, fig. 26; Buck
1957, fig. 309; Dodd, p. 280.

T 3 Temple image
Bernice P. Bishop Museum, Honolulu
(7654). Acquired from the American
Board Commissioners for Foreign
Missions, Boston.
Height: 77 in. Kona style.
Provenance: Undetermined; probably
Kona, Hawaii.
Photograph: Bishop Museum.
Published: Archey, fig. 33; Arning, p. 77;
Buck 1957, fig. 308; Davenport, p. 24;
Dodd, p. 286; Luquiens, p. 23.

T 4 Temple image
Peabody Museum, Salem, Mass. (E 12071).
Gift of John T. Prince in 1846.
Height: 79 in. Kona style.
Provenance: Undetermined; probably
Kona, Hawaii.
Photograph: Peabody Museum.
Published: Brigham 1898, pl. XIX; Buck
1957, fig. 308; Dodd, p. 282; Linton,
Wingert, and d'Harnoncourt, p. 66;
Luquiens, p. 20; Peabody Museum, fron-
tispiece; Wingert 1946, pl. following
p. 63.

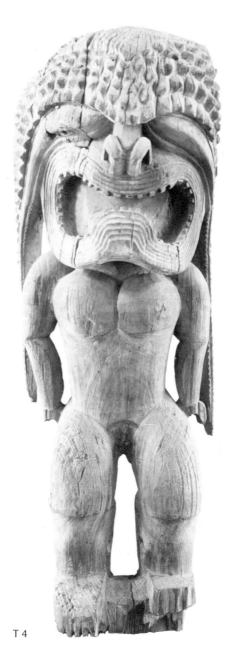

T 4

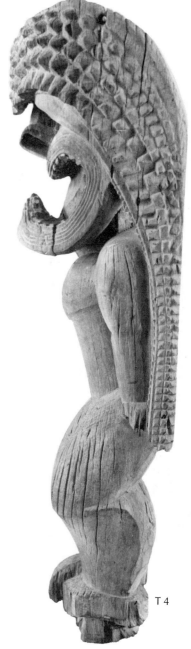

T 4

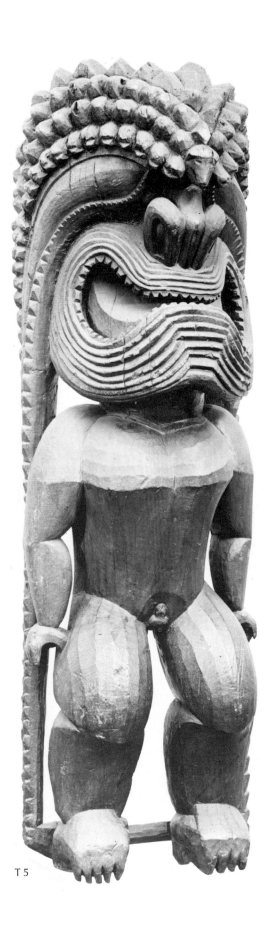

T 5

T 5 Temple image
British Museum, London (1839–4–26–8).
Height: approx. 93 in; height of figure:
79 in. Kona style.
Provenance: Undetermined; probably
Kona, Hawaii.
Photograph: British Museum.
Published: Brigham 1898, fig. 59; Brigham
1913, fig. 223; Buck 1957, fig. 308; Cox
1964, opp. p. 54; Dodd, p. 287; Edge-
Partington, I: 55, no. 17; Luquiens;
frontispiece.

T 6 Temple image
British Museum, London (LMS223). From
the London Missionary Society.
Height: 50 in; height of figure: 29¾ in.
Kona style.
Provenance: Collected by Tyerman and
Bennett (in the Pacific, 1821–1829) from
a *heiau* at Kawaihae, Hawaii.
Photograph: British Museum.
Published: Archey, p. 16a; Brigham 1913,
fig. 14; British Museum, fig. 150; Buck
1957, fig. 308; Dodd, pp. 279, 289; Duff,
no. 172; Guiart, p. 392; Luquiens, p. 3;
Poignant, p. 22; Tischner and Hewicker,
pl. 83; Wardwell, fig. 6.

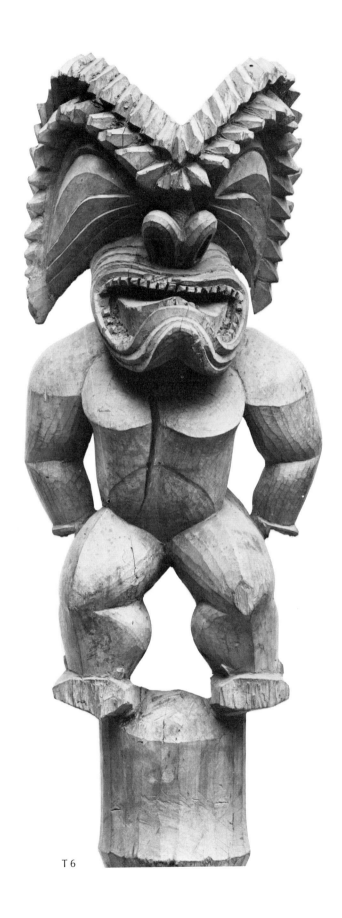

T 6

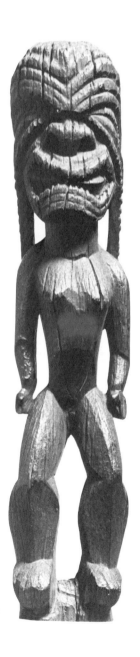

T 7

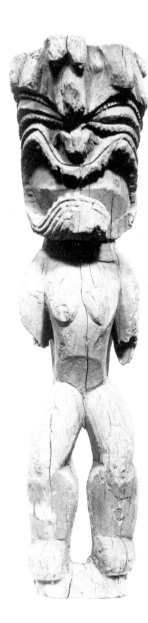

T 8

T 7 Temple image
Pitt-Rivers Museum, Oxford, England
(PRXV138). From the Beasley Collection.
Acquired from the Blackmore Museum
in 1931.
Height: 29 in. Painted or stained black.
Kona style.
Provenance: Undetermined; probably
Kona, Hawaii.
Photograph: Cox.
Published: Emory 1938, pl. 1.

T 8 Temple image
British Museum, London (1656).
Height: 54 in. Remains of red paint on
face. Kona style.
Provenance: Undetermined; probably
Kona, Hawaii.
Photograph: British Museum.
Published: Brigham 1913, fig. 15.

T 9 Temple image
National Museum, Copenhagen (I.a.6).
From Steen Bille, who was in Hawaii
aboard the *Galathea* in 1846.
Total height: 30 in; height of figure:
approx. 20 in. Probably a *heiau* fence
post image.
Provenance: Undetermined; possibly the
island of Hawaii.
Photograph: National Museum.
Published: Brigham 1913, fig. 45.

T 10 Temple image
Peabody Museum, Salem, Mass. (E17530).
Obtained from the Oldman Collection.
Height: 86 in.
Provenance: Undetermined; possibly
from Hale-o-Keawe, Honaunau, Hawaii.
Photograph: Courtesy of the Peabody
Museum.
Published: Brigham 1913, fig. 249; Pea-
body Museum, pl. I.

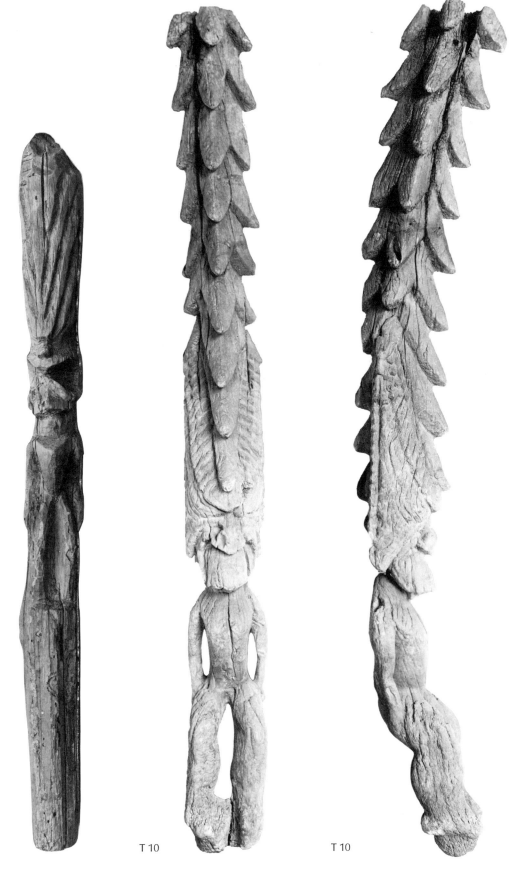

T 9 T 10 T 10

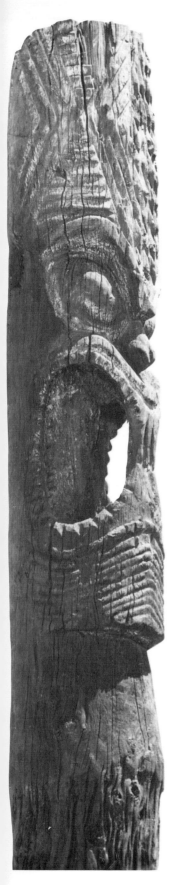

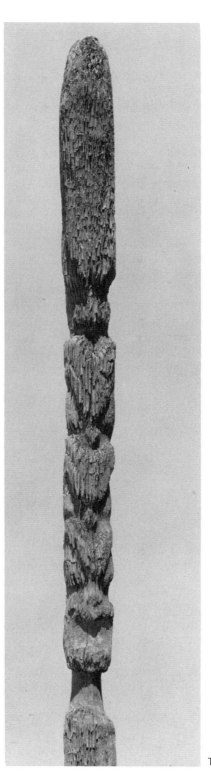

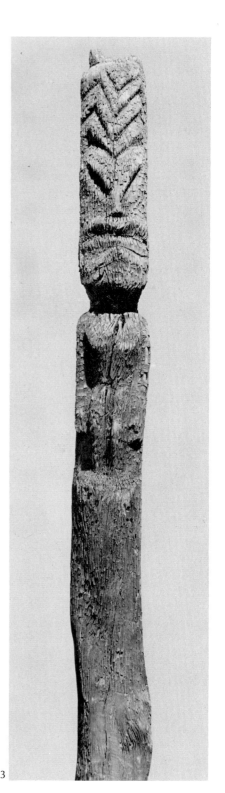

T 11 T 12 T 13

T 11 Temple image
Bernice P. Bishop Museum, Honolulu
(11096).
Height: 117 in; diameter: 15 in.
Provenance: Found in the mud near
Wainuenue Bridge near Kapaa, Kauai, in
1909 by E. J. Morgan.
Photograph: Davenport and Cox.
Published: Buck 1957, fig. 328; Luquiens,
p. 24.

T 12 Temple image
Bernice P. Bishop Museum, Honolulu
(B1804).
Total height: 108 in; height of carved
portion: 68 in; diameter: 3½ in. There
are four faces. Probably a *heiau* fence
post image.
'Ohi'a wood.
Provenance: Dug up during cultivation
of a field at Paukukalo, Wailuku, Maui,
with cat. no. T12.
Photograph: Davenport and Cox.

T 13 Temple image
Bernice P. Bishop Museum, Honolulu
(B1805).
Height: 90 in; height of figure: 33 in.
Probably a *heiau* fence post image. *'Ohi'a*
wood.
Provenance: Dug up during cultivation of
a field at Paukukalo, Wailuku, Maui,
with cat. no. T11.
Photograph: Davenport and Cox.
Published: Buck 1957, fig. 328.

T 14 Temple image
Bernice P. Bishop Museum, Honolulu
(C8486).
Height: 80 in; height of figure: 64 in.
Provenance: Collected at Waipio Valley,
Hawaii, with cat. no. T15.
Photograph: Bishop Museum.
Published: Buck 1957, fig. 307a.

T 15 Temple image
Bernice P. Bishop Museum, Honolulu
(C8485).
Height: 80½ in; height of figure: 61 in.
Provenance: Collected at Waipio Valley,
Hawaii, with cat. no. T14.
Photograph: Bishop Museum.
Published: Buck 1957, fig. 307b.

T 14/T 15

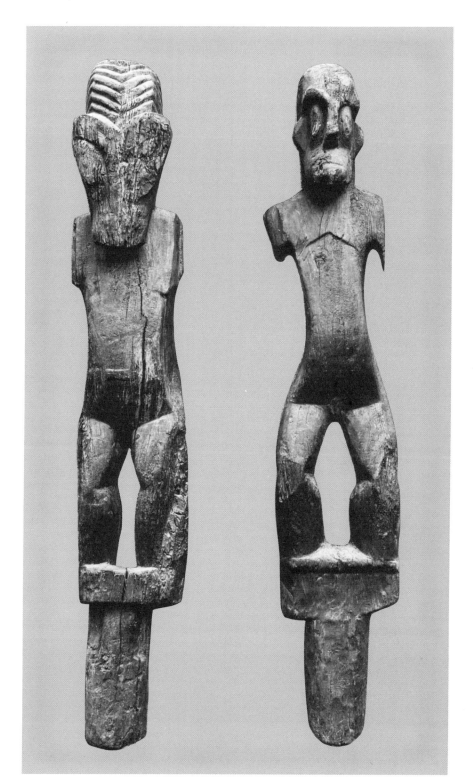

T 16 Temple image
Bernice P. Bishop Museum, Honolulu
(4896). From the trustees of Oahu College.
Height: 10 in; height of figure: 75 in.
Provenance: Undetermined.
Photograph: Bishop Museum.
Published: Brigham 1903, fig. 6.

T 17 Temple image
Bernice P. Bishop Museum, Honolulu
(4897). From the Queen Emma Collection.
Height: 74 in. Slab type.
Provenance: Undetermined.
Photograph: Davenport and Cox.

T 18 Temple image
Bernice P. Bishop Museum, Honolulu
(C8814).
Height: 43 in. Slab type.
Provenance: Collected on the island of
Kahoolawe.
Photograph: Bishop Museum.
Published: Buck 1957, fig. 311.

T 19 Temple image
Bernice P. Bishop Museum, Honolulu
(4068).
Height: 113 in; height of figure: 78 in.
Slab type.
Provenance: Collected near Kapaa, Kauai,
by W. R. King in 1878, who wrote: "On
the table land at Kapaa . . . an old
native ditch called by the natives 'Auwai
Puhi'. . . . In 1878 I commenced clean-
ing out the ditch from Kapahi up . . .
the remains of an old dam were found.
. . . in it what looked like a log, but
proved to be an idol made of wood. On
questioning the natives . . . I learned
that the idol was known to them by
tradition, it being named 'Manuokalanipo,'
and having been originally set up on
the top of the dam to protect it" (Letter
from W. R. King, Sept. 7, 1896, in the
Bishop Museum, Honolulu, Hawaii Source
Material III, p. 406).
Photograph: Bishop Museum.

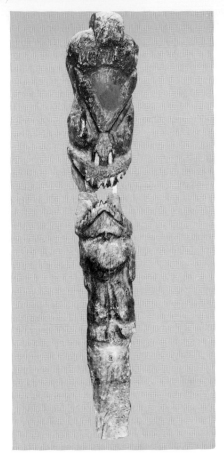

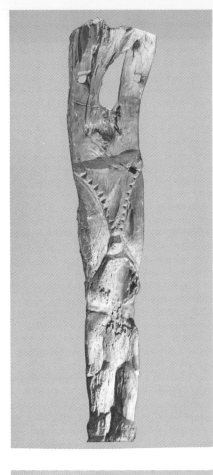

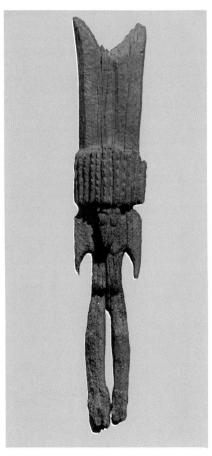

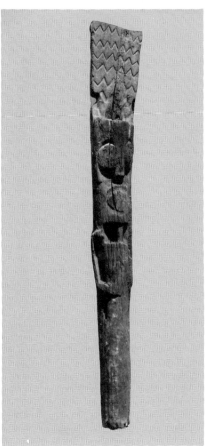

T 18/T 19

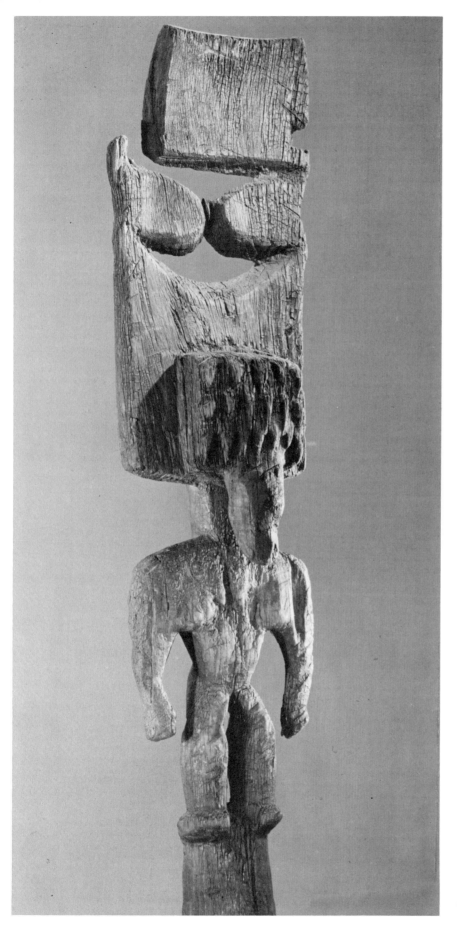

T 20

T 20 Temple image
Bernice P. Bishop Museum, Honolulu
(6816).
Height: 65½ in; height of figure and
headdress: 38 in. Slab type.
Provenance: Collected from the mud in
a rice field at Ewa, Oahu, in 1899.
Photograph: Davenport and Cox.
Published: Buck 1957, fig. 310.

T 21 Temple image
Collection of John J. Klejman, New York.
Formerly in the Leverian Museum, London, 1784–1786. Probably collected in Hawaii in 1778–1779 during Capt. James Cook's third voyage.
Height: 31 in.
Provenance: Undetermined; probably island of Hawaii.
Photograph: Bishop Museum, courtesy of John J. Klejman.
Published: Force and Force, p. 79 (watercolor sketch by Sarah Stone, made in 1783).

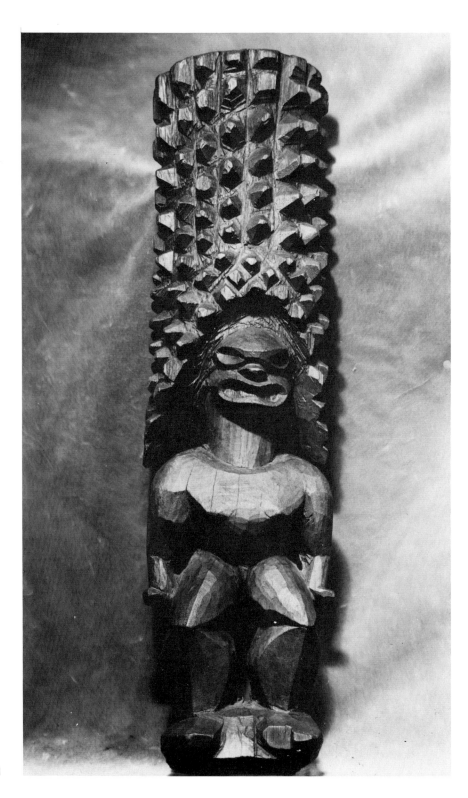

T 21

T 22 Temple image
Bernice P. Bishop Museum, Honolulu
(1364).
Height: 42 in; height of figure: 23 in.
Possibly a *heiau* fence post image.
Provenance: Undetermined.
Photograph: Bishop Museum.

T 23 Temple image
Bernice P. Bishop Museum, Honolulu
(B9244).
Height: 44 in; height of figure: 33½ in.
Post type.
Provenance: Found in the mud of a rice
field at Aiea, Oahu, c. 1905.
Photograph: Davenport and Cox.
Published: Buck 1957, fig. 328c.

T 24 Temple image
Bernice P. Bishop Museum, Honolulu
(8049).
Height: 66½ in. Slab type.
Provenance: Collected from a swamp at
Kealia, Kauai.
Photograph: Davenport and Cox.
Published: Buck 1957, fig. 328a; Luquiens,
p. 9.

T 22

T 23

T 24

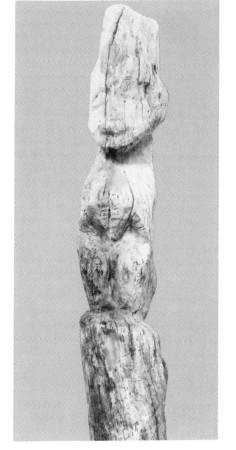

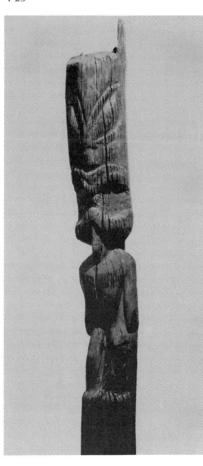

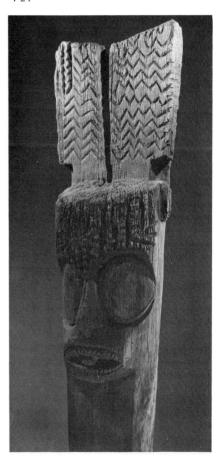

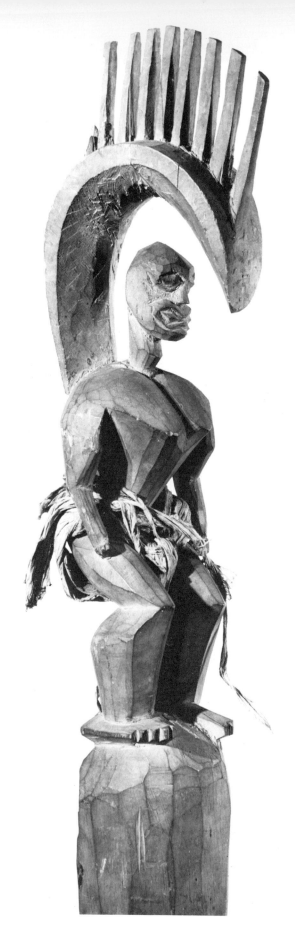

T 25 Temple image
Musée de l'Homme, Paris (79–10–11).
Collections Nationales, 1879.
Height: 35 in; height of figure: 21 in.
Called "Pele" but sex not discernible.
Provenance: Undetermined. Collected in
Hawaii prior to 1879.
Photograph: Musée de l'Homme.
Published: Behm-Blancke, fig. 5; Buck
1957, fig. 304; Dodd, p. 276; Guiart,
pl. 400; Luquiens, p. 10; Poignant, p. 50.

T 26 Temple image
Temple Square Museum, Salt Lake City
(102).
Height: 19 in; height of figure: 15¾ in.
Provenance: Undetermined.
Photograph: Temple Square Museum.
Published: Brigham 1898, fig. 71; Dodd,
p. 277; Eickhorn, fig. 36.

T 27 Temple image
Bernice P. Bishop Museum, Honolulu
(6693).
Height: 53 in; height of figure: 29½ in.
Post type.
Provenance: Undetermined.
Photograph: Bishop Museum.
Published: Behm-Blancke, fig. 5; Buck
1957, fig. 304.

T 25

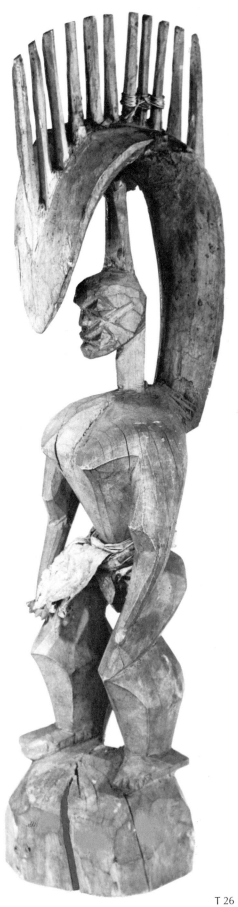

T 26

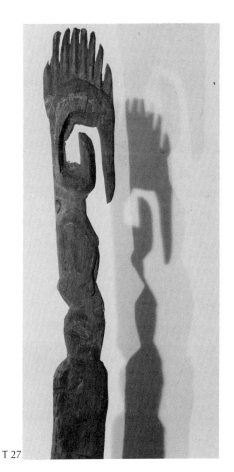

T 27

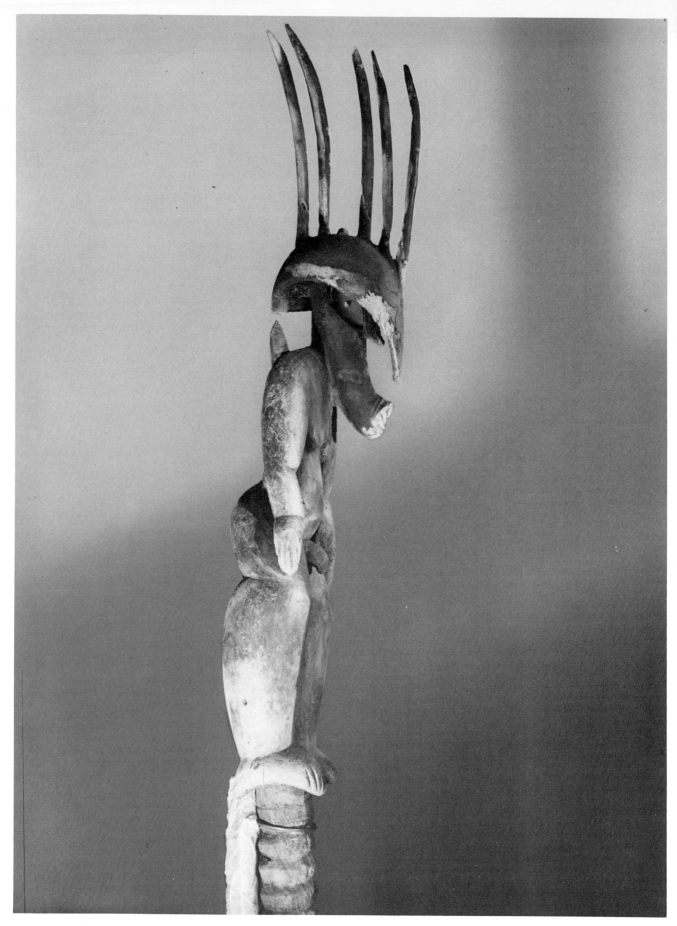

T 28

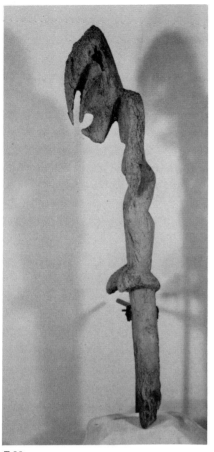

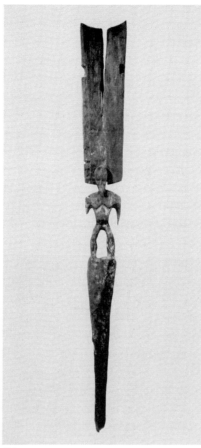

T 29

T 30

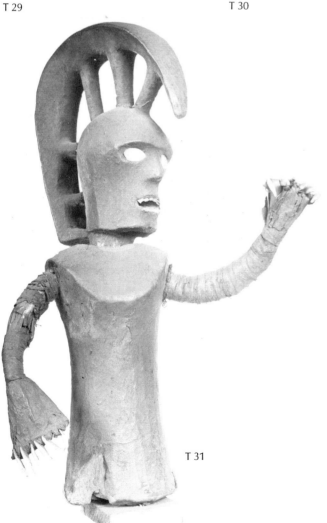

T 31

T 28 Temple image
Bernice P. Bishop Museum, Honolulu (D2772).
Height: 71¼ in; height of figure: 36 in. Light brown wood. Head and crest stained black. Pearl shell remains in right eye.
Provenance: Collected from a cave on Maui in 1963, with cat. no. T29.
Photograph: Cox.

T 29 Temple image
Bernice P. Bishop Museum, Honolulu (D2773).
Height: 31¾ in; height of figure: 20½ in. Light brown wood. Badly eroded.
Provenance: Collected from a cave on Maui, 1963, with cat. no. T28.
Photograph: Bishop Museum.

T 30 Temple image
Collection of Gerald W. Fisher, Honolulu.
Height: 82½ in; height of figure, not including crest: 18½ in.
Provenance: Found in a swamp at Kahuku, Oahu.
Photograph: Honolulu Academy of Arts.
Published: Buck 1957, fig. 311; Honolulu Academy of Arts, no. 8; Wardwell, no. 75.

T 31 Temple image
British Museum, London (+249).
Height: 20½ in; wood covered with dark tapa. Arms and head are attached separately. Fingers are of dogteeth, eyes of pearl shell, upper teeth of bone, and a fish palate is used for the lower teeth. Similar in construction to the Hawaiian marionettes or articulated puppets used in certain hula performances, as described by Emerson in *Unwritten Literature of Hawaii*, pp. 91–92. (see cat. nos. *a*, *b*, *l*, and *F*).
Provenance: Undetermined.
Photograph: British Museum.
Published: Brigham 1898, fig. 49; Brigham 1915, fig. 219; Dodd, p. 248; Edge-Partington, I: 58, no. 2; Poignant, p. 52.

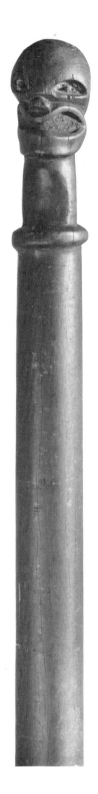

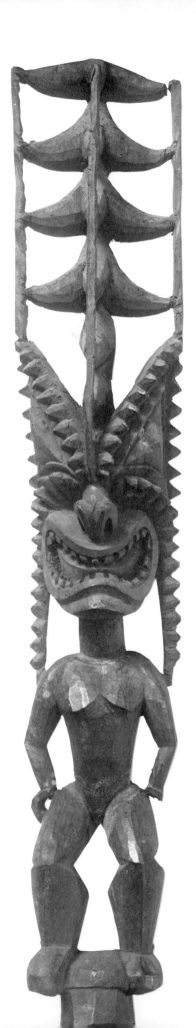

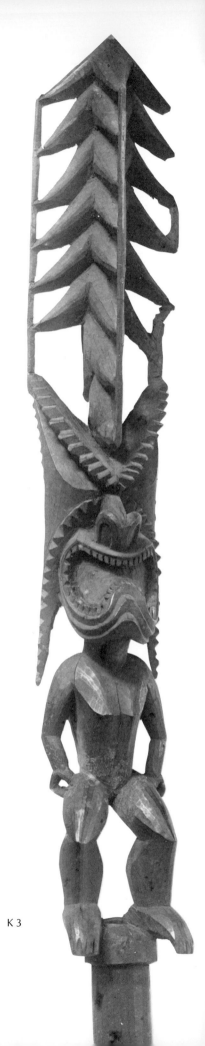

K 1 K 2 K 3

K 1 Lono image
Bernice P. Bishop Museum, Honolulu
(7659). From the American Board Com-
missioners for Foreign Missions, Boston.
Height: 122 in; height of neck and head:
7 in; diameter: 2 in. *Kauila* wood.
Provenance: Collected from a cave near
Kaawaloa, Kealakekua Bay, Hawaii, c.
1830. Presented by Chief Kamakau to
Mr. Samuel Ruggles.
Photograph: Davenport and Cox.
Published: Ii, p. 71.

K 2 *Akua kā'ai* image
Bernice P. Bishop Museum, Honolulu
(9067).
Height: 42½ in; height of figure: 27¼
in. Kona style.
Provenance: Collected from a burial cave
at Honokoa Gulch, Kawaihae, Hawaii, in
1904, with cat. nos. K3, A2, A3, S13, S14.
Photograph: Bishop Museum.
Published: Brigham 1906, figs. 5, 6; Buck
1957, fig. 305; Dodd, p. 275; Luquiens,
p. 27.

K 3 *Akua kā'ai* image
Bernice P. Bishop Museum, Honolulu
(9068).
Height: 44 in; height of figure: 27½
in. Kona style.
Provenance: Collected from a burial cave
at Honokoa Gulch, Kawaihae, Hawaii,
in 1904, with cat. nos. K2, A2, A3, S13,
S14.
Photograph: Bishop Museum.
Published: Archey, fig. 34; Brigham 1906,
figs. 5, 6; Buck 1957, fig. 305; Dodd,
p. 275; Luquiens, p. 27.

K 4 *Akua kā'ai* image
Bernice P. Bishop Museum, Honolulu
(4044).
Height: 20 in; height of figure: 12 in.
Entire image stained black. Eyes are of
pearl shell, teeth are of bone. A second
small figure on the edge of the hollow
cylinder has been broken off. Possibly
a sorcery image.
Provenance: Kauai.
Photograph: Bishop Museum.
Published: Brigham 1903, p. 6; Buck
1957, fig. 304; Dodd, p. 231; Edge-
Partington, II: 2.

K 4

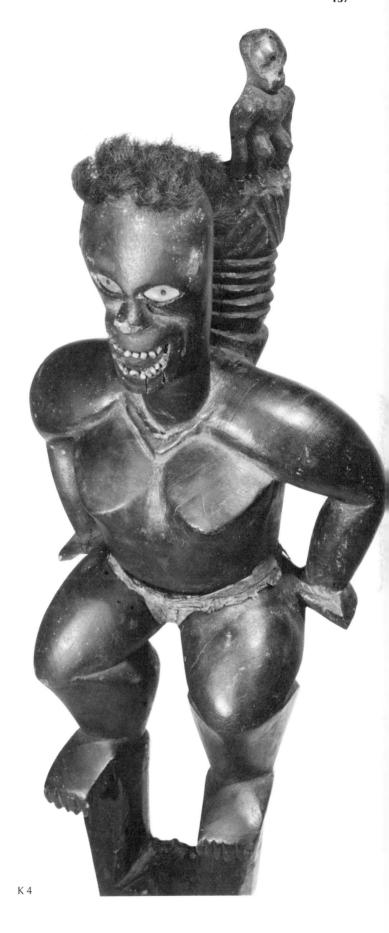

K 5 *Akua kā'ai* image
University Museum, Philadelphia (10550).
On loan from the Academy of Natural
Sciences, Philadelphia. Gift of W. H.
Jones in 1878.
Height: 23 in; height of figure: 13 in.
Provenance: Collected from the ruins of
a *heiau* near Honolulu, Oahu.
Photograph: University Museum.
Published: Davenport, p. 18; Linton,
Wingert, and d'Harnoncourt, p. 61;
Wingert 1946, pl. following p. 63.

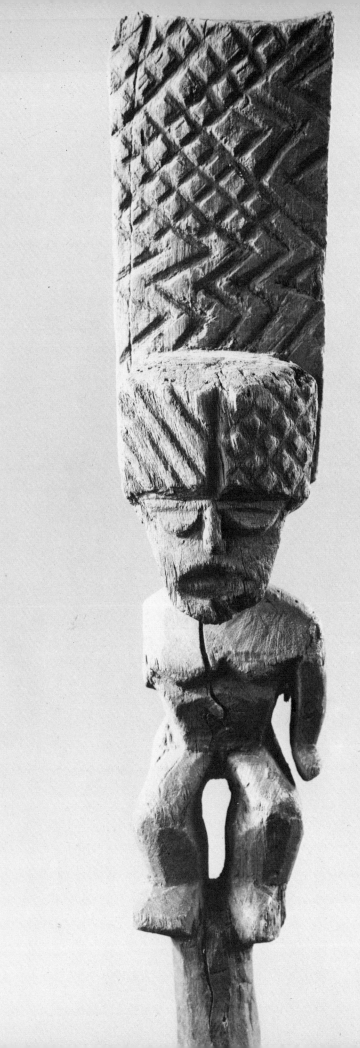

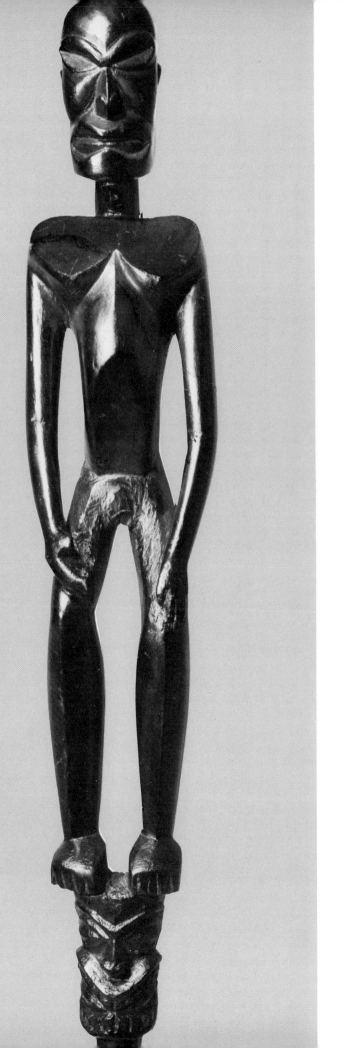

K 6 *Akua kā'ai* image
Royal Scottish Museum, Edinburgh (1950–230). From the Beasley Collection.
Height: 39¾ in; height of figure: 21¼ in; height of lower head: 3½ in. Hard, red wood painted black.
Provenance: Undetermined.
Photograph: Royal Scottish Museum.
Published: Emory 1938a, p. 9;
Force and Force, p. 171.

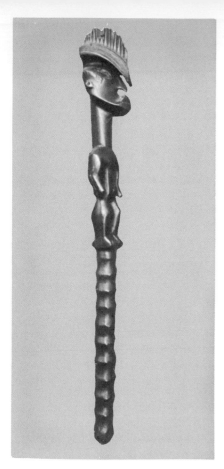

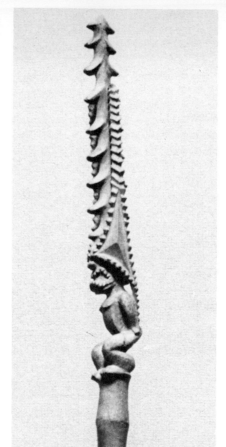

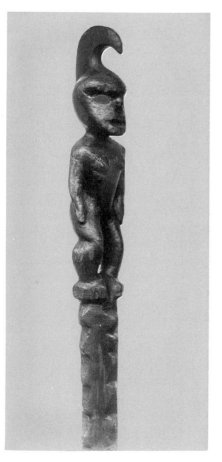

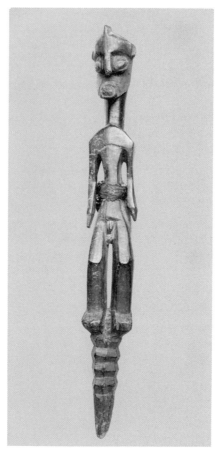

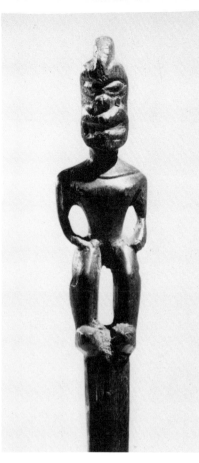

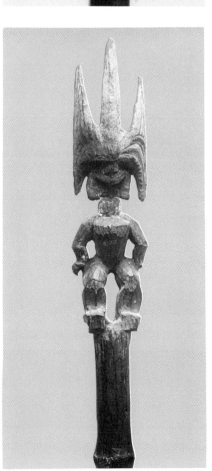

K 7 *Akua kā'ai* image
Roger Williams Park Museum, Providence,
R.I. (11304, E3099). Acquired from the
Providence Franklin Society, to whom it
was donated by Capt. D. T. Aborn in
1829.
Height: 16¼ in; height of figure: 9 in.
Provenance: Undetermined. This head
style has been attributed to the island of
Maui, but there is little evidence for this
designation.
Photograph: Davenport.
Published: Dodd, p. 229; Wardwell,
no. 81.

K 8 *Akua kā'ai* image
Pitt-Rivers Museum, Oxford, England
(PR69.L.36).
Height: 14 in; height of figure: 8½ in.
Kona style.
Provenance: Undetermined; probably
Kona, Hawaii.
Photograph: Cox.
Published: Edge-Partington, II: 37, no. 6.

K 9 *Akua kā'ai* image
Bernice P. Bishop Museum, Honolulu
(D1534). Eric A. Knudson Collection.
Height: 28 in; height of figure: 6 in.
Dark brown wood. Eyes inlaid with shell.
Provenance: Collected from a cave on
Kauai, c. 1850.
Photograph: Bishop Museum.

K 10 *Akua kā'ai* image
Honolulu Academy of Arts (351.1).
Height: 33¼ in; height of figure: 25 in.
Provenance: Collected from a burial cave
in Waimea Valley, Oahu, in 1935.
Photograph: Bishop Museum.
Published: Buck 1957, fig. 301; Dodd,
p. 229; Honolulu Academy of Arts, no. 1;
Wardwell, no. 82.

K 11 *Akua kā'ai* image
Museum of Primitive Art, New York
(61.265).
Height: 12½ in; height of figure: 5½ in.
Right arm missing in early photographs.
Provenance: Collected from Hale-o-
Keawe, Honaunau, Hawaii, by midship-
man Joseph N. Knowles of H.M.S.
Blonde in 1825, with cat. no. K13. Cat.
nos. T1, T2, K16, K44, and A19 were col-
lected by members of the same party.
Photograph: Museum of Primitive Art.
Published: Dodd, p. 231; Emory, "God
Sticks," pl. III; Wardwell, no. 79.

K 12 *Akua kā'ai* image
Bernice P. Bishop Museum, Honolulu
(L887).
Height of figure: 5¾ in. Lower portion of
head missing. Kona style.
Provenance: Collected at Keaupuka,
Kona, Hawaii.
Photograph: Bishop Museum.
Published: Buck 1957, fig. 305a.

K 13 *Akua kā'ai* image
Honolulu Academy of Arts (3075.1).
Height: 22 in; height of figure: 9 in.
Kona style.
Provenance: Collected from Hale-o-
Keawe, Honaunau, Hawaii, by midship-
man Joseph N. Knowles of H.M.S. *Blonde*,
1825, with cat. no. K11. Also collected
by members of that party were cat. nos.
T1, T2, K16, K44, and A19.
Photograph: Honolulu Academy of Arts.
Published: Buck 1957, fig. 305b; Emory
1938a, pl. III; Honolulu Academy
of Arts, no. 2; Wardwell, no. 80.

K 14 *Akua kā'ai* image
Bernice P. Bishop Museum, Honolulu
(1358). From the Damon Estate.
Height: 14½ in; height of figure: 4¾ in.
Provenance: Collected from Puukohola
heiau, Kawaihae, Hawaii.
Photograph: Bishop Museum.
Published: Buck 1957, fig. 301b; Luquiens,
p. 58.

K 15 *Akua kā'ai* image
Bernice P. Bishop Museum, Honolulu
(187).
Height: 9½ in; height of head: 2½ in.
Provenance: Collected at Alae, South
Kona, Hawaii.
Photograph: Bishop Museum.
Published: Buck 1957, fig. 304c; Wingert
1953, p. 100.

K 16 (right) *Akua kā'ai* image
Bernice P. Bishop Museum, Honolulu
(C10189). Presented to Peter H. Buck by
Mr. Bloxam, a descendant of Andrew
Bloxam, in New Plymouth, New Zealand,
in 1949, for the Bishop Museum.
Height: 14½ in; height of figure: 5½ in.

K 13

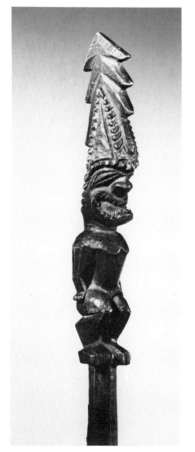

K 14

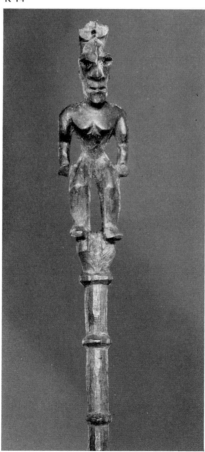

K 15

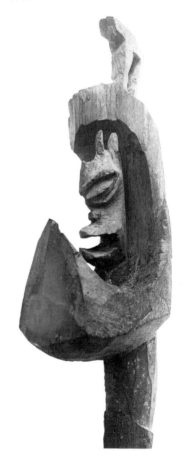

K 16

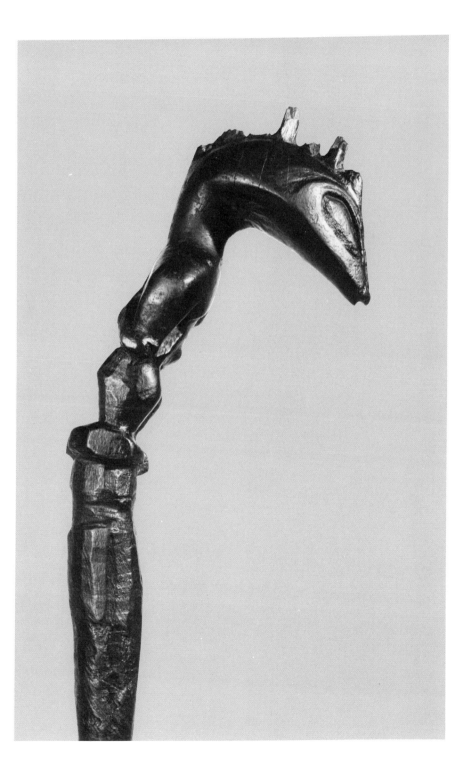

Provenance: Collected from Hale-o-Keawe at Honaunau, Hawaii, in 1825 by Andrew Bloxam, botanist on the H.M.S. *Blonde*. Cat. nos. T1, T2, K11, K13, K44, and A19 were also collected by members of the Bloxam party.
Photograph: Bishop Museum.
Published: Brigham 1913, fig. 157; Buck 1957, fig. 304a; Guiart, pl. 398; *Mirror* (London), Oct. 7, 1826, p. 7.

K 17 *Akua kāʻai* image
Bernice P. Bishop Museum, Honolulu (10348). From A. S. Cleghorn, the Kaiulani Collection.
Height: 14½ in; height of figure: 7½ in.
Provenance: Undetermined.
Photograph: Davenport and Cox.
Published: Buck 1957, fig. 303b.

K 17

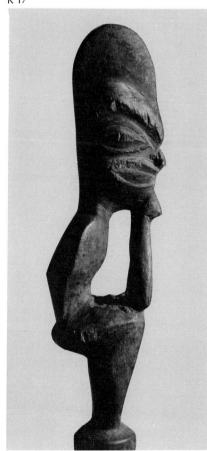

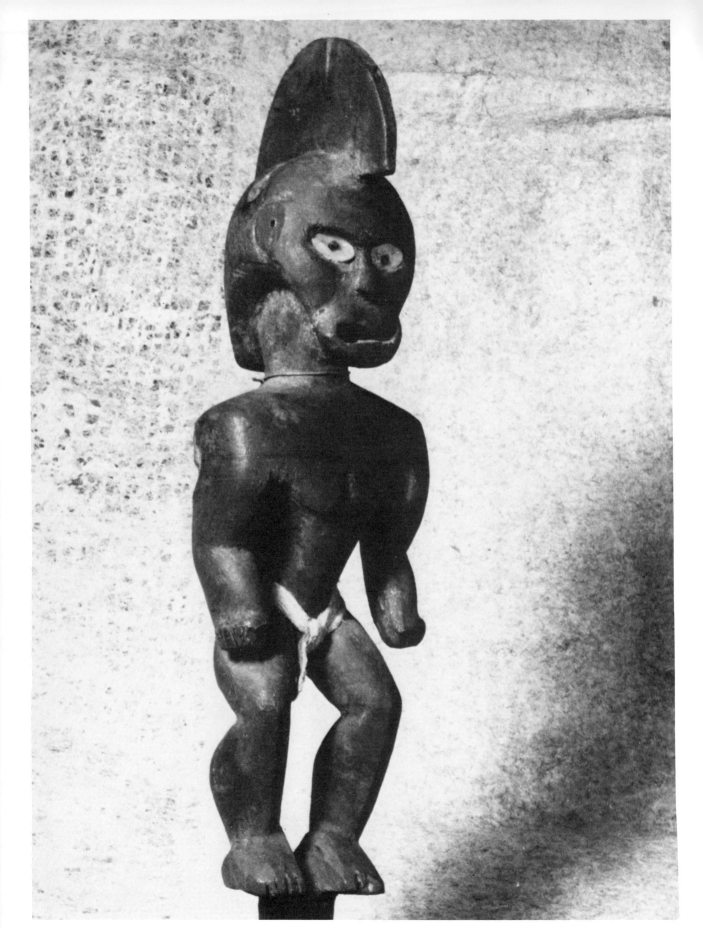

K 18 *Akua kāʻai* image
British Museum, London (55 12–20 48).
From Surgeon W. Davis, R.N., 1855.
Height: 12½ in; height of figure: 11½ in.
Stick support broken off. Eyes inlaid
with pearl shell. Tapa *malo* (loincloth).
Provenance: Undetermined.
Photograph: Cox.
Published: Brigham 1898, fig. 50; Brigham
1913, fig. 220.

K 19 *Akua kāʻai* image
Bernice P. Bishop Museum, Honolulu
(1362).
Height: 8 in. Light-colored wood. Stick
has been cut off. Cockscomb-type head-
dress. Stained black.
Provenance: Undetermined.
Photograph: Bishop Museum.
Published: Arning, pl. 2–2; Behm-Blancke,
fig. 6; Buck 1957, fig. 302; Dodd,
p. 231; Wingert 1953, p. 101.

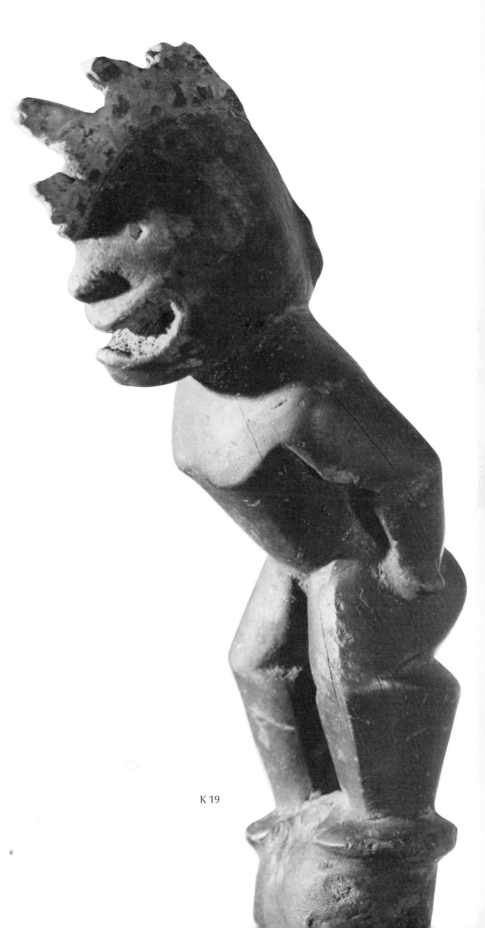

K 18

K 19

K 20 *Akua kā'ai* image
Art Gallery and Museum, County Borough
of Brighton, Sussex, England (694).
Height: 7½ in; height of figure: 5½ in.
Stick support has been cut off.
Provenance: Undetermined.
Photograph: County Borough of Brighton.

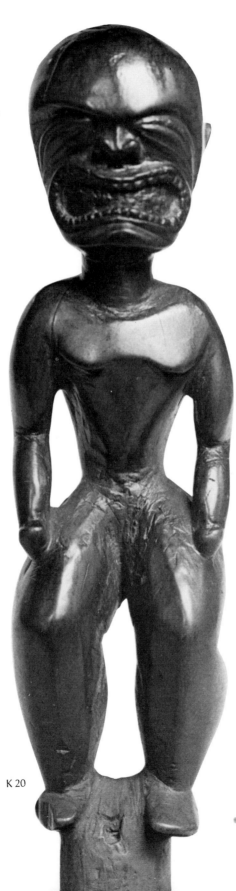

K 20

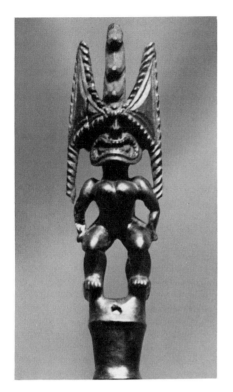

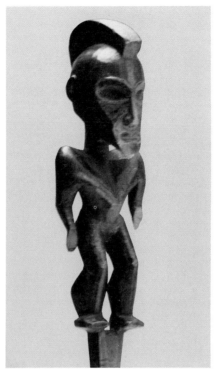

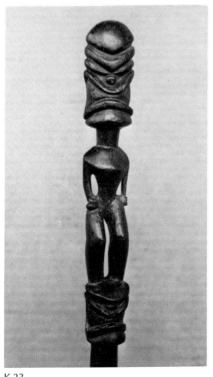

K 23

K 21 *Akua kā'ai* image
Pitt-Rivers Museum, Oxford, England
(PR69.L.34). From C. M. Laing, 1936.
Height: 14½ in; height of figure: 5½ in.
Light-colored wood stained black and
polished. Kona style.
Provenance: Undetermined; probably
Kona, Hawaii. Collected by Capt. Edward
Lawson, owner of whaling ships in the
South Pacific c. 1800–1820.
Photograph: Pitt-Rivers Museum.
Published: Dodd, p. 229; Poignant, p. 53.

K 22 *Akua kā'ai* image
Collection of James T. Hooper. Formerly
the Totems Museum, Arundel, England.
Height: 11½ in; height of figure: 7 in.
Provenance: Undetermined.
Photograph: Cox.

K 23 *Akua kā'ai* image
Lyman House Memorial Museum, Hilo,
Hawaii (10604). On loan from Levi C.
Lyman, 1933.
Height: 17 in; height of figure: 8¾ in.
Provenance: Collected from a cave in
Kona, Hawaii, by a Mr. Kiniakua.
Photograph: Cox.

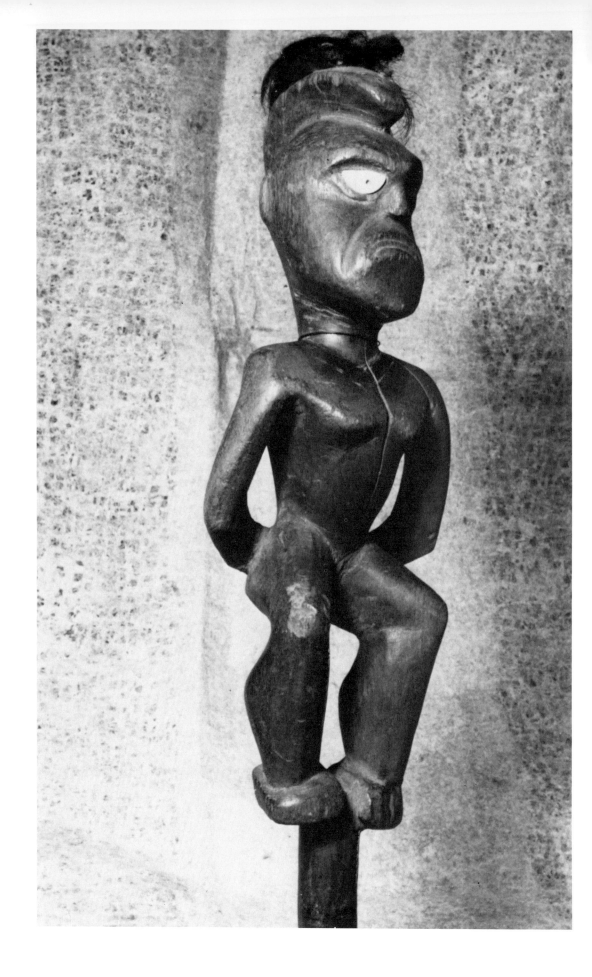

K 24

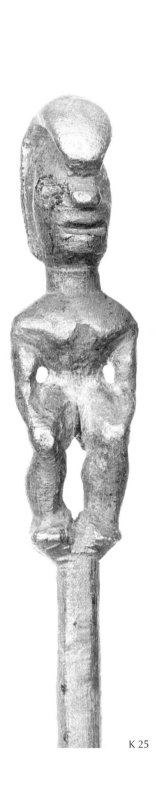

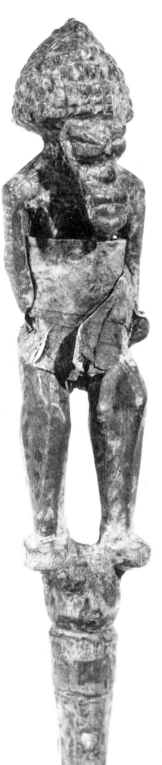

K 24 *Akua kā'ai* image
British Museum, London (HAW75).
Height: 17 in; height of figure: 13½ in.
Human hair on crest. Shell eyes.
Provenance: Undetermined.
Photograph: Cox.
Published: Brigham 1898, fig. 63; Brigham 1913, fig. 222.

K 25 *Akua kā'ai* image
Bernice P. Bishop Museum, Honolulu (7977).
Height: 12 in; height of figure: 3⅞ in.
Eyes inlaid with shell.
Provenance: Undetermined.
Photograph: Bishop Museum.
Published: Buck 1957, fig. 301a.

K 26 *Akua kā'ai* image
Temple Square Museum, Salt Lake City (101).
Height: 10¼ in; height of figure: 6½ in.
Tapa around torso.
Provenance: Undetermined.
Photograph: Temple Square Museum.
Published: Brigham 1898, fig. 71.

K 25

K 26

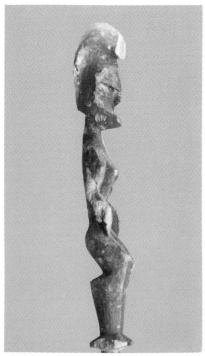

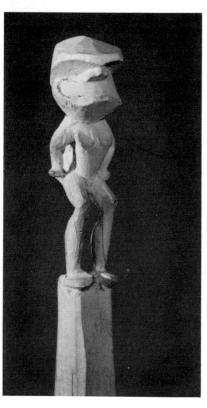

K 27 *Akua kā'ai* image
Bernice P. Bishop Museum, Honolulu
(B6796).
Height: 21 in; height of figure: 10½ in.
Provenance: Undetermined.
Photograph: Bishop Museum.
Published: Buck 1957, fig. 301c.

K 28 *Akua kā'ai* image
Bernice P. Bishop Museum, Honolulu
(6930).
Height: 9½ in; height of figure: 3½ in.
Light-colored wood.
Provenance: Undetermined.
Photograph: Davenport and Cox.

K 27

K 29 *Akua kā'ai* image
Bernice P. Bishop Museum, Honolulu
(1360).
Height: 13½ in; height of figure: 11½
in. Light-colored wood, possibly *'ahakea*.
Provenance: Undetermined.
Photograph: Bishop Museum.
Published: Arning, p. 75.

K 30 *Akua kā'ai* image
Bernice P. Bishop Museum, Honolulu
(1359).
Height: 5½ in; height of figure: 4½ in.
Light-colored wood, possibly *'ahakea*.
Provenance: Undetermined.
Photograph: Bishop Museum.
Published: Arning, p. 75.

K 28

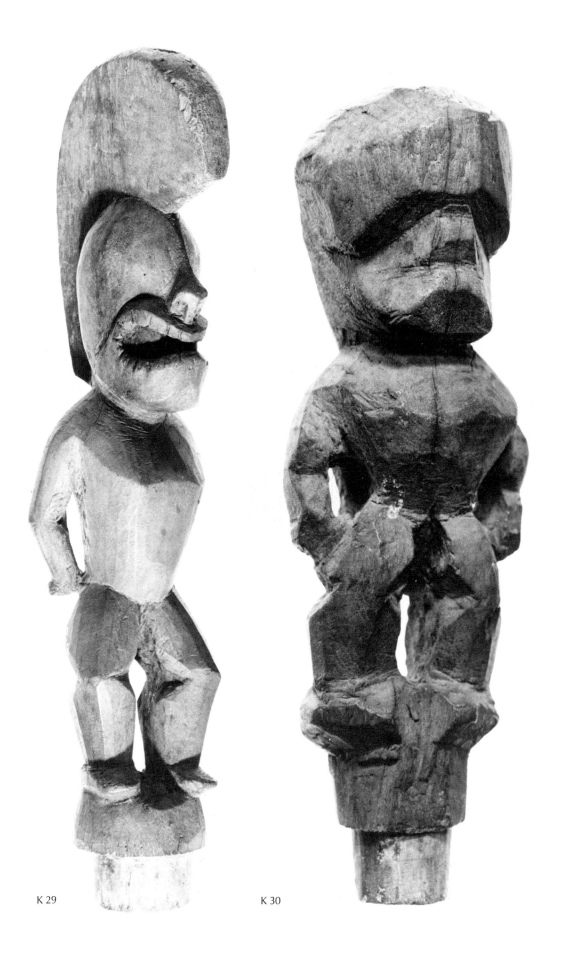

K 29 K 30

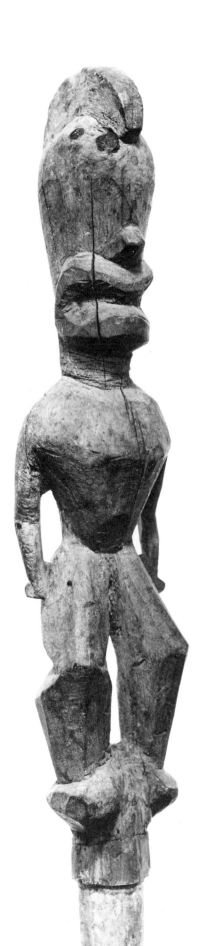

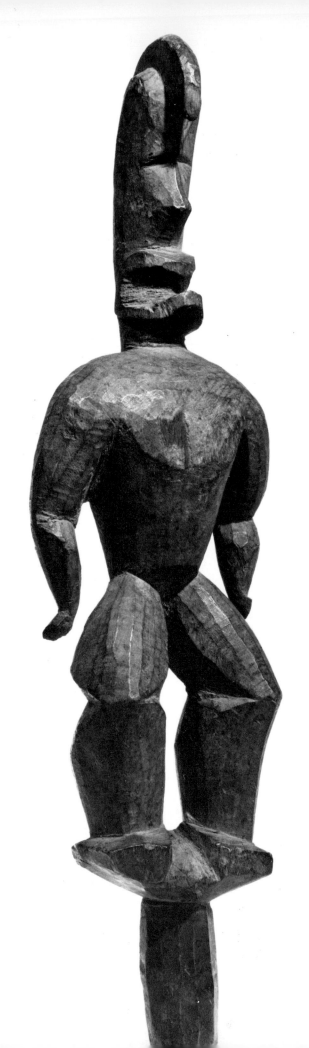

K 31

K 32

K 31 *Akua kā'ai* image
Bernice P. Bishop Museum, Honolulu
(1361).
Height: 10 in; height of figure: 8 in.
Light-colored wood, possibly *'ahakea*.
Provenance: Undetermined.
Photograph: Bishop Museum.
Published: Arning, p. 75.

K 32 *Akua kā'ai* image
Staatliches Museum für Völkerkunde,
Munich (91.49).
Height: 13½ in; height of figure: 11¼ in.
Soft, light-colored wood.
Provenance: Undetermined.
Photograph: Staatliches Museum für
Völkerkunde.
Published: Brigham 1913, fig. 216.

K 33 *Akua kā'ai* image
Staatliches Museum für Völkerkunde,
Munich (L955).
Height: 14½ in. Crudely carved. Soft,
light wood. Base has been cut off.
Provenance: Undetermined.
Photograph: Staatliches Museum für
Völkerkunde.
Published: Brigham 1913, fig. 217.

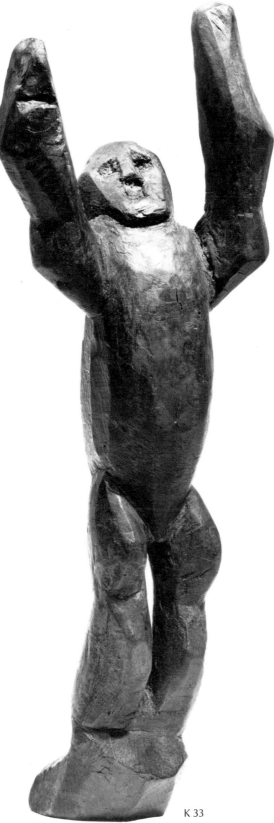

K 33

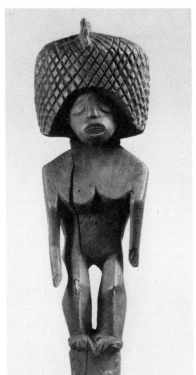

K 34

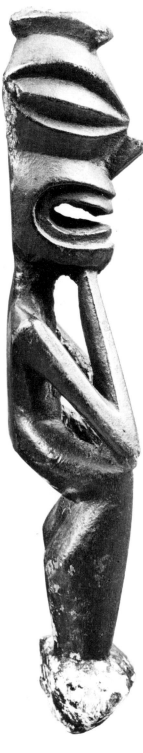

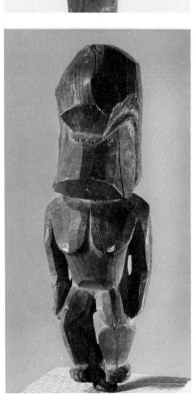

K 35

K 36

K 34 *Akua kā'ai* image
Museum für Völkerkunde, Dahlem, Berlin
(VI 8366). From the Arning Collection.
Height: 37½ in; height of figure: 14¾
in. A light-colored, soft wood, probably
'ahakea.
Provenance: Undetermined.
Photograph: Museum für Völkerkunde.
Published: Behm-Blancke, pl. III; Dodd,
p. 228; Eickhorn, fig. 9.

K 35 *Akua kā'ai* image
Museum für Völkerkunde, Dahlem, Berlin
(VI 8381). From the Arning Collection.
Height: 9 in.
Provenance: Collected from a taro patch
at Wailua, Kauai, in 1887.
Photograph: Museum für Völkerkunde.
Published: Dodd, p. 196; Eickhorn,
fig. 31.

K 36 *Akua kā'ai* image
Museum für Völkerkunde, Dahlem, Berlin
(VI 8379).
Height: 6¾ in. Said to be a sorcery
image.
Provenance: Undetermined.
Photograph: Museum für Völkerkunde.
Published: Eickhorn, fig. 11.

K 37 *Akua kā'ai* image
Museum für Völkerkunde, Dahlem, Berlin
(VI 8382).
Height: 4¾ in; height of figure: 3½ in.
'*Ahakea* wood. Designated as a *kūula*
(fish god).
Provenance: Undetermined. "This figure
which is designated as a fish god Kuula
was found in 1879 by Theodor Lauter
under his house in a hidden cave at the
steep coast line. It was wrapped in Kapa
together with decayed remainders of
a second figure of which only one arm
and one leg were recognizable." Personal
communication from Dr. Henry Kelm,
Museum für Völkerkunde, June 1965.
Photograph: Museum für Völkerkunde.
Published: Eickhorn, fig. 28.

K 38 *Akua kā'ai* image
British Museum, London (LMS1440).
From the London Missionary Society.
Height: 12¾ in; height of figure: 5¾ in.
Provenance: Undetermined.
Photograph: Cox.
Published: Brigham 1913, fig. 16.

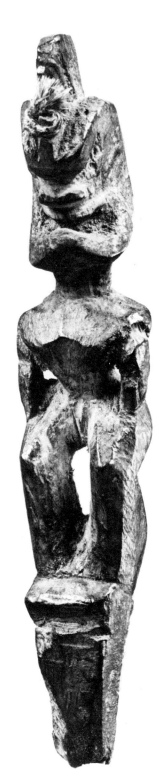

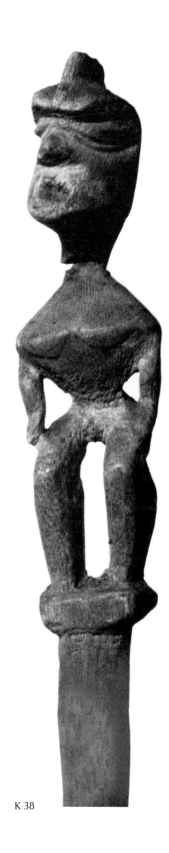

K 37

K 38

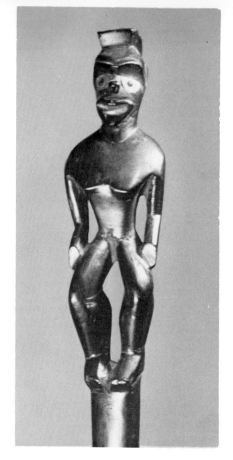

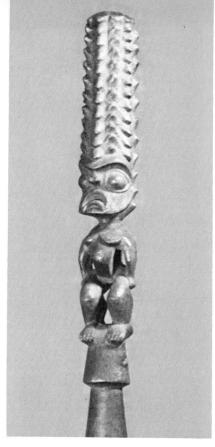

K 39 *Akua kā'ai* image
Canterbury Museum, Christchurch, New Zealand (E 150–1162). From the Oldman Collection (315).
Height: 19 in; height of figure: 7⅜ in.
Hard, dark wood, probably *kauila*.
Provenance: Undetermined.
Photograph: Cox.
Published: Dodd, p. 230; Duff, no. 133; Oldman, pl. 131.

K 40 *Akua kā'ai* image
Canterbury Museum, Christchurch, New Zealand (E 150–1200). From the Oldman Collection (302).
Height: 13 in; height of figure: 5½ in.
Provenance: Undetermined.
Photograph: Cox.
Published: Dodd, p. 228; Duff, no. 134; Oldman, pl. 131.

K 41 *Akua kā'ai* image
University Museum of Archeology and Ethnology, Cambridge, England (22–917). Collected by Admiral Gordon. Later, the property of the Goldsworth family, Widdicombe House, Kingsbridge. Gift of Louis Clark (University Museum curator, deceased), in 1922.
Height: 8½ in. Light brown wood. Fiber cord around neck, feet, and stump of stick support.
Provenance: Undetermined.
Photograph: Cox.
Published: Force and Force, p. 101.

K 42 *Akua kā'ai* image
Collection of Theodore Vredenburg, Hawaii (174, 5).
Height: 23 in; height of top figure: 5½ in; height of lower figure: 3 in. Light brown wood encrusted with black stains. Coconut fiber cord.
Provenance: Mana, Hawaii. Presented to Mr. Vredenburg c. 1940 by Mrs. J. F. Woods (Princess Kalanianaole) of Mana, Hawaii.
Photograph: Cox.

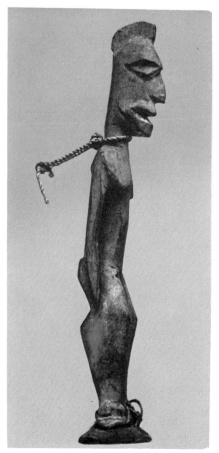

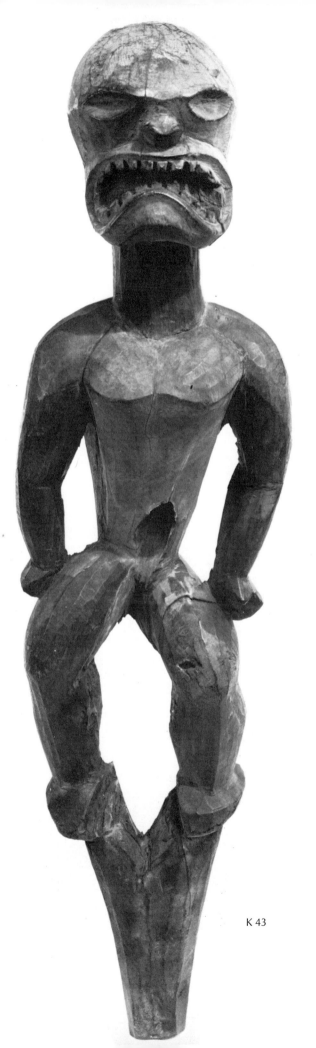

K 43 *Akua kāʻai* image
British Museum, London (HAW74).
Height: 30½ in; height of figure: 24 in.
Provenance: Undetermined.
Photograph: British Museum.
Published: Brigham 1898, fig. 52; Brigham 1913, fig. 221.

K 44 *Akua kāʻai* image
Pitt-Rivers Museum, Oxford, England (AM1704). Given to the Ashmolean Museum in 1826 by Reverend Andrew Bloxam, M.A., Worcester College, Oxford. Height: 12⅛ in. Probably *koa* wood. Provenance: Collected from Hale-o-Keawe, Honaunau, Hawaii, during the voyage of H.M.S. *Blonde* in 1825, with cat. nos. T1, T2, K11, K13, K16, A19. Photograph: Pitt-Rivers Museum. Published: Brigham 1913, fig. 33; Buck 1957, fig. 303a; Poignant, p. 65.

K 43

K 44

K 45

K 46

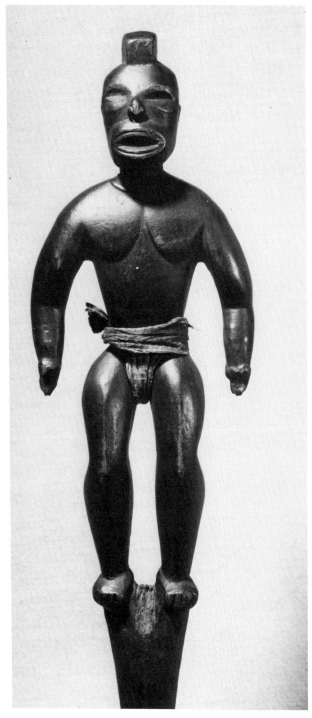

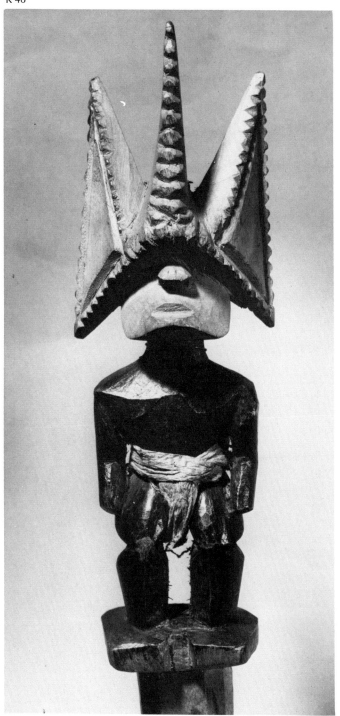

K 45 *Akua kā'ai* image
Royal Scottish Museum, Edinburgh
(UC 384). Collected by the Beechey
expedition, 1827.
Height: 16¼ in; height of figure: 11½ in.
Provenance: Undetermined.
Photograph: Royal Scottish Museum.
Published: Edge-Partington, II: 33, no. 4;
Wardwell, no. 78.

K 46 *Akua kā'ai* image
Royal Scottish Museum, Edinburgh
(1891–26).
Height: 11⅜ in; height of figure: approx.
7 in. Kona style.
Provenance: Undetermined; probably
Kona, Hawaii.
Photograph: Royal Scottish Museum.
Published: Edge-Partington, II: 33, no. 3.

K 47 *Akua kā'ai* image
Collection of Mrs. John M. Crossman,
Boston. Found in the home of David
Flitner, who was married to a Hawaiian
woman, c. 1860.
Height: 12⅞ in; height of figure: 4¾ in.
Provenance: Undetermined.
Photograph: Bishop Museum.

K 48 *Akua kā'ai* image
Collection of Alfred J. Osthiemer,
Honolulu.
Height: 23¾ in; height of figure: 14¾ in.
Dark brown wood, probably *kauila*.
Provenance: Undetermined.
Photograph: Bishop Museum.
Published: Sotheby and Co., no. 121.

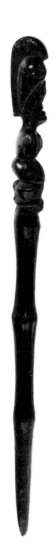

K 47

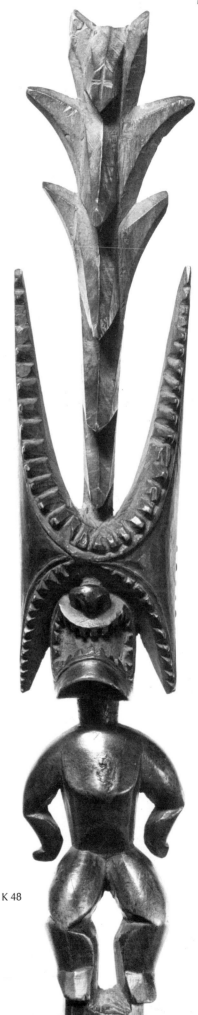

K 48

A 1 *'Aumakua* image
Bernice P. Bishop Museum,
Honolulu (C9595).
Height: 15½ in. Reddish brown wood,
highly polished.
Provenance: Undetermined.
Photograph: Bishop Museum.
Published: Buck 1957, fig. 300a; Dodd,
p. 234; Guiart, pl. 394.

A 2 *'Aumakua* image
Bernice P. Bishop Museum,
Honolulu (9072).
Height: 28½ in. Warm brown, strongly
grained wood, pearl shell eyes, human
hair, plain tapa loincloth in place when
discovered.
Provenance: Collected from a burial cave
at Honokoa Gulch, Kawaihae, Hawaii,
in 1904, with cat. nos. K2, K3, A3, S13,
S14.
Photograph: Davenport and Cox.
Published: Brigham 1906, figs. 2, 3, 4;
Buck 1957, fig. 296a; Guiart, pl. 393;
Luquiens, p. 31.

A 3 *'Aumakua i*mage
Hawaii Volcanoes National Park Museum,
Volcano, Hawaii (01 HNPK–01). From
the David McHattie Forbes Collection.
Height: 27 in. Dark brown wood,
polished. Shell eyes, human hair. When
found, a tongue was inserted into the
hole in the open mouth.
Provenance: Collected from a burial cave
at Honokoa Gulch, Kawaihae, Hawaii,
in 1904, with cat. nos. K2, K3, A2, S13,
S14.
Photograph: Davenport and Cox.
Published: Brigham 1906, figs. 3, 4; Buck
1957, fig. 296b; Honolulu Academy of
Arts, no. 3; Wingert 1953, no. 97.

A 4 *'Aumakua* image
Bernice P. Bishop Museum, Honolulu
(7655). From the American Board Com-
missioners for Foreign Missions, Boston,
1895.
Height: 14½ in. Called "poison god, Kālai-
pāhoa." Rectangular cavity in back of
torso has holes drilled on each side for
attaching a cover. Probably a sorcery
image.
Provenance: Undetermined.
Photograph: Davenport and Cox.
Published: Brigham 1903, p. 14; Buck
1957, fig. 297b; Eickhorn, fig. 37;
Kamakau 1961, p. 208; Luquiens, p. 17.

A 1/A 2

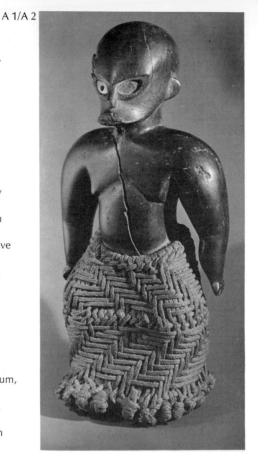 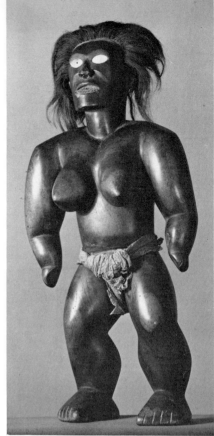

A 3/A 4

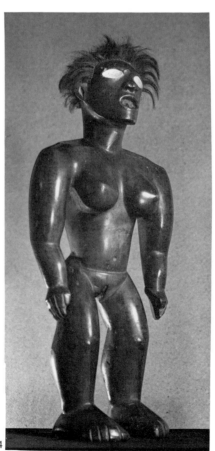 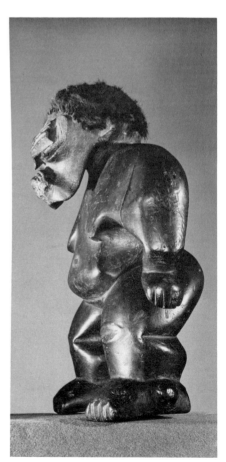

A 5 *'Aumakua* image
Bernice P. Bishop Museum, Honolulu
(7656). From the American Board Com-
missioners for Foreign Missions, Boston,
1895.
Height: 17½ in. Shell eyes and human
hair once in place, now missing.
Provenance: Undetermined.
Photograph: Davenport and Cox.
Published: Buck 1957, fig. 296c; Luquiens,
p. 13.

A 6 *'Aumakua* image
British Museum, London (1657).
Length: 26 in; height: 19 in.
Provenance: Possibly collected from Hale-
o-Keawe, Honaunau, Hawaii, during the
Cook expedition in 1778–1779. James
King, in his report of the third voyage of
Captain Cook, describes this image (or
one like it) as being found at Honaunau:
"... in which they found a black figure
of a man resting on his fingers and toes,

with his head inclined backwards; the
limbs well formed and exactly propor-
tioned, the whole beautifully polished
... called *Maee*, [*mō'i?*] and around it
placed thirteen others of rude and dis-
torted shapes which they said were
Eatooas [*akua*]" (Cook, *A Voyage to the
Pacific Ocean*, 3: 160). Lord Byron, in his
account of the *Blonde* in 1824–1825,
mentions this statement by King, but
not in reference to the images at Hale-o-
Keawe. Byron wrote: "The year is sacred,
and called *Maee*. Now it is curious
that Captain King saw a polished idol
called *Maee*, of unusually good work-
manship, resting on its toes and fingers,
and having about it thirteen small idols
representing inferior *Eatooas* or spirits;
these probably were designed for the
thirteen months of which the year was
composed" (Byron, *Voyage of H.M.S.
Blonde*, p. 12). Byron had not seen the
image in question and assumed an
incorrect meaning for it. *Mō'ī* is the cen-
tral and major god of a group of gods
(*akua*). The image was probably not at
Hale-o-Keawe in 1825; otherwise either
Bloxam or Byron would have mentioned
it in their rather complete descriptions
of the contents of the house.
Photograph: British Museum.
Published: Brigham 1898, fig. 56; Edge-
Partington, I: 58, no. 6.

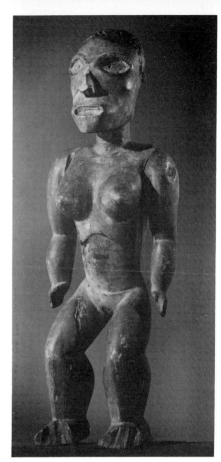

A 5

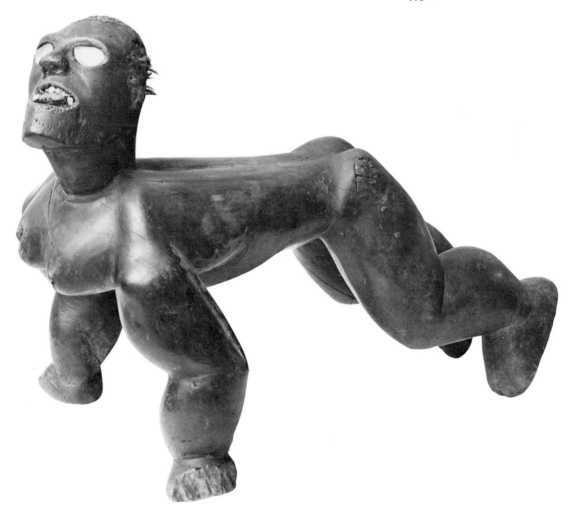

A 6

A 7 *'Aumakua* image
Staatliches Museum für Völkerkunde,
Munich (91.50).
Height: 29 in.
Provenance: Undetermined. Authenticity
doubtful on the basis of style.
Photograph: Staatliches Museum für
Völkerkunde.
Published: Brigham 1913, fig. 215.

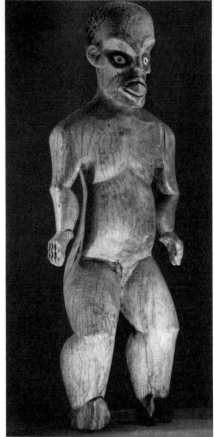

A 9

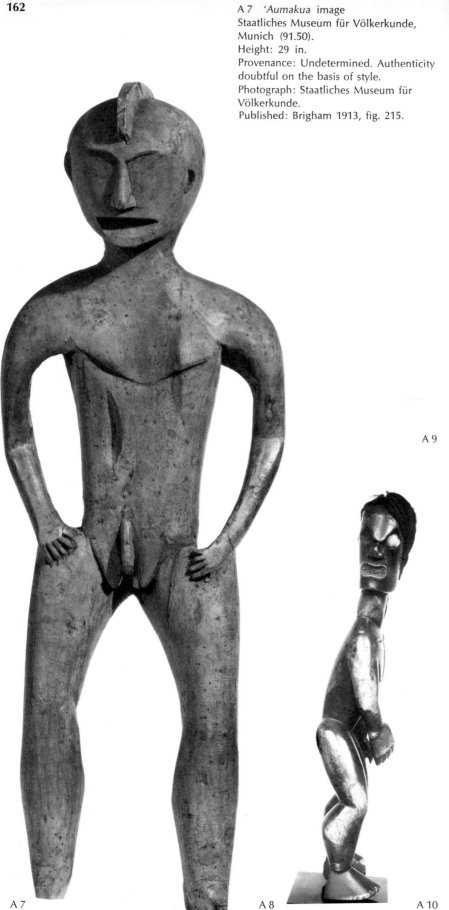

A 7

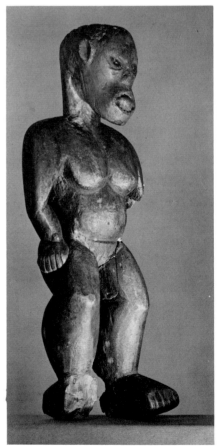

A 8

A 10

A 8 *'Aumakua* image
National Museum of Ireland, Dublin
(1607/80). Presented by the Royal Dublin
Society, 1880.
Height: 24 in. One pearl shell eye re-
mains in place. Human hair is pegged in
with iron nails.
Provenance: Undetermined.
Photograph: National Museum of Ireland.
Published: Buck 1957, fig. 297c; Dodd,
p. 234.

A 9 *'Aumakua* image
Bernice P. Bishop Museum, Honolulu
(132). From the J. S. Emerson Collection,
1888.
Height: 36 in. Possibly a sorcery image.
It has an elliptical cavity in the back,
from the shoulders to the base of the
spine, with perforations at the edges for
attaching a cover. The eyes are of paper
or tapa, rimmed with black paint. Some
bristles of human hair remain pegged
into the head. Lizards are painted in
black on the forehead, cheeks, and chin.
This latter detail fits the description of
the tattoo of Keawe-ai in a genealogy
given by Lo'e to John F. G. Stokes in 1919
at Hale-o-Keawe, Honaunau, Hawaii
(Stokes unpubl. ms.).
Provenance: Collected at Hauula, Koolau,
Oahu, 1852.
Photograph: Bishop Museum.
Published: Bishop Museum, fig. 32;
Brigham 1903, fig. 73; Buck 1957, fig. 297.

A 10 *'Aumakua* image
Bernice P. Bishop Museum, Honolulu
(7658). From the American Board Com-
missioners for Foreign Missions, Boston,
1895. Obtained from Mr. Samuel Ruggles,
who was in Hawaii from 1820–1835.
Height: 27 in.
Provenance: Kaawaloa, Hawaii, c. 1830.
Photograph: Davenport and Cox.
Published: Buck 1957, fig. 296e; Luquiens,
p. 55.

A 11 *'Aumakua* image
Museum für Völkerkunde, Dahlem, Berlin
(VI 8375).
Height: 16⅞ in. Possibly a sorcery image.
Human teeth set into the mouth. There
is a cavity in the back of the head. *Kou*
wood.
Provenance: Collected in the vicinity of
Laupahoehoe-iki, Hamakua, Hawaii, in
1880. This image, a human skull, and the
torso of an image similar to cat. no. T31
were found in a stone-lined cavity
covered by a flat stone.
Photograph: Museum für Völkerkunde.
Published: Archey, pl. 16; Arning, pl. 1;
Buck 1957, fig. 300b; Edge-Partington,
III: 2; Eickhorn, fig. 7; Tischner and
Hewicker, pl. 89.

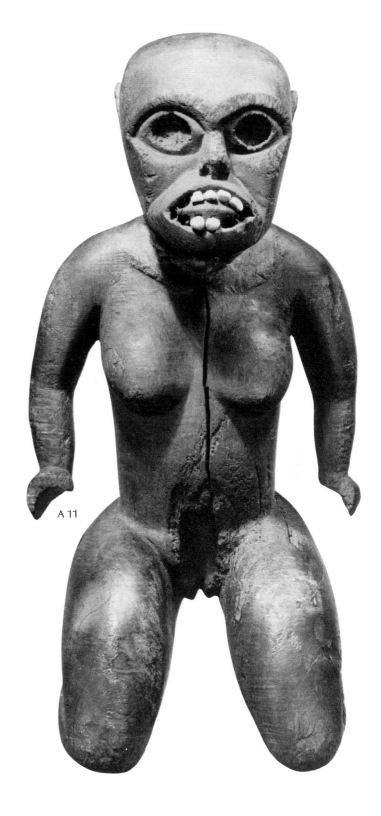

A 11

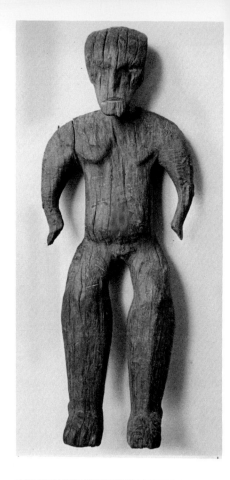

A 12 *'Aumakua* image
Bernice P. Bishop Museum, Honolulu
(6921). From the Kalanianaole Collection.
Height: 29 in.
Provenance: Undetermined.
Photograph: Bishop Museum.
Published: Buck 1957, fig. 299c; Wingert
1953, no. 98.

A 13 *'Aumakua* image
Bernice P. Bishop Museum, Honolulu
(B2739). On loan from the Damon
Collection.
Height: 16¾ in. Possibly a sorcery image.
There is a cavity in the center of the
back.
Provenance: Undetermined.
Photograph: Bishop Museum.
Published: Buck 1957, fig. 298a.

A 14 *'Aumakua* image
Collection of Warner Muensterberger,
New York.
Height: 23¼ in.
Provenance: Undetermined.
Photograph: Bishop Museum.
Published: Luquiens, p. 29.

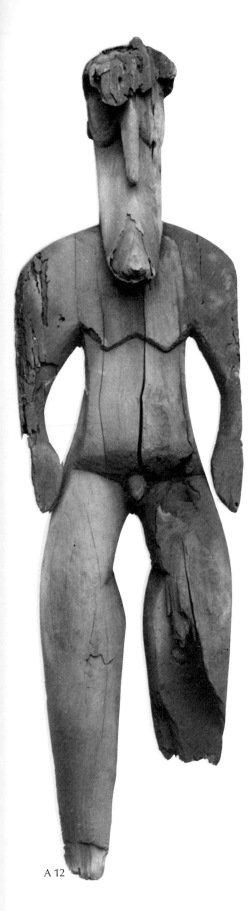

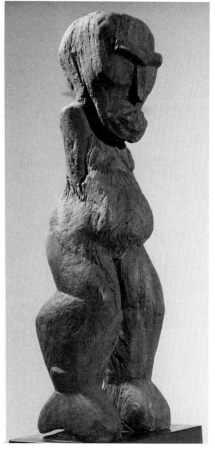

A 12 A 14

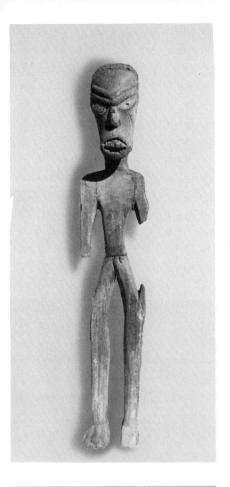

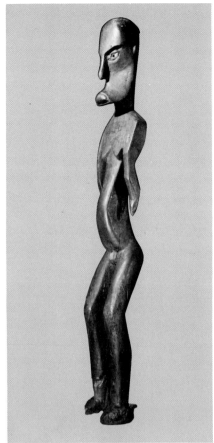

A 15 'Aumakua image
Bernice P. Bishop Museum, Honolulu (D3718). Acquired in 1965 from the Huntington Historical Museum, Huntington, Long Island. Collected by the missionary Reuben Hough prior to 1850. Height: 50½ in. Coconut wood. It is sawed in two at the waist and rejoined with an iron strap in the back.
Provenance: Undetermined.
Photograph: Bishop Museum.

A 16 'Aumakua image
Bernice P. Bishop Museum, Honolulu (7654). From the American Board Commissioners for Foreign Missions, Boston, 1895.
Height: 38 in.
Provenance: Undetermined.
Photograph: Davenport and Cox.
Published: Buck 1957, fig. 298c; Luquiens, p. 56.

A 17 'Aumakua image
Bernice P. Bishop Museum, Honolulu (1363). From the Hawaiian Government Collection.
Height: 21 in.
Provenance: Undetermined.
Photograph: Bishop Museum.
Published: Buck 1957, fig. 299b; Wingert 1953, no. 99.

A 18 'Aumakua image
National Museum of Ireland, Dublin (1606/80). Presented by the Royal Dublin Society in 1880.
Height: 14 in.
Provenance: Undetermined.
Photograph: National Museum of Ireland.
Published: Buck 1957, fig. 299a; Wardwell, no. 77.

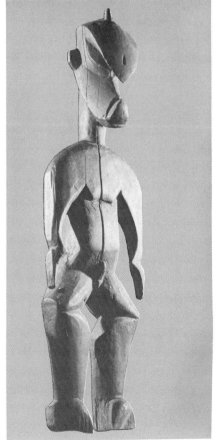

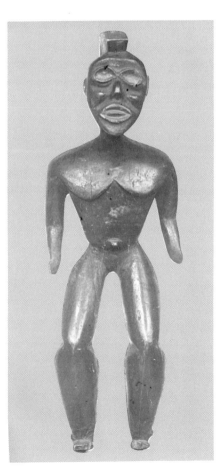

A 17/A 18

A 19 *'Aumakua* image
British Museum, London (1944 OC 2.716).
Height: 16 in. A seed is set into pearl
shell in the left eye. There is a socket for
a tongue. The *malo* is tapa, very solidi-
fied. Human hair pegged into the head.
Sex not discernible.
Provenance: Collected by John Knowles
at Hale-o-Keawe, Honaunau, Hawaii,
in 1825, during the voyage of H.M.S.
Blonde, with cat. nos. T1, T2, K11, K13,
K16, K44.
Photograph: Cox.
Published: Buck 1957, fig. 296d; Dodd,
p. 234; Emory 1938, pl. II;
Tischner and Hewicker, pl. 88.

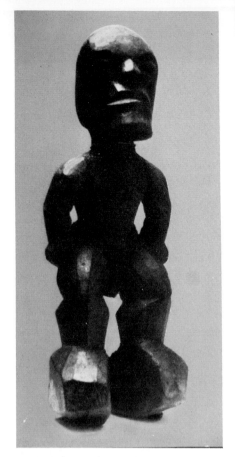

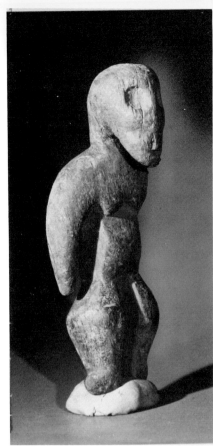

A 19 A 22/A 23

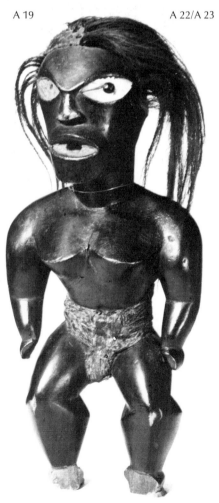

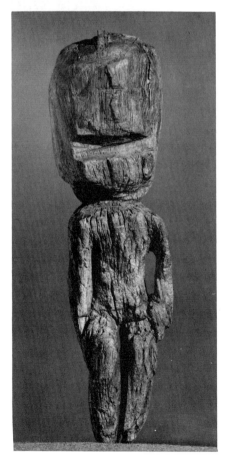

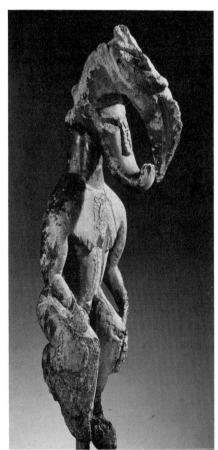

A 20 'Aumakua image
Collection of James T. Hooper (1632).
Formerly the Totems Museum, Arundel,
England. Image taken to England by
Captain Cutler, who lived in Hawaii prior
to 1880.
Height: 16 in.
Provenance: Undetermined.
Photograph: Cox.
Published: Rousseau, fig. 184.

A 21 'Aumakua image
Bernice P. Bishop Museum, Honolulu
(x59).
Height: 6⅛ in.
Provenance: Undetermined.
Photograph: Davenport and Cox.

A 22 'Aumakua image
Bernice P. Bishop Museum, Honolulu
(D11).
Height: 8¼ in. Light brown wood,
crudely carved.
Provenance: Undetermined.
Photograph: Davenport and Cox.

A 23 'Aumakua image (?)
Bernice P. Bishop Museum, Honolulu
(1341). From the Pacific Sugar Mill,
through L. H. Waldron.
Height: 19 in. Stained black. There is a
second face on the upper surface of
the crest. The image is badly eroded and
it is impossible to determine whether
it was on a post base as a temple image,
or freestanding as an 'aumakua image.
Provenance: Collected from a cliff cave at
Kukuihaele, Hawaii.
Photograph: Bishop Museum.

A 24 'Aumakua image
Private collection, London. Formerly in
the collection of the Earls of Warwick.
Height: 10¼ in; height of figure: 7¾ in.
Dark brown wood, polished. Human
hair, pearl shell in left eye. Rectangular
cavity in the crown of the head 1 × ⅞ ×
1½ in deep. Possibly a sorcery image.
Provenance: Undetermined. Probably
collected prior to 1780, possibly during
Captain Cook's third voyage.
Photograph: Raymond Fortt, London.
Published: Sotheby and Co., no. 178.

A 24

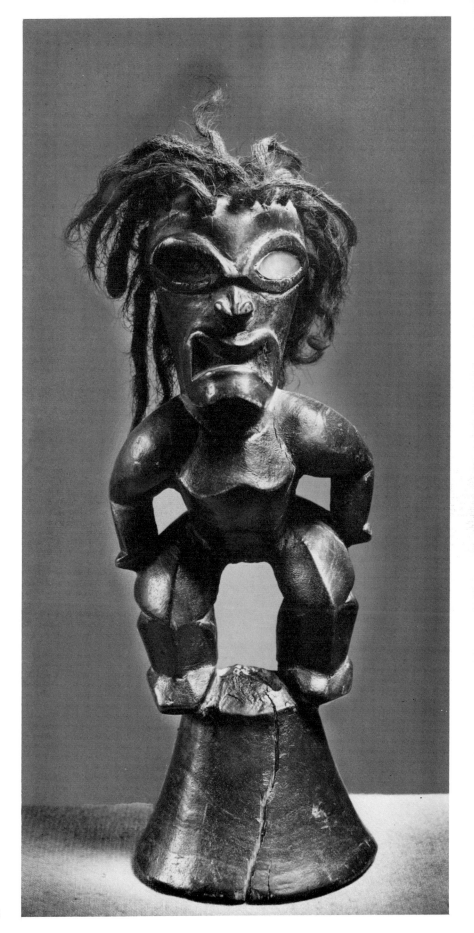

168

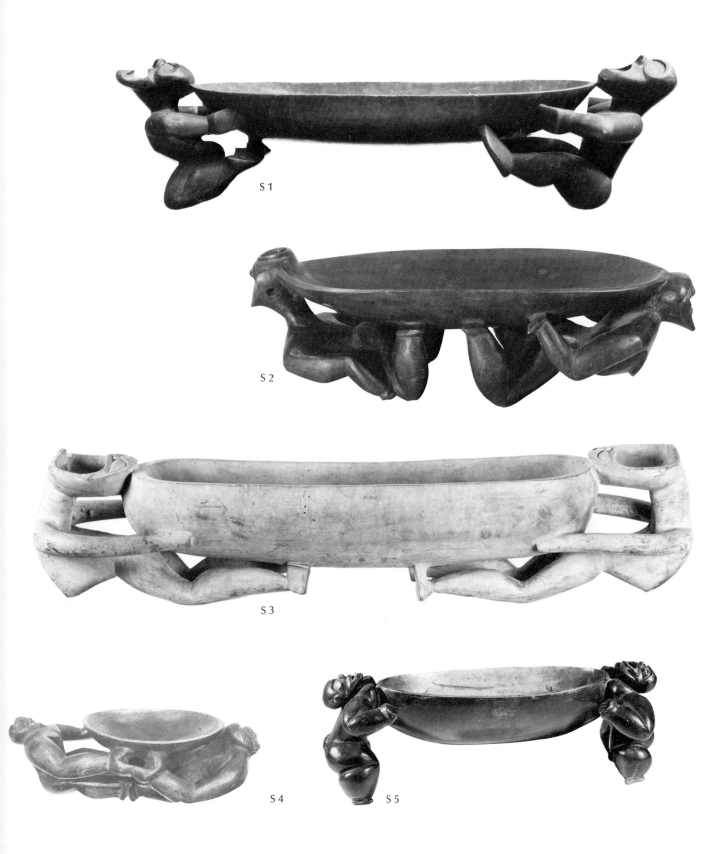

S 1

S 2

S 3

S 4 S 5

S 1 Bowl with two support figures
Bernice P. Bishop Museum, Honolulu
(408). From the Princess Keelikolani
Collection.
Length: 45½ in; height: 12 in. The
mouths of the figures are small supple-
mentary dishes. The eyes may have been
inlaid with shell.
Provenance: Undetermined.
Photograph: Davenport and Cox.
Published: Brigham 1903, fig. 69; Buck
1957, fig. 25a; Cox 1960, p. 53; Dodd,
p. 165; Luquiens, p. 40.

S 2 Bowl with two support figures
Rijksmuseum voor Volkenkunde, Leiden
(547–2).
Length: 13¾ in; height: 6¼ in. Eyes are
of pearl shell.
Provenance: Undetermined.
Photograph: Rijksmuseum voor Volken-
kunde.
Published: Brigham 1898, pl. XI; Dodd,
p. 232.

S 3 Bowl with two support figures
Musée de l'Homme, Paris (80–75–2).
Length: 38 in; height: 9 in. The figures
face outward, the mouths are open as
supplementary dishes.
Provenance: Undetermined.
Photograph: Musée de l'Homme.
Published: Luquiens, p. 40.

S 4 Bowl with two support figures
Peabody Museum, Cambridge, Mass.
(53571). From the Boston Museum. Gift
of the David Kimball heirs in 1899.
Length: 12¼ in; height: 3⅛ in. Stained
black.
Provenance: Undetermined.
Photograph: Bishop Museum.
Published: Buck 1957, fig. 25c; Linton,
Wingert, and d'Harnoncourt, p. 65;
Wardwell, no. 83.

S 5 Bowl with two support figures
Bernice P. Bishop Museum, Honolulu
(5181). From the Queen Emma Collec-
tion. Said to have been owned by King
Liholiho (Kamehameha II) and his
ancestors.
Length: 10 in; height: 3¾ in. Dark wood,
stained black and polished. Possibly
an 'awa bowl.
Provenance: Undetermined.
Photograph: Davenport and Cox.
Published: Buck 1957, fig. 25b; Edge-
Partington, III: 13.

S 6 Bowl with two support figures
British Museum, London (HAW46).
Length: 18 in; height: 9⅞ in. Kou wood,
pearl shell eyes, teeth made from sec-
tions of bone. Two openings, through the
mouth of one figure and through the
upper body of the other. Probably an
'awa bowl. One of a pair (with cat.
no. S7).
Provenance: Undetermined.
Photograph: British Museum.
Published: Brigham 1898, fig. 97; Brigham
1913, fig. 12; British Museum, fig. 153;
Buck 1957, fig. 26a; Cox 1960, p. 53;
Edge-Partington, III: 58, no. 3; Guiart,
pl. 395; Kamakau 1961, p. 16; Muenster-
berger, pl. 120; Tischner and Hewicker,
pl. 86.

S 6

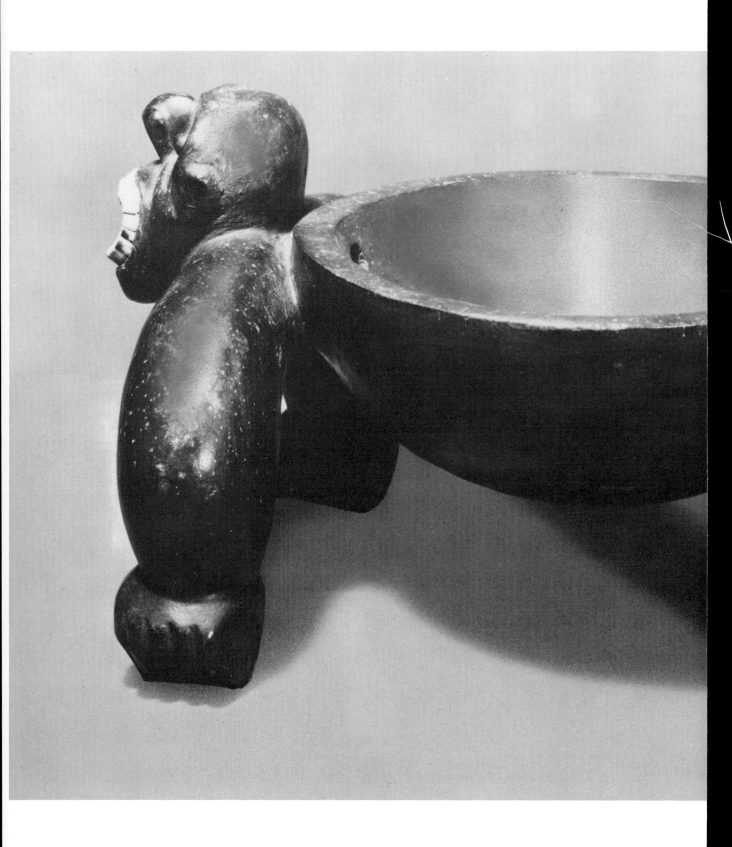

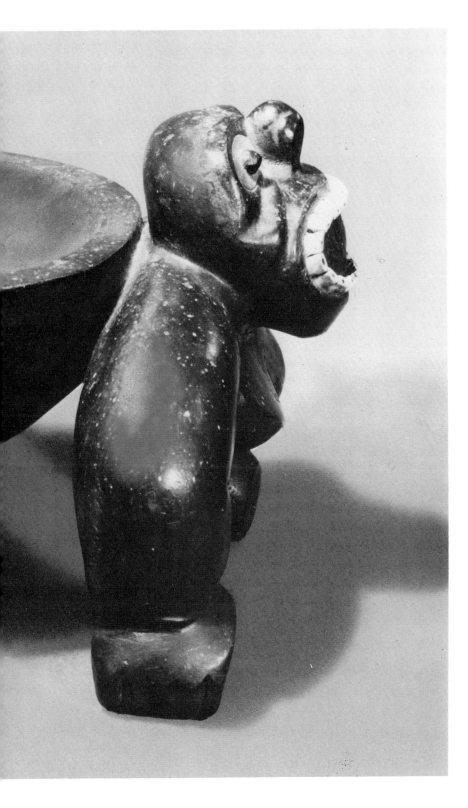

S 7 Bowl with two support figures
Collection of John J. Klejman, New York.
Length: 17½ in; height: 9½ in. One of
a pair (with cat. no. S6). Probably of *kou*
wood. Pearl shell eyes held in place
with wooden pegs. Teeth made from
sections of bone. Two openings, from the
bowl through the mouth of each figure.
Probably an *'awa* bowl.
Provenance: Undetermined.
Photograph: Bishop Museum, courtesy of
John J. Klejman.

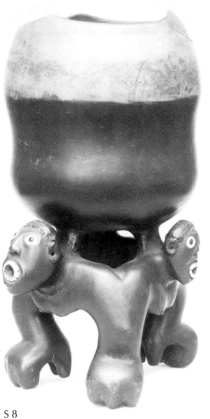

S 8

S 8 Bowl with three support figures
British Museum, London (HAW48).
Height: 11¾ in; diameter: 3¾ in. *Kou*
wood stained black except for upper
third of bowl. Shell eyes with seed centers, human teeth. A *poi* bowl.
Provenance: Undetermined.
Photograph: British Museum.
Published: Brigham 1898, fig. 51; Brigham
1906, fig. 14; Brigham 1913, fig. 51;
Buck 1957, fig. 26b; Edge-Partington, I:
58, no. 4.

S 9 Bowl with three support figures
British Museum, London (54, 12–27, 119).
Height: 7¾ in. Hard, brown wood.
Provenance: Undetermined.
Photograph: Cox.
Published: Archey, pl. 17a; Brigham 1898,
fig. 54; Brigham 1913, fig. 10; Edge-
Partington, I: 58, no. 5; Guiart, pl. 396;
Tischner and Hewicker, pl. 87.

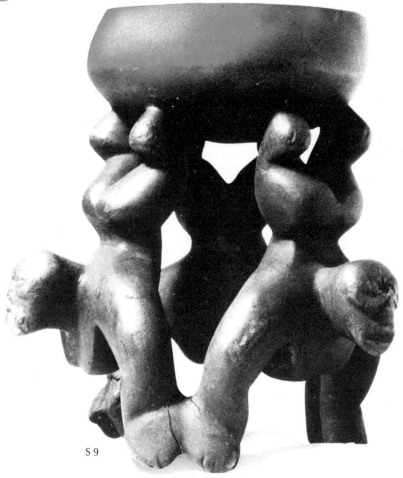

S 9

S 10 Bowls joined by a figure
British Museum, London (HAW47).
Length: 11 in. Eyes inlaid with shell.
Human hair and a small bundle of red
feathers attached to the head. Tapa *malo*.
Shell disks set in as joint marks held
in place with wooden pegs.
Provenance: Undetermined.
Photograph: British Museum.
Published: Brigham 1898, fig. 55; Buck
1957, fig. 26c; Edge-Partington, I: 58,
no. 7; Guiart, pl. 397.

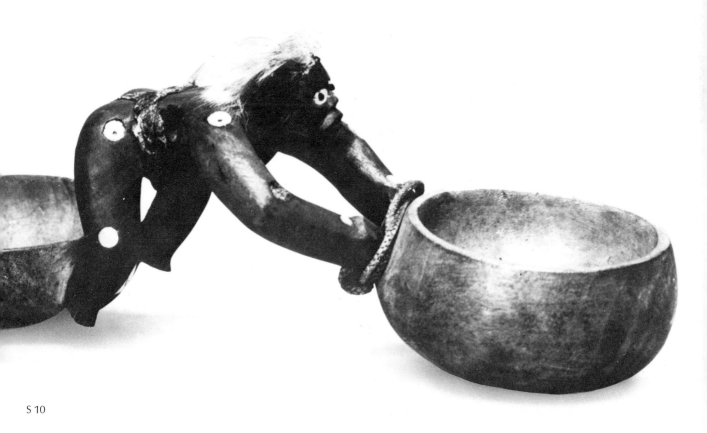

S 10

S 11 Bowl with figure as a handle
Museum für Völkerkunde, Vienna (175).
Total length: 11¼ in; length of figure:
approx. 3 in.
Provenance: Undetermined.
Photograph: Bishop Museum.
Published: Brigham 1898, fig. 8.

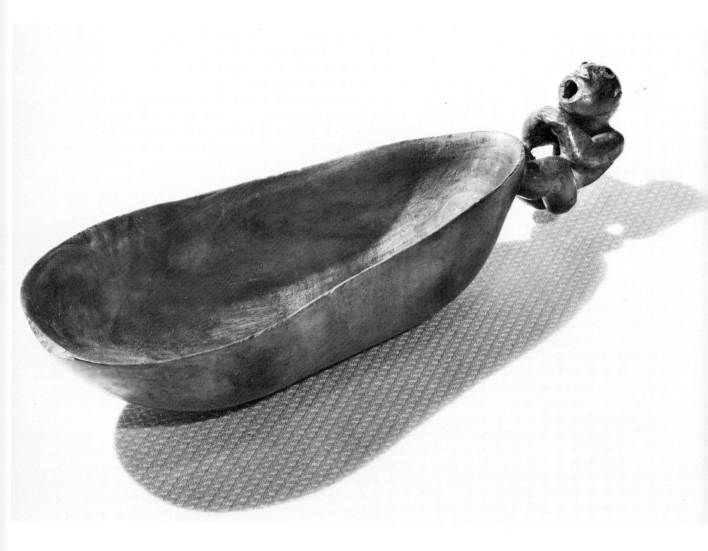

S 11

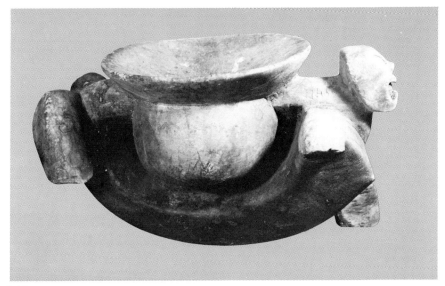

S 12

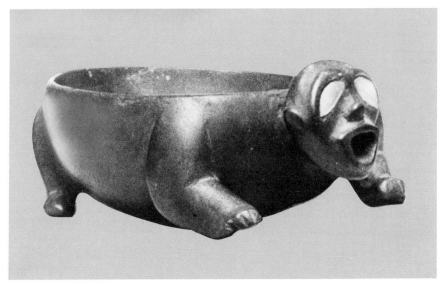

S 13

S 12 Bowl with support figure
Bernice P. Bishop Museum, Honolulu
(D565).
Length: 18 in; height: 9½ in. *Koa* wood.
Provenance: Collected from a cave in a
valley above Pearl Harbor, Oahu, 1953.
Photograph: Bishop Museum.

S 13 Bowl figure
University Museum of Archeology and
Ethnology, Cambridge, England (22.916).
Length: 7 in; height: 3 in. Dark brown
wood. Eyes inlaid with shell. A hole
through the mouth functioned as a
pouring spout.
Provenance: Undetermined.
Photograph: Cox.

S 14 Bowl with two figures
Bernice P. Bishop Museum, Honolulu
(9073). Purchased from William Wagner.
Length: 14 in; height: 9¼ in; diameter:
10½ in. Bowl and figures inlaid with
human molars. The upright figure has
square holes in the head for attaching
hair. Probably a food refuse bowl.
Provenance: Collected from a burial cave
at Honokoa Gulch, Kawaihae, Hawaii,
in 1904, with cat. nos. K2, K3, A2, A3,
S14.
Photograph: Bishop Museum.
Published: Brigham 1906, figs. 7, 8, 9, 10;
Buck 1957, fig. 33f.

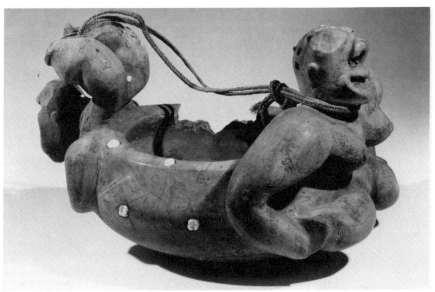

S 14

S 15 Game board with two support figures

Hawaii Volcanoes National Park Museum, Volcano, Hawaii (02 HNPK–01). From the David McHattie Forbes Collection. Length: 13⅜ in; width: 10½ in; height: 8 in. Dark brown wood, polished. The eyes were originally inlaid with shell. Called a *papamū*, a board on which the game *kōnane* is played.
Provenance: Collected from a burial cave at Honokoa Gulch, Kawaihae, Hawaii, in 1904, with cat. nos. K2, K3, A2, A3, S13.
Photograph: Davenport and Cox.
Published: Brigham 1906, fig. 13; Buck 1957, fig. 245c; Luquiens, p. 54; Wingert 1953, no. 102.

S 16 Carrying pole with two heads at each end

Collection of Dr. J. C. FitzGerald, Maui (1).
Length of pole: 59¼ in; average length of heads: 2 in. *Kauila* wood.
Provenance: Undetermined.
Photograph: Bishop Museum.

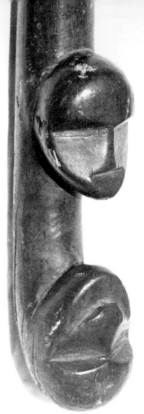

S 16

S 15

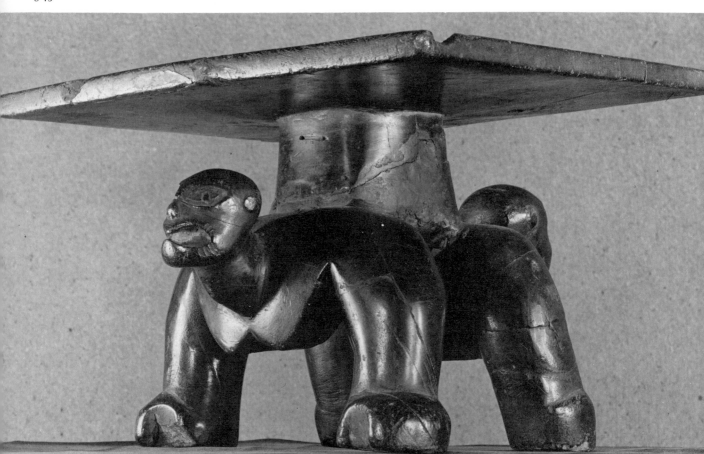

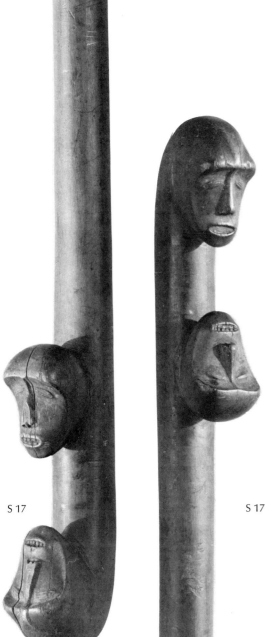

S 17

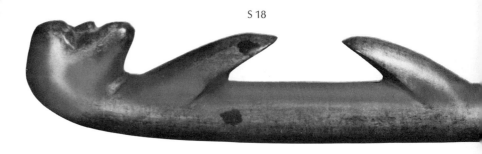

S 17

S 18

S 17 Carrying pole with two heads at each end
Bernice P. Bishop Museum, Honolulu (144). From the J. S. Emerson Collection (356).
Length: 71½ in; average length of head: 2½ in.
Provenance: Undetermined.
Photograph: Davenport and Cox.
Published: Buck 1957, fig. 6a; Edge-Partington, III: 5, no. 16.

S 18 Carrying pole with one head at each end
Canterbury Museum, Christchurch, New Zealand (E 150.1186). From the Oldman Collection (300).
Length: 67½ in; length of heads: 1½ in and 2¼ in. *Kauila* wood.
Provenance: Undetermined.
Photograph: Cox.
Published: Duff, no. 136; Oldman, pl. 130.

S 19 Carrying pole with one head at each end
Bernice P. Bishop Museum, Honolulu (146).
Length: 69½ in; length of heads: 3 in and 3½ in.
Provenance: Undetermined.
Photograph: Bishop Museum.
Published: Buck 1957, fig. 6c; Edge-Partington, III: 5, no. 19.

S 20 Carrying pole with two heads at each end
Bernice P. Bishop Museum, Honolulu (145).
Length: 85¾ in; average length of heads: 2 in.
Provenance: Undetermined.
Photograph: Bishop Museum.
Published: Buck 1957, fig. 6; Edge-Partington, III: 5, no. 17.

S 21 Carrying pole with two heads at each end
Chicago Natural History Museum (273597). From the A. W. F. Fuller Collection.
Length: 63 in; average length of heads: 2¾ in. Dark brown wood, polished.
Provenance: Undetermined.
Photograph: Chicago Natural History Museum.

S 19

S 20

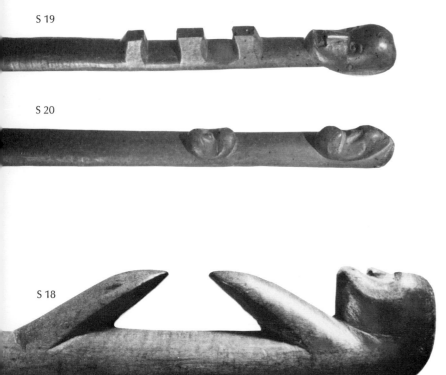

S 18

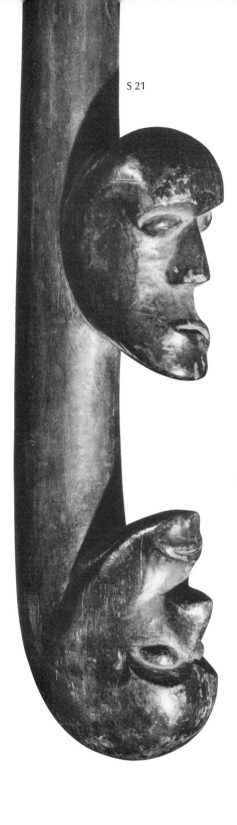

S 21

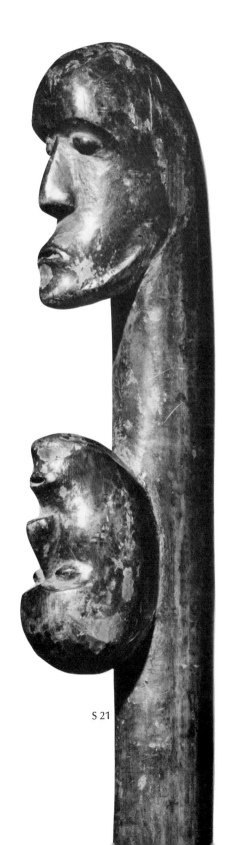

S 21

180

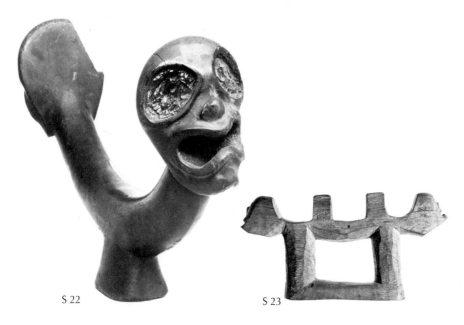

S 22

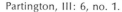

S 23

S 22 Support rack with two heads
British Museum, London (VAN313).
From the Vancouver Collection. Probably
collected in 1792 during Vancouver's
visit to Hawaii.
Length: 12 in; height: 7 in. Hard, brown
wood, highly polished. Eyes once inlaid.
Described as a spear rack.
Provenance: Undetermined.
Photograph: British Museum.
Published: Edge-Partington, II: 32, no. 9.

S 23 Support rack with two heads
Bernice P. Bishop Museum, Honolulu
(3907). From the Hawaiian Government
Collection.
Length: 13¼ in; height: 6½ in; height
of heads: 2½ in. Light brown wood. A
rack for securing fish spears or poles
to the outrigger boom of a canoe.
Provenance: Undetermined.
Photograph: Bishop Museum.
Published: Buck 1957, fig. 196e; Edge-
Partington, III: 6, no. 4.

S 24 Support rack with a figure on
each end
Bernice P. Bishop Museum, Honolulu
(3905).
Length: 25 in; height of figure: 4 in.
Light brown wood. Lashing holes at the
base of each end. One figure has been
broken off and lost. A rack for secur-
ing fish spears or poles to the outrigger
boom of a canoe.
Provenance: Undetermined.
Photograph: Bishop Museum.
Published: Buck 1957, fig. 196b; Edge-
Partington, III: 6, no. 1.

S 24

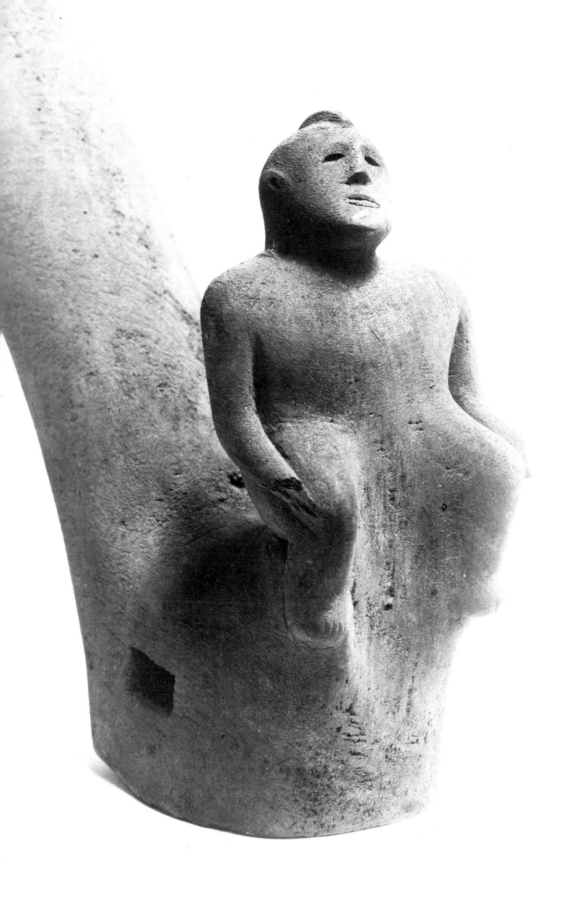

S 24

S 25

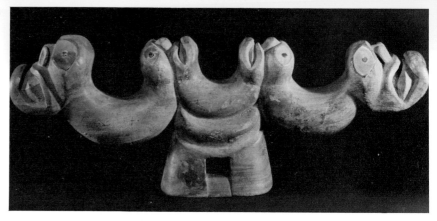

S 25 Support rack with four heads
Museum für Völkerkunde, Dahlem, Berlin
(VI 257).
Length: 13 in; height: 4¾ in. Eyes inland
with shell. A spear or pole rack, prob-
ably for a canoe.
Provenance: Undetermined.
Photograph: Museum für Völkerkunde.
Published: Dodd, p. 115; Eickhorn, fig. 35.

S 26 Support rack with two heads
Bernice P. Bishop Museum, Honolulu
(3906). From the Hawaiian Government
Collection.
Length: 10 in; height: 4 in; height of
heads: 3 in. A pole or spear rack, prob-
ably for use on a canoe.
Provenance: Undetermined.
Photograph: Davenport and Cox.
Published: Buck 1957, fig. 196d; Edge-
Partington, III: 6, no. 3.

S 27 Support rack figure
British Museum, London (4681).
Length: 10 in. A pole or spear rack,
possibly for a canoe.
Provenance: Undetermined.
Photograph: British Museum.
Published: Edge-Partington, I: 58, no. 8.

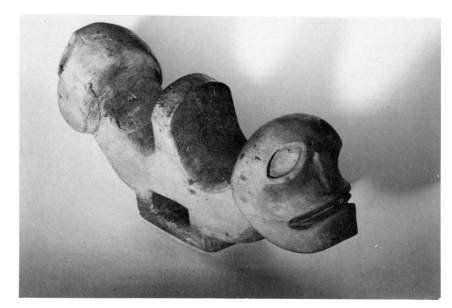

S 26

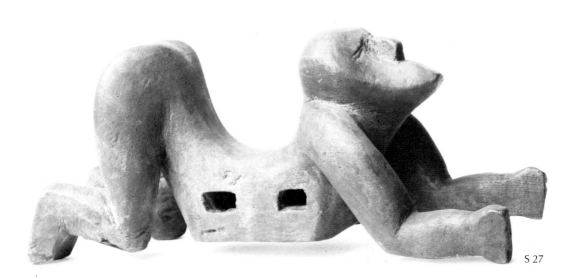

S 27

S 28 Drum with eighteen support figures
and nine heads
Canterbury Museum, Christchurch, New
Zealand (150.1185). From the Oldman
Collection (301).
Height: 18½ in; diameter: 13¼ in;
height of figures: approx. 4 in. Eyes were
at one time inlaid. Drum and base
carved from one piece of wood.
Provenance: Undetermined.
Photograph: Cox.
Published: Archey, pl. 17b; Buck 1957,
fig. 260b; Dodd, p. 179; Duff, no. 127;
Muensterberger, pl. 121; Oldman, pl. 123.

S 29 Drum base with seven figures and
seven heads
Bernice P. Bishop Museum, Honolulu
(D309). A gift from Geoffrey C. Davies
from the Theo. F. Davies Collection.
Height: 7 in; diameter: 6½ in. *Kou* wood.
Provenance: Undetermined.
Photograph: Bishop Museum.
Published: Bishop Museum, p. 16; Buck
1957, fig. 261; Cox 1960, p. 52; Dodd,
p. 233.

S 30 Drum with five figures
Collection of James T. Hooper (1686).
Formerly the Totems Museum, Arundel,
England.
Height: 11⅝ in; diameter: 6½ in.
Provenance: Undetermined.
Photograph: Cox.
Published: Poignant, p. 57; Rousseau,
fig. 185.

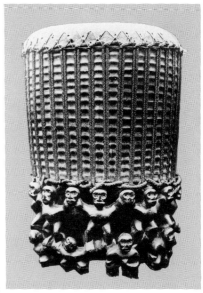

S 28

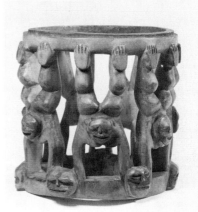

S 29

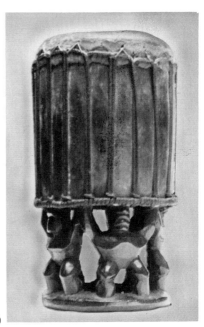

S 30

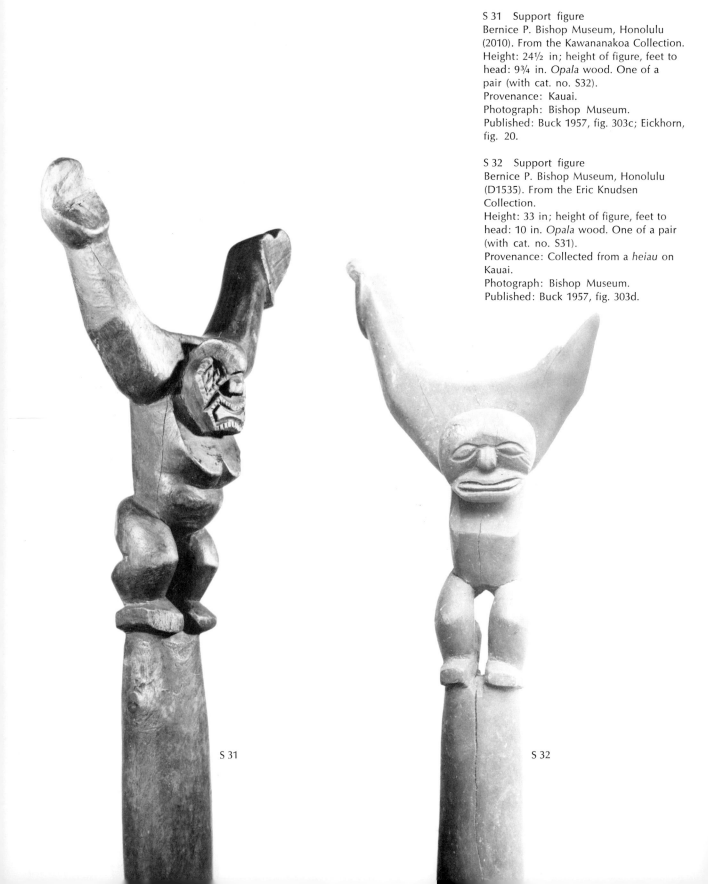

S 31 Support figure
Bernice P. Bishop Museum, Honolulu
(2010). From the Kawananakoa Collection.
Height: 24½ in; height of figure, feet to
head: 9¾ in. *Opala* wood. One of a
pair (with cat. no. S32).
Provenance: Kauai.
Photograph: Bishop Museum.
Published: Buck 1957, fig. 303c; Eickhorn,
fig. 20.

S 32 Support figure
Bernice P. Bishop Museum, Honolulu
(D1535). From the Eric Knudsen
Collection.
Height: 33 in; height of figure, feet to
head: 10 in. *Opala* wood. One of a pair
(with cat. no. S31).
Provenance: Collected from a *heiau* on
Kauai.
Photograph: Bishop Museum.
Published: Buck 1957, fig. 303d.

S 31 S 32

S 33 Support figure
Bernice P. Bishop Museum, Honolulu
(2300). From Charles E. Potter.
Height: 5½ in.
Provenance: Collected in Kona, Hawaii,
by Dr. Seth Andrews, who was a medical
missionary there, 1836–1848.
Photograph: Bishop Museum.

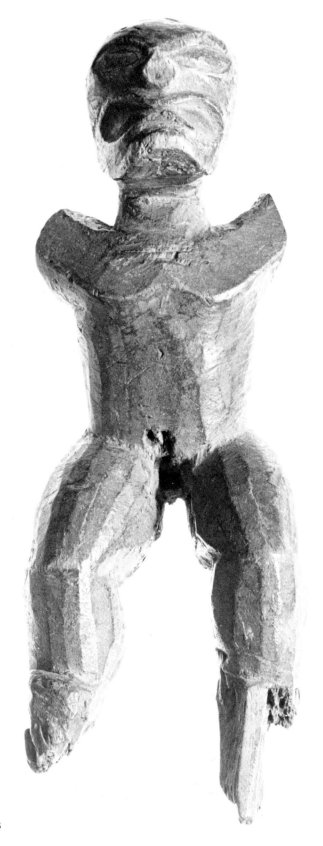

S 33

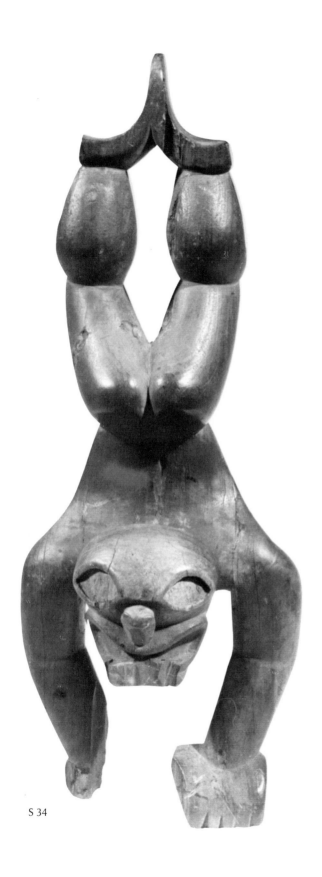

S 34

S 34 Support figure
Bernice P. Bishop Museum, Honolulu
(C8816).
Height: 15½ in. The hands were lashed
to a horizontal bar, the feet joined to
form a double-crescent rack unit, now
broken.
Provenance: Undetermined.
Photograph: Bishop Museum.
Published: Bishop Museum, p. 18; Cox
1960, p. 52; Dodd, p. 130.

S 35 Support figure
Chicago Natural History Museum (272602).
From the A. W. F. Fuller Collection.
Height: 9 in. The hands originally formed
crescent-shaped support units, now
broken.
Provenance: Undetermined.
Photograph: Chicago Natural History
Museum.
Published: Edge-Partington, III: 4, no. 2.

S 36 Support figure
Collection of Eric Knudsen, Kauai (110).
Height: 10½ in. Stained with white
pigment.
Provenance: Undetermined; probably
Kauai.
Photograph: Bishop Museum.

S 37 Support figure
Bernice P. Bishop Museum, Honolulu
(11017).
Height: 12 in.
Provenance: Hilo, Hawaii.
Photograph: Bishop Museum.

S 38 Support figure
Bernice P. Bishop Museum, Honolulu
(6849).
Height: 16¼ in.
Provenance: Undetermined.
Photograph: Bishop Museum.

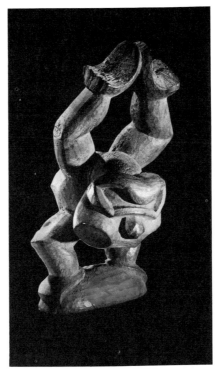

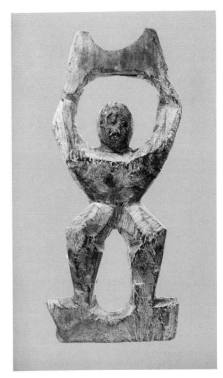

S 35/S 36

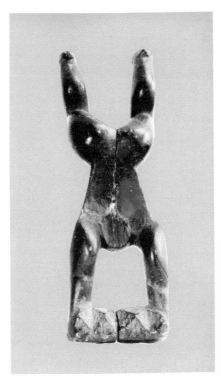

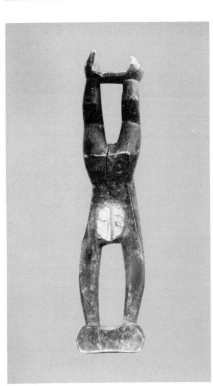

S 37/S 38

S 39 Support figure
Bernice P. Bishop Museum, Honolulu
(C8817).
Height: 14 in. Feet joined by bar notched
at ends. Eyes inlaid with shell.
Provenance: Undetermined.
Photograph: Bishop Museum.
Published: Edge-Partington, III: 4, no. 1.

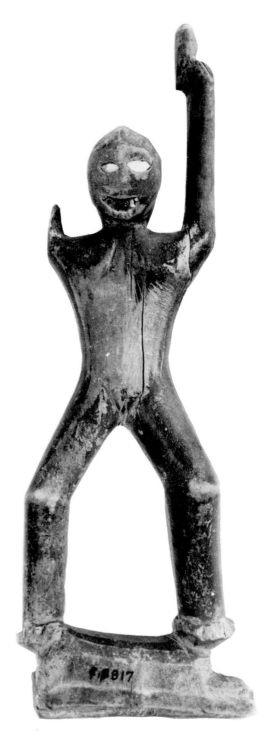

S 39

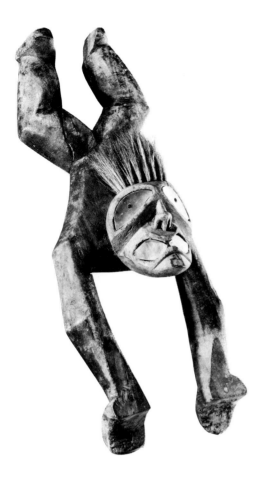

S 40

S 40 Support figure
Museum für Völkerkunde, Dahlem, Berlin
(VI 256).
Height: 17 in. Eyes and mouth inlaid with
pearl shell, human hair bundles pegged
into head. Probably used with feet up-
ward.
Provenance: Undetermined.
Photograph: Museum für Völkerkunde.
Published: Dodd, p. 132; Eickhorn, fig. 33.

S 41 Support figure
Roger Williams Park Museum, Providence,
R.I. (9071, E2733).
Height: 15 in. Eyes inlaid with shell,
head is stained black.
Provenance: Undetermined.
Photograph: Roger Williams Park Museum.
Published: Dodd, p. 235.

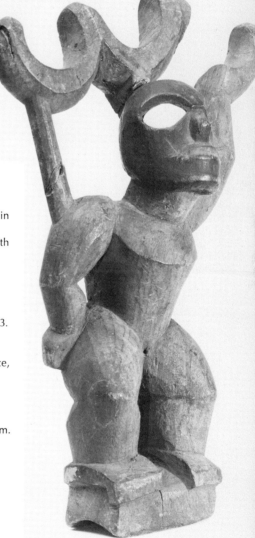

S 41

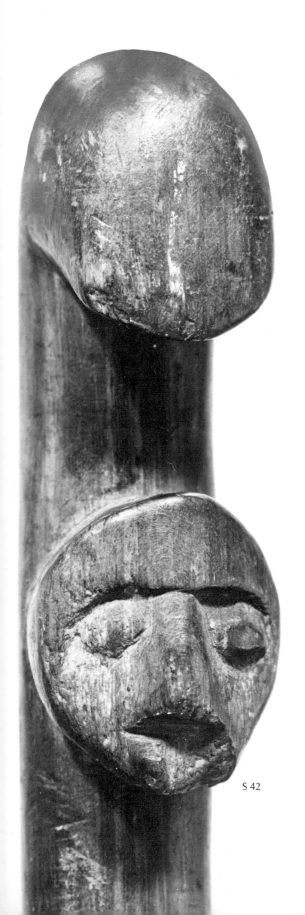

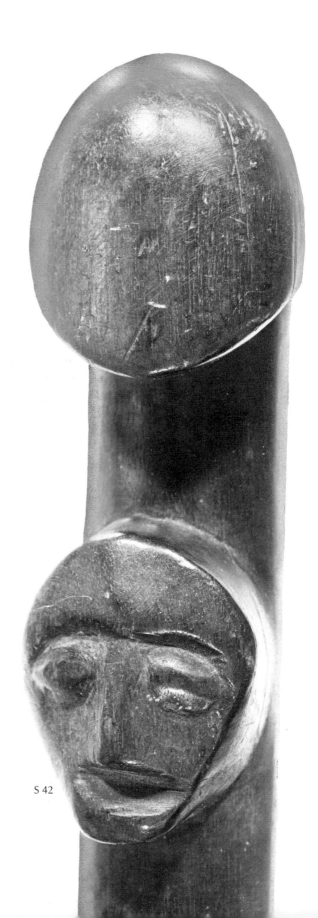

S 42

S 42

S 42 Carrying pole with one head at each end
Bernice P. Bishop Museum, Honolulu (D3357). From the James Phillips Collection.
Length: 49 in; length of heads: 1½ in.
Provenance: Undetermined.
Photograph: Bishop Museum.

S 43 Support rack with two heads
British Museum, London (4682).
Length: 6½ in; height: 4¾ in. A spear or pole rack, probably for use on a canoe.
Provenance: Undetermined.
Photograph: Cox.

S 44 Carrying pole with two heads at each end
Honolulu Academy of Arts (2485). From the Mrs. C. M. Cooke Collection, 1928.
Length: 64 in; average length of heads: 2¾ in. Heavy, dark brown wood, polished. Probably *kauila*.
Provenance: Undetermined.
Photograph: Honolulu Academy of Arts.

S 43

S 44

A–H Lost
a–m Fragments

A Akua kā'ai image (lost)
Museum für Völkerkunde, Dahlem, Berlin.
Lost during World War II.
Stick support was carved to represent
cord lashing pattern. See figure 39.
Provenance: Undetermined.
Published: Barrow, fig. 4; Behm-Blancke,
fig. 17; Eickhorn, fig. 10.

B Akua kā'ai image (lost)
Museum für Völkerkunde, Dahlem, Berlin.
Lost during World War II.
Height: 8¼ in. Head was missing.
Similar to cat. no. K31.
Provenance: Undetermined.
Published: Eickhorn, fig. 32.

C 'Aumakua image (lost)
Louvain Museum, Belgium. The museum
was destroyed during World War II.
The image was on loan to the Bishop
Museum, Honolulu, from the Catholic
Church, and was taken to Louvain in
1936.
Height: 15¾ in. The upper torso and
head were considerably eroded. Male.
Similar to cat. no. A10.
Provenance: Collected in Waipio Valley,
Hawaii, with cat. nos. T14 and T15.
Published: Buck 1957, fig. 298b.

D Akua kā'ai image (lost)
British Museum, London (6285). Presented
to the museum by Julius L. Benchley,
Esq., in 1870.
In two fragments of pale brown wood,
the upper part of the body and head
measured 4½ in.
Provenance: Undetermined.

E Akua kā'ai image
Whereabouts unknown, thought to have
been at the Methodist Missionary Society,
London.
Height: 10¼ in. The support stick was
broken or cut off. Upper part of body
leaning forward. Shell set in eyes. Head
bald. Arms broken at elbows.
Provenance: Undetermined.

F Head of an image
Whereabouts unknown.
The head and high, helmetlike crest were
apparently covered with tapa. It was
probably part of an image similar to cat.

no. T31, or the head of a marionette.
(See also cat. nos. *a*, *b*, and *l*.)
Provenance: Undetermined. Probably
collected at Hale-o-Keawe, Honaunau,
Hawaii, in 1825 by the Bloxam party.
Published: *Mirror* (London), Oct. 7, 1826,
p. 7.

G Akua kā'ai image
Whereabouts unknown. It was with the
Leverian Museum Collection, London, in
1783.
Size not recorded, but this appears to be
a small image of the Kona style, with
a high towering and notched crest. Eyes
are triangular and within the hair pattern.
Similar to cat. no. K8.
Provenance: Probably Kona, Hawaii.
Probably collected during the Cook ex-
pedition, which was in Hawaii in 1778
and 1779.
Published: Force and Force, p. 97 (water-
color sketch by Sarah Stone, made in
1783).

H Slab image
Whereabouts unknown. It was in a
private collection in Honolulu in 1941
(Mrs. Gerrit Wilder).
Height: 30½ in. A head with protruding
mouth and slab headdress, which takes
the form of inverted legs holding a
square panel, decorated with a carved,
hatch pattern between the "feet."
Provenance: Records are conflicting, but
it probably was found with cat. no. T23
in a rice field at Aiea, Oahu, 1905.

a Head of an image
British Museum, London (HAW77).
Height: 11½ in. Head covered with dark brown tapa. Black and brown cordage wrapped around the helmet crest, top of head, upper lip, and neck. The eyes are of pearl shell, shark's teeth are set into the mouth. It was probably used with a torso and arms, as in cat. no. T31. Or it may have been the head of a marionette or puppet used in certain hula performances, as described by Emerson in *Unwritten Literature of Hawaii*, pp. 91–92. (See also cat. nos. *F*, *b*, and *l*.) Possibly collected during the Cook expedition that was in Hawaii in 1778 and 1779.
Provenance: Undetermined.
Published: Force and Force, p. 101 (watercolor sketch by Sarah Stone, made in 1783).

b Head of an image
British Museum, London (HAW76).
Height: 11 in. Made of pale wood, blackened, with eyes of pearl shell. The head was once covered with feathers. Human hair around the temples. Wooden teeth are set into the mouth. It may have been used in an assembled image, as in cat. no. T31, or possibly as the head of a marionette. (See also cat. nos. *a*, *l*, and *F*.)
Provenance: Undetermined.

c Head of an image (fragment)
Bernice P. Bishop Museum, Honolulu (C8729).
Head only, with partial forehead crest, similar in form to cat. no. K7, but larger. Chin broken off.
Provenance: Found in a cave at Keauhou, Hawaii, in 1936.

d Image (fragment)
Bernice P. Bishop Museum, Honolulu (1365). J. S. Emerson Collection.
Height: approx. 6 in. Probably a *kā'ai* image, designated as *akua lawai'a* (fisherman's god). Extremely eroded, helmet-like crest, as in cat. no. K25.
Provenance: Found in a cave in the fort at Kailua, Kona, Hawaii, in 1885. Ahuena *heiau* (figure 4) was converted into a fort in 1820.

e Head of an image (fragment)
Bernice P. Bishop Museum, Honolulu (C3525).
Height: 7 in. Badly deteriorated, features barely discernible.
Provenance: Found in a fishing shrine on Kahoolawe Island, 1913.

f Image fragment
Bernice P. Bishop Museum, Honolulu (1342).
Height: approx. 9 in. Left side of image only, badly worm-eaten. There are radiating fanlike flutes in the headdress.
Provenance: Found in a cave at Kukuihaele, Hawaii, with cat. no. A23.

g Image fragment
Bernice P. Bishop Museum, Honolulu (7542).
Height: 8 in. Extremely deteriorated. Was wrapped in a tapa bundle, with *'awa*.
Provenance: Found in a cave on Molokai.

h Slab image fragment
Bernice P. Bishop Museum, Honolulu (D378).
Height: 54 in. Left side of crest and head of a slab image similar to cat. no. T19. Extremely weatherworn.
Provenance: Found on the ruins of a *heiau* at Puuhakina, southwest Molokai, in 1952.

i Leg of a *kā'ai* image
Bernice P. Bishop Museum, Honolulu (01 Gen. 13).
Length: 4¼ in. Deteriorated leg and part of shaft support.
Provenance: Excavated at Kuliouou shelter site, Oahu, in 1950.

j Head of an image (fragment)
Bernice P. Bishop Museum, Honolulu. On loan from Hawaii Volcanoes National Park.
Height: approx. 12 in. Soft wood, splintered and weatherworn, remnant of crest.
Provenance: Collected from a stone cache at Keauhou, Kau, Hawaii, in 1962, with cat. no. *k*.

k Head of an image (fragment)
Bernice P. Bishop Museum, Honolulu. On loan from Hawaii Volcanoes National Park.
Height: approx. 12 in. Soft wood, splintered and weatherworn.
Provenance: Collected from a stone cache at Keauhou, Kau, Hawaii, with cat. no. *j*.

l Torso of an image
Museum für Völkerkunde, Dahlem, Berlin (VI 8376).
Made of breadfruit wood with pegs of coconut palm wood embedded in a regular pattern over the surface. It was probably covered with tapa and used for the base of an assembled image, as in cat. no. T31, or possibly as the body of a marionette. (See cat. nos. *a*, *b*, and *F*.) The interior is hollowed out.
Provenance: Collected in the vicinity of Laupahoehoe, Hawaii, in 1880, with cat. no. A11.
Published: Eickhorn, pp. 7, 8.

m Crest of a slab image (fragment)
Canterbury Museum, Christchurch, New Zealand (E 150.1197). From the Oldman Collection (303).
Height: 14½ in; width: 7½ in. Left side of the crest of a slab image, similar to cat. no. T24, but in better condition. Deeply cut chevron, pyramidal and zigzag patterns. Perforation for attaching tapa streamer.
Provenance: Collected at Hanalei, Kauai, in 1861.
Published: Duff, no. 135; Oldman, pl. 132.

Bibliography

Arago, Jacques, et al. 1825. *Voyage Autour du Monde sur l'Uranie*. Paris: Pillet Ainé. (Atlas of Plates)

Archey, Gilbert. 1965. *Art Forms of Polynesia*. Bulletin, Auckland Institute and Museum, no. 4. Wellington: Whitcombe and Tombs.

Arning, Eduard. 1931. *Ethnographische Notizen aus Hawaii*. Hamburg: DeGruyter and Co.

Barrow, Terry. 1961. "Maori Godsticks in Various Collections." *Dominion Museum Records in Ethnology* 1(6): 213–229.

Beckwith, Martha Warren. 1970. *Hawaiian Mythology*. Reprint. Honolulu: University of Hawaii Press. (First published in 1940 by Yale University Press.)

Behm-Blancke, G. 1955. "Zum Problems der Nordwestpolynesischen Ahnenfiguren des Primärstil." *Weimarer Ethnographische Mitteilungen*: 2–22.

Bernice P. Bishop Museum. 1956. *Guide to the Bishop Museum Press*. Honolulu: Bishop Museum Press.

Bloxam, Andrew. 1925. *Diary of Andrew Bloxam, Naturalist of the "Blonde" on her trip to the Hawaiian Islands from England, 1824–25*. Bernice P. Bishop Museum Special Publication, no. 10. Honolulu: Bishop Museum Press.

Brigham, William T. 1898. "Report of a Journey around the World Undertaken to Examine Various Ethnological Collections." *Occasional Papers*, Bernice P. Bishop Museum 1(1).

——— 1903. *A Handbook for Visitors to the Bernice P. Bishop Museum*. Bernice P. Bishop Museum Special Publication, no. 3. Honolulu: Bishop Museum Press.

——— 1906. "Old Hawaiian Carvings." *Memoirs, Bernice P. Bishop Museum* 2(2): 165–183.

——— 1913. "Report of a Journey around the World to Study Matters Relating to Museums." *Occasional Papers, Bernice P. Bishop Museum* 5(5).

British Museum. 1925. *Handbook to the Ethnographical Collections*. 2nd ed. London: Oxford University Press.

Buck, Peter H. 1938. *Ethnology of Mangareva*. Bernice P. Bishop Museum Bulletin, no. 157. Honolulu: Bishop Museum Press.

——— 1944. *Arts and Crafts of the Cook Islands*. Bernice P. Bishop Museum Bulletin, no. 179. Honolulu: Bishop Museum Press.

——— 1957. *Arts and Crafts of Hawaii*. Bernice P. Bishop Museum Special Publication, no. 45. Honolulu: Bishop Museum Press.

Byron, George Anson. 1828. *Voyage of H.M.S. Blonde to the Sandwich Islands in the Years 1824–1825*. London: T. Murray.

Choris, Louis 1822. *Voyage Pittoresque, Autour du Monde*. Paris: Firmin Didot.

Cook, James. 1784. *A Voyage to the Pacific Ocean, Undertaken by the Command of His Majesty, for Making Discoveries in the Northern Hemisphere.* 3 vols. and Atlas. London: G. Nicol and T. Cadell.

Cox, J. Halley. 1960. "Are These the Menehunes?" *Paradise of the Pacific* 72(10): 52–53.

———— 1964. "Kukailimoku, or the War God Ku." In *Man through His Art,* vol. 1, *War and Peace.* Greenwich, Conn.: New York Graphic Society.

———— 1967. "The Lei Niho Palaoa." In *Polynesian Cultural History, Essays in Honor of Kenneth P. Emory,* edited by Genevieve A. Highland et al. Bernice P. Bishop Museum Special Publication, no. 56. Honolulu: Bishop Museum Press.

Davenport, William H. 1964. "Hawaiian Feudalism." *Expedition* 6(2): 15–27.

Dodd, Edward. 1967. *The Ring of Fire,* vol. 1, *Polynesian Art.* New York: Dodd, Mead and Co.

Duff, Roger (ed.). 1969. *No Sort of Iron: Culture of Cook's Polynesians.* Souvenir handbook, Cook Bicentenary Exhibition. Christchurch: Caxton Press.

Edge-Partington, James. 1890, 1895, 1898. *An Album of the Weapons, Tools, Ornaments, Articles of Dress of the Natives of the Pacific Islands.* 3 vols. Manchester: J. C. Norburg.

Eickhorn, August. 1929. "Alt-Hawaiische Kultobjects und Kultgeräte." *Baessler Archiv* 13(1).

Elbert, Samuel E. (ed.). 1959. *Selections from Fornander's Hawaiian Antiquities and Folk-lore.* Honolulu: University of Hawaii Press.

Ellis, William. 1827. *A Narrative of a Tour through Hawaii.* London: H. Fisher, Son, and P. Jackson.

———— 1963. *Journal of William Ellis.* Honolulu: Advertiser Publishing Co.

Emerson, Nathaniel B. 1909. *Unwritten Literature from Hawaii, the Sacred Songs of the Hula, Collected and Translated, with Notes and an Account of the Hula.* Bureau of American Ethnology Bulletins, no. 38. Washington, D.C. (Reprint edition 1959 published by C. E. Tuttle.)

Emory, Kenneth P. 1934. *Tuamotuan Stone Structures.* Bernice P. Bishop Museum Bulletin, no. 118. Honolulu: Bishop Museum Press.

———— 1938. "Notes on Wooden Images." *Ethnologia Cranmorensis* 2: 2–7.

———— 1938a. "God Sticks." *Ethnologia Cranmorensis* 3: 9–10.

Force, Roland W., and Maryanne Force, 1968. *Art and Artifacts of the 18th Century.* Honolulu: Bishop Museum Press.

Guiart, Jean. 1963. *The Arts of the South Pacific.* New York: Golden Press.

Honolulu Academy of Arts. 1967. *Oceanic Arts.* Honolulu: Honolulu Academy of Arts.

Ii, John Papa. 1959. *Fragments of Hawaiian History.* Translated by Mary

Kawena Pukui, edited by Dorothy B. Barrère. Honolulu: Bishop Museum Press.

Kamakau, Samuel M. 1961. *Ruling Chiefs of Hawaii.* Honolulu: Kamehameha Schools Press.

———— 1964. *Ka Po'i Kahiko. The People of Old.* Translated by Mary Kawena Pukui, edited by Dorothy B. Barrère. Bernice P. Bishop Museum Special Publication, no. 51. Honolulu: Bishop Museum Press.

Kooijman, Simon. 1964. "Ancient Tahitian God Figures." *Journal of the Polynesian Society* 73(2): 110–125.

Linton, Ralph, Paul S. Wingert, and Rene d'Harnoncourt. 1946. *Arts of the South Seas.* New York: Museum of Modern Art.

Luomala, Katharine. 1955. *Voices on the Wind.* Honolulu: Bishop Museum Press.

Luquiens, Huc-Mazelet. 1931. *Hawaiian Art.* Bernice P. Bishop Museum Special Publication, no. 18. Honolulu: Bishop Museum Press.

Malo, David. 1951. *Hawaiian Antiquities.* 2nd ed. Translated by Nathaniel B. Emerson. Bernice P. Bishop Museum Special Publication, no. 2. Honolulu: Bishop Museum Press.

Muensterberger, Warner. 1955. *Sculpture of Primitive Man.* New York: Harry N. Abrams.

Oldman, W. O. 1953. *Polynesian Artifacts; The Oldman Collection.* Memoirs, Polynesian Society, vol. 15, 2nd ed.

Peabody Museum. 1920. *The Hawaiian Portion of the Collections in the Peabody Museum of Salem.* Salem, Mass.: Peabody Museum.

Poignant, Roslyn. 1967. *Oceanic Mythology.* London: Paul Hamlyn.

Pukui, Mary Kawena, and Samuel H. Elbert. 1965. *Hawaiian-English Dictionary.* 3rd ed. Honolulu: University of Hawaii Press.

Rousseau, Madelaine. 1951. *L'Art Oceanien.* Le Musée Vivant, no. 38. Paris: Association populaire des Amis des Musées.

Sotheby and Co. 1969. *Catalogue of Primitive and Indian Sculpture.* London: Sotheby and Co.

Stokes, John F. G. n.d. Unpublished manuscript, Bernice P. Bishop Museum.

Tischner, Herbert, and Frederick Hewicker. 1954. *Oceanic Art.* New York: Pantheon Books.

Wardwell, Allen. 1967. *The Sculpture of Polynesia.* Chicago: Art Institute of Chicago.

Wilkes, Charles. 1845–1848. *Narrative of the United States Exploring Expedition, 1838–1842.* Philadelphia.

Wingert, Paul S. 1946. *Outline Guide to the Art of the South Pacific.* New York: Columbia University Press.

———— 1953. *Art of the South Pacific Islands.* London: Thames and Hudson.

Photo Credits

Credits are given here for photographs reproduced within the text portion of the book. They are listed by figure number unless otherwise indicated. Credits for photographs in the catalog section are given there.